FACE TO FACE
THE ART OF **PORTRAIT PHOTOGRAPHY**

TRANSLATED FROM THE FRENCH BY MICHAEL TAYLOR

COPYEDITING: JENNIFER LADONNE

TYPESETTING: CLAUDE-OLIVIER FOUR

PROOFREADING: CHRISOULA PETRIDIS AND FUI LEE LUK

CAPTION RESEARCH: HELEN ADEDOTUN

COLOR SEPARATION: PAYTON, BILBAO

DISTRIBUTED IN NORTH AMERICA BY RIZZOLI INTERNATIONAL PUBLICATIONS, INC.

ORIGINALLY PUBLISHED AS *PORTRAITURÉS : "BE KIN) TO ME"*
© ÉDITIONS DU REGARD, 2003

ENGLISH-LANGUAGE EDITION
© ÉDITIONS FLAMMARION, 2004

WWW.EDITIONS.FLAMMARION.COM

04 05 06 4 3 2 1

FC0462-04-X
ISBN: 2-0803-0462-3
DÉPÔT LÉGAL: 10/2004

PRINTED IN SPAIN BY I.G. CASTUERA

PAUL ARDENNE

FACE TO FACE

THE ART OF **PORTRAIT PHOTOGRAPHY**

PHOTO RESEARCH
ÉLISABETH NORA

Flammarion

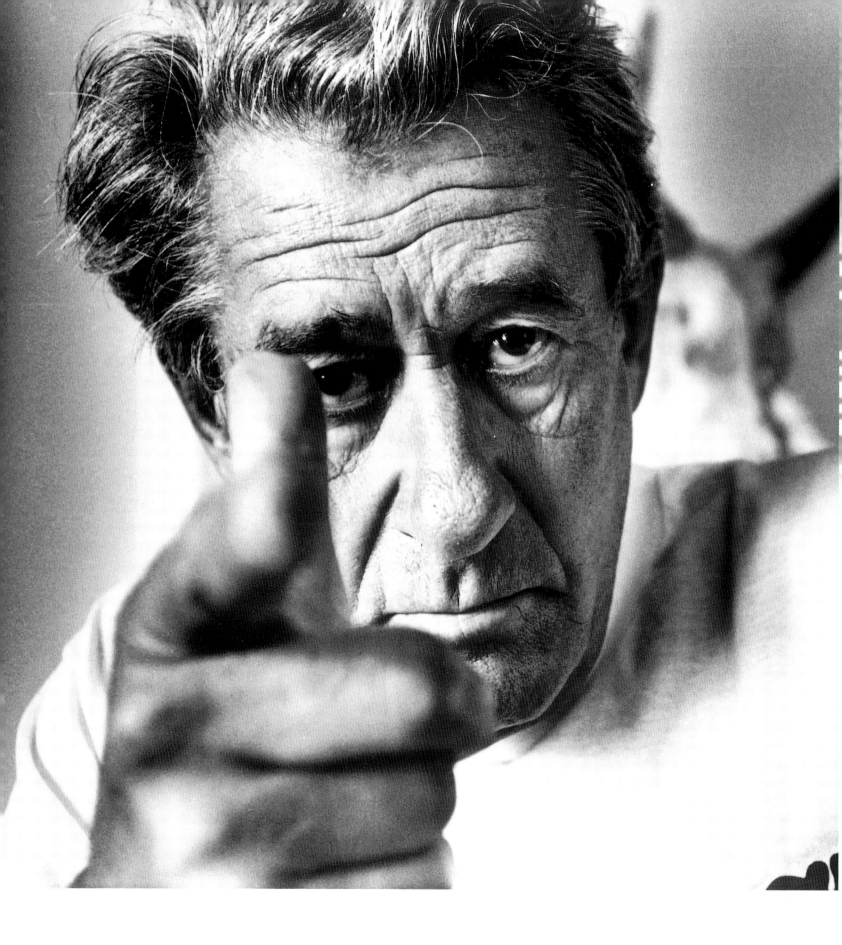

THE MODEL AND THE PORTRAITIST:

REFLECTIONS ON THE PLIGHT OF A HOSTAGE

PAUL ARDENNE

I

Pascal's dictum about the self being hateful should by extension apply to the portrayed self—the photographic portrait. Yet everything would seem to suggest otherwise. The photographic portrait is a perfectly respectable genre—witness its popularity from its inception in the nineteenth century up to now. Whether in the form of an identity photo, a family snapshot, an art photograph, a personal or social record, the photographic portrait dominates the field of mechanical images, clear proof of how well it answers our craving for images of ourselves.

Yet despite all of this we *must* hate it. Not out of jealousy at its success (which is immense), its chameleon-like adaptability (which is boundless), or its aesthetic potential (which is inexhaustible), but on behalf of the individual and his rights, of the model whom the camera lens imprisons in the film frame. For he is a hostage, a figure in thrall to the sovereignty of the portrait that captures him. The moment we pose in front of a lens—trapped by our unrepentant narcissism—we become its hostage. Likewise, when the photographer takes a picture of us, according to his own needs, without our knowledge or control, we are hostages to his purpose. When we attempt to take our own portrait, we become a hostage of our feeble efforts at staging it (and how ruthlessly the portrait lays these efforts open to view). Whatever form it takes, the photographic portrait shows scant respect for the body—and this is precisely where the problem lies. The rule of the portrait is the rule of dependence, of the confiscated will. Never is there less question of me being myself than when I'm being portrayed. The photograph gives me a face, but it also causes me to lose face.

*

To show more interest in the features of the model than in those of the portraitist is to attach importance to the equivalent of a corpse. Although brimming with vitality, once photographed, the body displayed in

the picture (mine or someone else's) ceases to be alive. I die the instant I'm portrayed; I surrender my physical condition as a real human being and enter the sphere of impalpable images. Is this an acceptable state of affairs? Long before the birth of photography, religious and secular authorities reacted to the practice of representing the human body (etymologically speaking, making "present again") either by banning such representation outright, as did the iconoclasts, who thought it smacked of idolatry; or by granting its ability to assert the subject's individual qualities, as did the image worshippers. As an advocate of self-love shamelessly displaying itself, the model embraces the latter's position and views the portrait as a fundamental development in the epic of the human body.

The success of the photographic portrait isn't just due to the many technical improvements that led to the invention of those two historical means of light-sensitive imagery: the daguerreotype, in 1839, and its democratic successor, the calotype, in 1841. Arising in the West in the aftermath of the Enlightenment, the portrait's growing popularity was also due to Western man's individualized relationship with the body, marked in equal measure by his preoccupation with himself and his preoccupation with appearances. If to be is to be perceived, to cite Bishop Berkeley's phrase, to be portrayed is equivalent to exponentially increasing one's chances of being. Much has been said in treatises on photography about the fervor kindled even before 1850 by lowering the cost of producing photographic portraits; a fervor so great that it permanently undermined the status of the painted portrait. For photography, too, has the power to stun and excite the imagination, to make us dream—qualities that the poet Charles Baudelaire, author of *The Flowers of Evil*, claimed as the exclusive prerogative of painting. (Baudelaire regarded the new art with disfavor despite the fact that he willingly submitted to having his portrait taken by Nadar and Carjat.) The wholesale endorsement of the photographic portrait in the West (which André Adolphe Disdéri, inventor of the celebrated *carte-de-visite*, or calling card, an inexpensive wet-plate method consisting of multiple copies of the same portrait, was to turn to substantial advantage) filled a tremendous need—the craving to give away pictures of oneself. And it satisfied something else as well, the hankering for a vengeful apparition. The reason why members of Europe's lower middle class, encouraged by the revolution of 1848, developed a taste for photography and played such a large part in its commercial success, was not only that they sought to gain political power, but also that they required concrete, clearly identifiable likenesses of their political representatives. The nature of the aristocratic and upper-middle-class portrait was almost entirely painterly; that of the lower-middle-class portrait, nearly always photographic. The growth of political democracy that went hand in hand with the growth of photography meant that the subject of a

portrait was not just an actor who had stepped fortuitously onto the twofold stage of history and the image, but someone who made political and social demands—he aspired both to seize power and to control the means of visual representation. For him, gaining power also meant preempting the power to make images and thus enshrining himself in the image.

Seen from our vantage point nearly two centuries later, this demonstrative, militant infatuation with the photographic portrait looks rather old-fashioned. No one today disputes its validity. Given the social narcissism that is the essence of our spectacle-struck society, the photographic portrait is a perfectly logical enterprise. It has become a natural form of figurative representation in all Western societies. Beginning in infancy, every citizen is repeatedly positioned in front of a camera—and now, thanks to the late-twentieth-century invention of the ultrasound, is even photographed before birth. It's perfectly conceivable that a child's first portrait in the family photo album is a scanned image taken during the mother's pregnancy; a body in formation yet already a composed picture of a "self." So commonplace has the photographic image become (automatic photo booths, ID cards, ritual snapshots marking all the stages in a person's life: christening, birthdays, graduation, wedding, and so forth), that its absence now seems incomprehensible. To refuse to submit to the camera is to expose oneself to criticism. A person who attains a degree of celebrity without the benefit of photography excites both fans and paparazzi (witness the frenzied, now legendary search for portraits of Lautréamont, Maurice Blanchot, and Thomas Pynchon). To be is to be portrayed; to gain a place in the cycle of the ego's metaphysics where the visible portion of the body—the "me" in the picture—allegedly tells one everything about the sitter.

*

Among the roles afforded us by the contemporary world is that of the photographic subject or model. The eleventh commandment might well be: Thou shalt be Pictures (in the plural); thou shalt submit to the ritual of portraiture as though it were a circumcision or first communion. Being alive, one is destined to be "drawn" (the original meaning of the Old French *pourtret* or *pourtrait*, from the eleventh-century *pourtraire*, to draw), for your aim (*dessein*) at each stage of your life is your "drawing" (*dessin*).

Not everyone enjoys being photographed. As already mentioned, there are even those who avoid it. The refusal to be photographed can be viewed as a precaution, a defense against the disappointment of being confronted with one's own image and having to acknowledge its likeness. Yet, far from being me, my portrait is more a kind of performance, a theatricalization of my identity. However, the aversion to being portrayed can hardly be said to pose a serious challenge to portraiture. In this age of fame at all

costs, shunning the camera lens passes more for intellectual frivolity or unreasonable pride than true dissent. Archaic fears of having one's body or soul possessed by the camera's eye have long been put to rest; fears of the sort that Champfleury ridiculed in his story "La Légende du daguerreotype" (1863), whose protagonist, Monsieur Balandard, poses in front of the camera of a professional daguerreotypist only to experience his whole body being gradually absorbed by the picture-taking apparatus, like air slowly sucked into a vacuum, until all that's left is a mouth clamoring for its body to be returned. To refuse to be photographed is to deny oneself the pleasure of public display, the thrill of having one's picture snapped—an enjoyment familiar to anyone who revels in the narcissistic delight of knowing that a camera lens is focusing on their body. Consider the orgiastic exhibitionism of starlets strutting on the Croisette during the Cannes Film Festival, the extraordinary excitement their posturing generates in front of the clicking shutters of swarming photographers who pounce on them for lack of more glamorous prey (true film stars are more furtive, more difficult to "shoot"). Some of the models in Yann Toma's aptly named *Extases*, (1999), having been given free rein to stage a scene expressing their notion of ecstasy, chose to make love in front of the camera, others gave themselves the attributes of gods or goddesses. Pierre Molinier's self-portrait with erect penis—a masterpiece of its kind—could be described as a picture where everything has a hard-on, from the body of the notorious French photographer decked out as a common whore to the actual composition of that egregious "triumph of the flesh."

But must one really deplore the photographic portrait? In the examples cited here, it seems that the hostage—the person portrayed—is always a willing victim, perfectly happy to be preserved on film even if this means "dying". To take a portrait is to make a ritual sacrifice to the image, to engage in a "kill" where the subject is invariably cast in the role of victim. Yet there is nothing tragic about this elimination. At worst, to be photographed is to sacrifice the body to the picture (I was flesh and blood before the shutter clicked; I became a simulacrum afterward). Viewed as a murder, the photograph merely does away with the world of bright surfaces, which it captures without truly appropriating: the self that is photographed is embedded on the surface of the film, yet the physical self is still here, standing away from the theater of light and fiction that makes up the photographic universe. It's a gentle death that can be repeated incessantly. And it pays off, for it helps me endure in and through the picture; it enshrines me in the long term, perhaps even longer than the life span allotted to me—it will make it possible for me to be loved as I am, not just now but years later, even after my real death. After his mother's death, Roland Barthes, examining the emotional process of viewing snapshots in *Camera Lucida*, casts just such a look on her photograph and is overwhelmed

8

by the feeling of connectedness between the photographic image, love, and death; as though her real death did not take place altogether, for, thanks to her picture, her false death—the portrait—preserves her body in a "living" state.

Underpinning all of this is the fabric of sensual exchange (although it has nothing to do with fetishism) within the eroticized embrace of the loving gaze. In one of his interviews, Barthes declares in much the same vein: "I believe that the ideal development in photography, unlike painting, is the private picture, in other words, the photograph that communicates a loving relationship with someone. It only achieves full strength when there is a bond of love, even if it is only a virtual bond, with the person who is represented in it. It is something played between love and death. It's very romantic."

II

The model's first right is to be permitted to die within the image so as to be resurrected through it. Any "portraitological" analysis—to coin a word based on the pattern of "elegantology" and "fashionology" in Balzac's *Treatise on the Elegant Life*—owes it to the reader to start with an examination of the reasons that might have led the model to have her picture taken in the first place.
Listed in no particular order, they are as follows:
— The portrait's affective aspect. Admiration for oneself or for someone else.
— The pleasure of being portrayed.
— The portrait's mesmerizing nature and its cosmetic potential (another way of making oneself up).
— Its topographic function: placing others—the other—in my axis (the axis of my gaze, of my life). Or placing her in my axis in order to savor her image, her life.
— Its cognitive function. It enables me to know myself better—draw me a self, record me, even if it's only in the realm of illusion. (Except for their preoccupation with tradition, custom, or fashion, August Sander's portraits of social types tell us nothing tangible about the individuals he portrays.)
— Its remedial function: the portrait can "correct" reality; this is why we strike a pose. Recall the statement by the philosopher Emmanuel Lévinas in *Éthique et Infini* where he describes the face and its active "faciality" as the source of our respect for others ("I recognize you thanks to your face" and vice versa). There must be something inherently disappointing about the face and the body's appearance to make us want to pose.
— The portrait as a strategy of the persona (if one is to give credence to the theories of Carl Jung). At each important stage in life, Jung contends, we fashion an attitude, put on a mask, adopt a title

to solidify and legitimize our social self. To have one's portrait taken by Richard Avedon or Helmut Newton, or to go to Studio Harcourt instead of some obscure side-street photographer, does not signify the same kind of life, or the same presentation of one's life, as that expressed by an anonymous portrait.

—The portrait as icon; an image that catches something of the sacred character of the subject. For instance, the Argentinian women of the Plaza de Mayo in Buenos Aires holding portraits of their missing sons who disappeared under the military junta; Hamas militants at demonstrations or funerals in the Palestinian territories, brandishing portraits of suicide bombers who died for their cause. A way of viewing the body as a hieroglyph.

—The portrait as a means of rendering subjective experience; how I look in this pose or that one (my personal touch, my style, myself), in a particular situation—a hip adolescent, a lover or mistress, a tourist, an old-timer, a parent, a nature lover, driving my Jaguar or laid out on my deathbed, a friend of ordinary folk or important people, getting out of bed or standing in my bathroom, and so forth.

—The portrait as a way of injecting oneself into the flux of images and exchanging one's outer appearance with others; sending photos of oneself by mail or, with the aid of digital technology, by phone. Or perhaps even trafficking in deceptive pictures of oneself, passing them off for real likenesses (me looking young and handsome when in reality I have ceased to be either).

— The portrait as a way of existing. On the face of it, the portrait is a signature of one's existence. It can even create an existence if necessary, in which case it is always a step ahead of, or a step behind, the truth. This is nothing new. The gallery of ancestral portraits in Karlstein Castle near Prague, built in the era of the Emperor Charles IV, has a peculiarity that will hardly astonish image historians familiar with such deceptions: contained therein are full-length portraits of the local ruling dynasty's leading members, the living (at the time they were portrayed) as well as the dead. Some of those portrayed existed only as popular myths; others were painted as old men when in fact they died young. Several seem to be pictured as they were in real life, though doubtless not as they truly looked, since medieval portraits were commonly idealized and were never intended to be semblances. Beyond the institutional purpose of such a gallery (the individuals portrayed are the state, independent of any criteria of time or truth), what is most interesting here is the visionary value of the portraits and what they represent in terms of fantasy—a perfect genealogy, a family tree with each branch bearing a prince—and the degree to which reality and legend become intertwined. The portrait always invents a figure, and therefore, a being.

III

But to return to the initial question: Must we really despise the photographic portrait? We must admit that this is not an easy thing to do. For the portrait, as proven by its universal use, has a beguiling power all of its own. And it has certain qualities all of its own, too: a dazzling ability to accomplish tasks that are by nature complex, a remarkable capacity for expressing being and appearances simultaneously, for tidying the untidy, for offering consolation at the inevitability of decay and negotiating with death's dark syndicate. Still, it's clear that the portrait's astonishing popularity and constant adaptability do not by any means establish its credibility. However it is employed, the photographic portrait remains an image and, as such, a simple figuration, an automatic absence of ontology. Of course, the subject's picture is "accurate," but it is also, at the very least—and this is essential—an impression of reality. Furthermore, judging from the technical progress made since the inception of photography, the photographic portrait is an impression that is forever being improved upon. And an impression is, above all, a trace, and what is a trace but clear proof that something is.

The case to be made for the impression—an argument advantageous to the model and one he readily uses to justify his status—is not to be taken lightly. After all, if the body did not exist, there could be no portrait. The only logical reply to this argument is to point out that when it comes to expressing an identity the camera is about as good as speech is to the psychoanalyst: it reveals only that which allows itself to be revealed. So, the real question is: "Can the camera capture the model's being?" In other words, is it possible to base a kind of maieutic method on the ever-improving photographic technique and its corollary, the image's increasing ability to obscure reality, and, by extension, the reality of the body? Of course not. Flypaper captures flies, but the camera cannot hope to capture bodies in a physical sense. Certainly, the photographer focusing on his model's identity—like the psychoanalyst seeking the true identity of his patient by putting him on a couch and adopting a detached, theoretically more efficient attitude —is assisted by constantly improved equipment and techniques. And yet, although he is able to record the outward appearance of the model's body with increasing skill as photography advances, the photographer, whose eye is extended first by a portable box camera, then by high-resolution film and artificial lighting (from the magnesium-powder flash to the infrared viewfinder), cannot hope to capture the full measure of human physicality. In fact, its improved vision has even given rise to the negative perception that photography is irremediably imperfect. Where impressions of the human body are concerned, film and radioscopy both attempted to remedy this state of affairs, each with vastly increased powers to grasp physicality. The former

thanks to the development of the motion picture enhanced by the sound track, the later thanks to its ability to penetrate the body's surface. This paradox could perhaps be viewed as the tragic fate of photography; the most telling proof of its constantly defeated nature, if not its futility.

Does this mean that the portraitist's aim is to undermine the model? To answer this question we must once again stress photography's backdrop of defeat. We must also consider its ability to truly project anything at all. Let us confront the model with her naturally guilty acceptance of illusion. Does the model believe in the image? Never. And yet, despite everything, she has an ironclad faith in it, faith of a religious nature that corresponds to one's need to justify the ego: Just as the deity who created me proves that I exist for a reason, my portrait proves that there is a reason for my appearance. The power of the portrait—and the subject's belief in it—lies in its ability to instill faith where one would expect doubt to prevail. "The loser wins" is the model's ultimate weapon, even when photography is presented to her for what it is, a medium suffering from a deep infirmity. Although it is a weapon of last resort, its range is limited; in the hands of the model it has as little weight as belief—it never proves anything.

*

Let us begin our refutation of the model's position by quoting the perceptive filmmaker Jean Renoir: "A portrait can only be unconscious." What does this mean? Of course, one can portray oneself, but this is not equivalent to an act of self-knowledge. It's rather an act of being put in touch with oneself, as well as with the photographer and with the viewer (both are accessories to the portrait). It's also an act of being placed in a position where one views oneself in a reflexive relationship, much like rehearsing in front of a mirror. But, in fact, there is nothing authentic about it.

Although the portrait exhibits an identity, or what passes for an identity—a simple depiction of the body, an identity photo like those required by certain public institutions—it never actually asserts it. To state that a portrait can only be unconscious is to imply that one's consciousness of one's self, derived from looking at one's portrait, is both deceptive and unsatisfactory. Deceptive in the sense that when I look at my own portrait I must concede that what the picture presents is not me but a figure or effigy, and that my own truth remains buried, elusive, and inaccessible. It is unsatisfactory because, having been seduced into thinking that being photographed could help me understand my own identity, I find, in the end, that the enterprise to appropriate myself leaves me more deprived than enriched. Furthermore, I make the unpleasant but vital discovery that what I grasp with regard to myself—that image of me that the portrait holds up for my scrutiny— is not an expression of my vitality but the product of a tactical construction, an act of survival, an attempt

to correct reality and show myself off to advantage. Besides the obvious pleasure I derive from looking at my portrait—like Narcissus gazing at his reflection in a moment of suspended ideality wrested from flesh-and-blood corporeality; as far removed as possible from history and my strictly adventitious place in it—what I feel as I contemplate my picture is that I actually have less, not more, existence in it.

Indeed, the portrait, from which the body hopes to gain something by the mere fact that it figures in it, could be described as a genre in which the subject is made to undergo the trial of failing to measure up to himself. Does the image really duplicate me, does it truly reproduce my external appearance (regardless of whether or not it is flattering to my view or to that of my peers)? It is to this contradictory end that my "self" is diminished and thus unable to attain its essence—its truth. A preeminently subtractive genre, the portrait lives only in the illusion it proliferates: I want to believe that I am really as pictured rather than have to admit that I do not know myself; I cling to the surface because the depth escapes me; I settle for the fragment instead of the whole for in reality I have only a fragmentary perception of myself. The portrait reconciles me with my being and tells me I must doubt myself and even be angry with myself. It invites me to incorporate the "self" displayed in the image and simultaneously it "decorporates" me. It robs me of my body.

Thus the subject confronted with his image reexperiences Lacan's trial of the mirror alluded to above, though not in the same way as the child learning that the shape stirring on the reflecting surface before him—the image of a body matching his own body feature for feature—is not someone else, a playmate, but himself. While the child asks, "Who was I before I became myself?" the subject of the portrait wonders, "Who am I now that, thanks to the artifice of the image, I see clearly that I am not who I thought I was?" Lacan stresses this point; for the small child, accepting the image to be himself is a prerequisite for assimilating it. "It is enough to understand the mirror stage as an identification in the sense that analysis gives to this term," he writes. "That is to say as a transformation wrought in the subject when he assumes an image." But while the portrait does indeed transform the subject in the same way that seeing himself in a mirror transforms the child, by its very presence it nevertheless places in question any identification of the model. For, in truth, one cannot purely and simply take for granted that the portrait, that mere reflected image, is in fact the model's body, her total being. Compared to what the child experiences on seeing his reflection in a mirror—an experience of a positive nature, one that is affirmative and jubilant—the "transitive" function (as Charlotte Bühler calls it) no longer operates in the image. The image is binding for the child. It asserts: "You are you and you know who you are." But for the model it's an alienating experience; it says to her: "You are not you; in fact, you don't even know who you are."

IV

Another effective way of persuading the subject to relinquish his illusions (assuming he wants to relinquish them) is to enumerate the many mystifications concocted by means of a portrait. To begin with, consider the portrait as the record of an encounter. Even as the image of an encounter with oneself, it always bears witness to an encounter with someone else (the photographer). Take the case of the portrait of an artist and his model and the way it denotes a myth (or so one likes to think), replete with anecdotes of a privileged give-and-take, moments of exceptional interaction, swapped stories about what are generally decreed to be extraordinary experiences. All of this is supposed to make up a tissue of complex yet productive relationships that allegedly reveal the truth of the subjects in the picture. But it's all just a bluff.

The portrait photographer Gisèle Freund counts among her many gifts a remarkable skill for the *portrait-rencontre*, the portrait as an encounter. She, the photographer, plus the other, the model, make up a "them," a portrait in which the photographer does not appear but where her total complicity with the subject can be easily, though quite unnecessarily, inferred. Her portraits suggest that she understands the model better than anyone (better than his dog, better than the love of his life). They lead us to believe that in the end she has produced an accurate image (*une image juste*) of the model and not, to paraphrase Jean-Luc Godard, just a image (*juste une image*). Referring to the portrait, a genre she almost worked to death, Freund states (in *Mémoires de l'oeil*) that the portrait offers a privileged opportunity "to reveal man to man." This is a catchphrase, of course, of the more or less trenchant variety coined for lovers of bon mots, but given Freund's status as a theorist, it's a disturbing one all the same. One is tempted to merely smile at the famous organizer of encounter portraits and her claim that photography has the power to reveal. Is she sincerely convinced of this or is she feigning naivety? Whatever the case, the proposition simply doesn't hold. Bound by its essence to its fate as a gestalt, the photographic appropriation of the model is an act of luminous, rather than physical or psychological possession. At best it tells us about the position of a figure in the context of visual appearances. As for the attitude caught by the camera lens (about which so much has been said in connection with Freund)—an attitude that is supposed to reveal a particular frame of mind in the model and to articulate his or her truth—it proves nothing. The youthful André Malraux, his hair appealingly tousled by the wind, is only a young man named Malraux with wind-blown hair. James Joyce bending forward deep in contemplation is simply Joyce leaning toward the camera looking thoughtful. Unless we're to infer something further from the appearance of these two men, and unless we agree that the quality of a person's being depends upon his appearance, it is pointless to attempt to learn

anything more from either portrait, especially if we know nothing about the personalities of these two men. For anyone so inclined can easily present himself with wind-blown hair or leaning forward lost in thought.

To quote Jean-Marie Schaeffer, "To the degree that, even more radically than the painter, the photographer must always compose—in the literal sense of the term—with the model, the photographic genre is bound to be difficult and risky. In fact, it rests on an equilibrium that can be upset at any moment: either the model is, in a sense, conjured away by the photographer who seeks to establish the supremacy of his hunger for power by means of a strictly formal or strictly beautifying gesture; or the model uses the photographer to obtain a narcissistic picture of himself, even if this means falsifying his own life."

<div align="center">*</div>

Freund's deceptions or, to put it more charitably, the illusions she cultivates, derive from her mistaken belief in the legitimacy of the photographer's position. The fact of owning a camera leads the photographer to claim certain rights for herself. First, the right to appropriate images simply because a camera is made for taking pictures; and, by the same token, the right to appropriate the likeness of others by virtue of the fact that they are positioned in front of the lens, regardless of whether or not they've consented to being captured on film. The irreproachable Erich Salomon concealed a Leica under his briefcase and thus equipped made his way into the hushed, secretive circles of European diplomacy in the 1930s. Felix H. Man camouflaged himself amid the musicians in an orchestra pit in order to photograph Arturo Toscanini in the act of conducting. Freund herself returned from one of her trips to Argentina with a now famous series of photographs of Eva Peron and her husband caught by surprise in moments of intimacy (her reportage narrowly avoided being suppressed by the Argentinian Ministry of Information).

The fact that photography is essentially a craft that trades in reality and concrete signs contributes to the photographer's feeling that hers is a legitimate position. Photography is much like farming; just as the farmer plows, sows, and harvests his land, so the photographer selects a visual subject, clicks the shutter of her camera, and garners an image. Furthermore, the photographer knows that she possesses the proper tools, the appropriate state-of-the-art equipment for capturing reality. To her, the fact that this paraphernalia does not distort reality, thus enabling her to witness it accurately, justifies the task of recording the visible world. The beauty of all this lies in its avowal of the personal approach, in much the same way that a farmer's techniques may evolve differently from his neighbor's over time. The possibility of taking pictures in almost any circumstance, thanks to relatively lightweight photographic equipment developed in the late nineteenth century, as well as fast film, high-speed shutters, and wide-angle lenses, made

photographers feel confident that they could approximate a subject's truth. This conceit altered the very nature of the photographic portrait. Where the primitive tripod-bound camera, ponderous and difficult to operate, required lengthy exposure times and an aesthetics of the view, the appearance of the Kodak camera in 1888 fostered an aesthetics of the gaze. The "Kodak revolution"—the development of the portable camera—spelled the end of the static shot. Concurrently, as François Brunet shrewdly observes, it brought about a displacement of the center of the photographic practice from the darkroom to the photographer's eyes and brain. Though still frozen in the image, the motion of bodies in space, no longer merely suggested, could now actually be recorded. So could the model's physical gracefulness determined by her presence, relaxed pose, and natural expression in her habitual setting, all of which had thus far eluded the camera constrained by lengthy exposure times.

Thanks to this improved apparatus, the photographer was also able to shift his point of view (the "new vision" of the modern photographer). Freed from the constraints of the studio in an earlier era of photography, he now enjoyed a great deal more freedom of movement, which gave him access to places hitherto denied him (photojournalism was to have a considerable impact on the photographic portrait). Able to play the part of the hunter tracking his prey, he could even create exciting impressions of surprise. Henri Cartier-Bresson's "decisive moment" allowed photography to become an art of the opportune moment, capable of adapting to the world's pace, its sudden leaps and starts. These developments vastly enhanced the professional photographer's status and led him to set aside whatever doubts he might have had about the legitimacy of his enterprise. They even bolstered his belief that he was a kind of midwife to reality. So the camera came to be seen as an eminently respectable tool, one ideally suited to the modern era's grand undertaking of describing and recording the world, of organizing reproducibility and ultimately the hegemony of the visual media.

*

Last but not least, the photographer's sense of deserving his position also derives from the model. France's President François Mitterand commissioned Gisèle Freund to take his portrait seven years after his predecessor, Valéry Giscard d'Estaing, had Jacques-Henri Lartigue take his. More than a century earlier, Abraham Lincoln called on Matthew Brady to shoot his portrait. Queen Victoria and Prince Albert, reigning over a world that observed the standards of English rule, took pleasure in having their pictures taken and even had their own photo lab at Windsor Castle. Skilled propagandists, they arranged to have cards bearing their portraits distributed throughout the British Empire and beyond. (The London firm of Marian and Co. sold 70,000 portraits of

Prince Albert after he died.) On a more democratic level, the ordinary citizen sooner or later calls on photography out of sheer narcissism, much as a lightning rod draws lightning or a saint invites martyrdom.

The photographer's legitimate position becomes automatically sanctioned when the dominant culture is structured as a "videosphere" (as a media scholar might term it), a symbolic, cultural, or mental universe where the image, exerting a dominant, even tyrannical influence, governs the way signs are structured and is itself established as a major sign. This is particularly the case in Western societies, which have all turned their backs on iconoclasm. Exhibitionistic portrayals of the self are the ideal complement of political individualism, for they affirm a democracy of the image that mirrors the affirmed democratization of individuals.

V

Thus the model gazing admiringly at his own photo—engaged in an autoerotic communion with it to the point of losing his critical faculties—must heed this warning: The portrait is a lie; it lies to you, it lies to everyone—for it is photography's nature to lie. What's more, you are being taken in by your objective ally in the act of picture-taking: the photographer himself.

There is no more effective way of shattering the subject's illusions than by attacking the portraitist. And it's so easy to do; one merely has to question his specific motives, his reasons. ("The problem in this world," says a character in Jean Renoir's *Rules of the Game*, "is that everyone always has his own reasons.") What are the photographer's reasons? There are a vast number of them, private, political, professional, and ideological. And, as we've just seen, they're all amply justified. That is why the model is treated with scant respect, whatever the nature of the portrait, even when he merely figures incidentally in it. Alfred Stieglitz photographed clouds *and* Georgia O'Keefe. Man Ray's foremost concern was with ironing out the initial problems in his solarization technique. Nonetheless, even among these experiments we find portraits (i.e., *Meret Oppenheim*, 1928) faces and bodies subjected roughly to his graphic powers and his skillful but deconstructive work on light. Every photographer plunders the world—and the bodies in it—out of a kind of rapacity, not to mention an assertion of his freedom to take pictures however he chooses and according to his own rules. This means that the portraitist is constantly translating—as naturally as he breathes—without pausing to consider whether he should make allowances for the generic ambivalence of the photographic translation. For like any photographic act, shooting a portrait is a kind of translation. The body must be translated into a picture; its flesh, its living physicality has to be borrowed before it can be

rendered as an image, a figuration of a physical presence. Yet to speak of translation is inevitably to speak of betrayal, of distinguishing between the fields the subject is embedded in—reality on the one hand, representation on the other—rather than producing a perfect equivalence of the fleshly and the figured. The betrayal of the model is fatal, while the treachery of the photographer is preordained.

Given the model's situation, the physical difference between a body and an image and the lack of a morphological equivalence between them, the betrayal of the model can only prove fatal. His body has to submit to the arrangements of picture-taking with their frequently hierarchical nature and their proclivity for relationships of dominance. The portrait is born from an act and, as such, is the result of intentions that carry the weight of naked affirmations of power. Except in rare cases (at least one of which we will discuss later—the so-called "negotiated" portrait), the model and the photographer are not equals at the moment the portrait is taken; nor are they necessarily in agreement about the resulting image. After completing a series of photographs of Halifax, England for *Picture Post*, despite his advocacy of the strictest documentary standards, Paul Strand was criticized by the inhabitants of that industrial town for dwelling on the more sordid aspects of their community. Alperte, Chaykhet, and Toules's documentary *A Day in the Life of the Filipov Family*, shot in the spirit of the Russian Organization of Proletarian Photographers, came under sharp attack from its viewers, themselves proletarians, who complained that the photographers had prettified their surroundings and rendered them unrecognizable.

*

There is nothing tragic about the photograph being unable to conform to living beings; nor, as we have always known (remember the shadows in Plato's cave), is this in any way perverse. In short, there's nothing harmful about the rule of simulation—providing, at least, that the model regards himself as a theater, as material for a theatricalization. Providing too, as he surrenders willingly to the delights of self-reflection, that he treats his ego like Georges Bataille proclaiming in his *Somme athéologique* that he is "opening a theater within himself." Problems arise, however, when the model rejects any kind of theatricalization and allows himself to be deceived by the (in this context, unavoidably stupid) game of truth. They arise when he insists stubbornly on seeing truth where everything is false and when he asserts that his only criterion is the picture's accuracy or lack of accuracy. They arise when he ends up considering as unacceptable any equation other than the living being on one side, his image on the other, the pair of them irrevocably divided.

So it's inevitable that there should be a betrayal. But what about the portrait itself? By nature, it belongs, with no real possibility of a remedy, to the world of simulacra. The moment the model rejects its dizzying spell, the simulacrum tends to create the impression that he has been manipulated. The problem of so-called objective photography, as everyone knows, is that it merely documents an illusion—the illusion that as it records appearances it produces an archive of the real world. The whole ideology behind the photograph as a document (from the "Mission héliographique" in mid-nineteenth-century France to the New Objectivity, the work of Albert Renger-Pätzsch, August Sander, Berndt and Hilla Becher, Walter Benjamin's reading of Atget, and so forth) cannot alter the fact that visual signs are merely visual signs. Light impressions, reflections, replications, they do not draft the world; at best, they merely track it. All it takes to undermine the power of faith in the "objective" image is to live in the world, not just observe it.

After all, is it really inconceivable that the model should ask for a minimum of ethics along with the blandishment of being portrayed? We have to picture him as an adult, someone well-informed, perhaps even a person in a position to pass laws. Not simply a subject besotted with his own image and his virile qualities, but a person weary of flattery and the betrayals we've just mentioned; one who is willing to convene an actual tribunal in his thoughts, in lieu of Bataille's theater of fantasies, so as to ask for an explanation, to press for a model's bill of rights, to demand that photographers take a kind of Hippocratic oath and to ask awkward questions like, "Do you respect me? Have you taken proper care of my image? When photographing me, did you not rob me, take from me, plunder me?"

Paul Ricoeur has a convenient, by now canonic, definition of ethics. Ethics begins with an affirmation of one's own freedom and is sustained by one's avowed intention to allow one's neighbor to enjoy her freedom too. "I want your freedom to exist," says Ricoeur, stating an inalienable right to dialogue. If I don't include my neighbor in my project for freedom, and don't submit it to her so that she'll submit hers to me, I merely stagnate. I'm merely an absolute—read: worthless—libertarian, an unsocialized king of the world. As a model, in other words an individual who has been socialized through a photographic portrayal (and its triad: the model, the photographer, and the viewer), my inclination to ask questions relating to ethics is perfectly natural. After all, that's me in the picture. What use am I being put to? Isn't the photographer using me as a visual tool, a material to shape as he chooses? "To look at a photograph," says Philippe Ortel, "is to reactivate the initial dialogue between the photographer and the model as one imagines the circumstances in which the picture was taken." There are portraits that show unambiguously what that dialogue consisted of, only they contravene the very concept of dialogue. This is especially the

case with portraits where no exchange or connection is to be seen, where, in fact, the subject and the photographer ignore each other, the latter being entirely free to make use of the former. The work of a photographer like Weegee (among others) is particularly interesting from this standpoint, both for its legendary irreverence—its deliberate neglect of the concept of the model's right to have their picture taken, hence of ethics in general—and its contribution to the genre of the local reportage. To "steal" pictures, as Weegee does, of recent murder victims, gangsters collared or gunned down by the police, suicides, or people killed in some urban disaster, and to turn them into icons of modernity (not unlike monochromes or the heroic figures of builders glorified by fascist or revolutionary regimes), involves more than just celebrating the baser human instincts by ostensibly appealing to the enjoyment we derive from vulgar and sensationalized displays of tragedy. It involves ruthlessly asserting the photographer's arbitrary power, his unqualified right to capture a person's face or body with a total lack of consideration, up to and including a reversal of perspectives—clear proof of Weegee's incomparable skill at exploiting the model's Achilles heel, her incorrigible narcissism. Consider the ridiculous onlookers (me, you, them) crowding eagerly in front of the New York press photographer's camera in the hope of an unlikely appearance on the pages of a tabloid. "Afternoon. . . They are watching me make their picture. . . and also a fire," notes Weegee in a caption for one of the photographs he took at the site of a conflagration. On examining this picture, Vincent Lavoie remarked, "A woman on the far left of the picture seems to be so taken with the prospect of having her portrait circulated in public that she has struck a pose reflecting the criteria set by the cultural industry of the times (women's magazines and films)."

When she takes my picture, doesn't my neighbor (in this case, the photographer) deprive me of my freedom? By appropriating my outward appearance, doesn't she at the same time reveal my life to be something other than it really is? Isn't she subordinating me to her freedom? The whole problem lies in the difference of projections. The ideal situation would be that the subject of the picture willfully projects a being and the photographer then faithfully captures it in the picture he takes. But though it appears to involve a simple exchange, this scheme of things is nevertheless quite deceptive. Even in the best of cases, the concurrence of the model's and the portraitist's aims is always the result of an unequal negotiation, one without any prospect of spontaneous and wholehearted consensus. Once again, Jean-Marie Schaeffer states the matter definitively: "If it is true that the portrayed can only attain his own identity by exposing himself to the always risky mediation of the photographer's gaze, the photographer in his turn exposes himself through the manner by which he does or does not take responsibility for this situation of mediation. In other words, the

photographic portrait always presupposes an agreement covering the conflicting claims and the negotiating of two desires." It goes without saying, adds Schaeffer, that "there is no reason why the photographer's desire to produce a work should coincide with the desire of the model to obtain a picture of himself. So, the portrait attains its truth in the manner by which it negotiates the tension between two viewpoints as they collide and probe each other." This is why, from the very outset, a portrait—it makes no difference whether it's a photograph or a painting—sets a challenge. Who will prevail, the portraitist or the model? Who will rob the other? Which of them will be able to say, "Here is the man, and there is my triumph?"

VI

When we look at a portrait, common sense tells us that it is successful if it simultaneously expresses the glamour of both the subject and the photographer. David Bailey's *Mick Jagger from a Box of Pinups*, 1964, is a portrait of the young lead singer of the Rolling Stones. Bailey insinuates his own tastes into the picture by having Jagger don a fur hood (which encloses his head in what looks like a halo) and strike a somewhat facetious pose—in short, he does a contemporary Disdéri in the *Vogue* style. After all, the picture needed some frills if it was to distinguish itself from run-of-the-mill commercial portraiture. As a result, what we have is, unsurprisingly, an icon—an image that generates faith or is at least connected with faith ("I love rock and roll through Mick Jagger"; "I love photography and its potential to give pleasure through David Bailey"). In the present case, of course, the photographic icon permits the fan to enjoy a double celebration: it pays homage to the photographer as well as to the subject. It's a successful photograph.

But what is the price of success? It succeeds thanks to a Faustian bargain (diabolical rather than dialogic); an agreement to be inscribed in eternity despite the perishable and, finally, ordinary nature of all things. No longer is it a case of the poet's "You've given me your dross and I've turned it into gold"; it's something else, something beyond values and differences, something more like: "We've made a good deal." For whatever is being exchanged—truth or a falsehood, respect, contempt, or indifference—is of little import when the only challenge is to hold a gaze and to be master of it. To hold it by means of the picture for as long as the picture lasts, the way a battalion holds a position in war, if possible, permanently. To control the gaze, knowing that in this instance the fight does not take the guise of the time-honored struggle over banning images, but is rather a campaign for the absolute image—producing a superlative picture, compelling recognition for it, and making it last. This is what Robert Mapplethorpe—who refers unabashedly to transcendence; that distancing of the living subject (his work is almost a resurrection of

neoclassical art)—states quite bluntly: "My whole point is to transcend the subject. . . . Go beyond the subject somehow, so that the composition, the lighting, all around, reaches a certain point of perfection. That's what I'm doing. Whether it's a cock or a flower."

The portrait's success derives from a perfect balancing of the arts of suspending motion and belief and from working the mechanisms of private and public seduction. The successful picture is no Medusa; it isn't like the gorgon's head on Athena's shield hypnotically "striking death into your eyes" (as Jean-Pierre Vernant puts it). Gazing at it doesn't cause you to falter in any way. On the contrary, you're captivated by the picture, immensely gratified, absorbed by its seductively smooth surface. Where the image is concerned, the "good deal" extends well beyond the shot itself. It encompasses, prior to the actual taking of the picture, both the model and his or her camera-carrying mentor, and subsequently includes the viewer as well. The unanimous acceptance that surrounds a portrait has nothing to do with that picture's truth stemming, one would like to think, from its accuracy or its faithful rendering of an appearance, position, attitude, or event. Rather, it is the result of a conscious, casual, collective, and perfectly felicitous surrender, which expresses something that is able to overcome boredom or despondency (in the case of a portrait, the boredom or dejection that can come from looking at oneself or at other people). Call it a diversion toward the diverting. Criticism doesn't cease with the unanimous acceptance of a picture, but at least, in our urge to say "yes" to the portrait, it chooses its camp—the coterie of devotion.

*

On the ethical level, the fact that the poetics of the "good deal" (a happy transaction enjoyed by all participants in the photograph) so often regulates the making of portraits, means that ethics are kept at a distance. On reflection, could it be otherwise?

If the portrait is made at the model's instigation, he will reject any visual component that might prove detrimental to him. Adolf Hitler insisted on seeing every photograph in which he appeared, cutting off a corner of those he did not want published, such as shots of himself, harbinger of the allegedly "pure" race, wearing spectacles. The German people could not guess from official portraits of Joseph Goebbels that the Third Reich's minister of propaganda had a clubfoot. Pictures of Mao taken during the Long March were subsequently retouched by drones in the official propaganda office to remove the cigarette wedged between his lips.

Alternatively, if the photographer initiates the portrait, he will reject any photographic treatment that threatens to give an unfavorable impression of his skill and prove damaging to his reputation. Recall the early insistence of photographers—as early as the development of the daguerreotype, despite its

essentially technical and artisanal nature—to be given the status of artists, that is to say masters of the image. Or, take the blend of Pictorialism and Naturalism around the turn of the twentieth century that elevated the photographer from a kind of sub-artist or mechanical painter to a composer of visual truth—one who deals with reality "on another level," in the words of Peter Henry Emerson, who knew whereof he spoke. Or the proclamation of the subjective imperative championed as a cause and a supreme right by an ever-increasing number of photographers, from the devotees of Pure Photography in the United States to the more broadly international school of Subjective Photography (subjectivity being perceived as the best possible defense against those who contest the photographer's right to self-determination).

Finally, one should not expect the viewer—that crucial link in the aesthetic sequence—to concern himself with the ethics of the photographic portrait. His response is determined by his interest in the picture; he looks at what catches his eye, enjoys what flatters him, values whatever symbolically enhances him. Emotion, that powerful adjunct to the flattered gaze, springs from an affective recognition; it goes hand in glove with narcissistic affection. "I'm moved by what designates me," it says.

The history of the photographic portrait endlessly reiterates the impossibility of equilibrium between model and portraitist, not to mention the triad of model, photographer, and viewer. This history runs counter to reciprocal respect and the notion of "Take me as I am." All appearances to the contrary, it is mainly laid bare in pictures expressing competitiveness, supremacy, self-infatuation, and even hate. Confrontation is the thing that drives this history, not concord.

But, as a rule, this is a concealed history. Not so many decades ago, a substantial number of anthropological photographers still obtained pictures surreptitiously. Theirs was a photography, pernicious in spirit, which treated human beings as alien bodies. Denied at first in the name of racism, the humanity of their subjects was subsequently vindicated, but only on condition that it met certain preestablished criteria. Such was the spirit that guided the photographic classification of the British Empire's races around 1870, a project undertaken under the aegis of, among other institutions, T.H. Huxley's Ethnological Society—a virtual survey of "civilized" and "savage" peoples. Such too, roughly speaking, was the spirit behind F. J. Moulin's remarkable portfolio of 600 plates in his photographic records of Algeria, *Souvenirs d'Algérie*, published a few years earlier. Moulin portrayed the North-African Arabs opposed to colonization (this was in 1856–57, precisely at the time when Algeria was coming under French rule) as listless, unprepossessing people. In a work that reveals the extent to which, in the words of Anne McCauley, "colonial policy influenced the actual shape of [Moulin's] pictures." McCauley describes them thus: "The

portraits of French soldiers and Algerians favorable to France are distinguished from pictures of the opponents of the imperial policy, with whom he uses a sort of deprecatory formal rhetoric consisting of sprawling bodies, shots taken from above, blurred areas, and an absence of vertical lines." Photography as such was a formidable weapon in the struggle between imperialists and nationalists.

In other instances, the confrontational principle inherent in the photographic portrait is openly acknowledged in the name of a freely confessed abhorrence. Eugène Appert, who snapped pictures of Communard prisoners at Versailles with the gaze of a professional policeman and enemy of the working class, peppered the captions to his photographs with comments flavored by social rejection; of the right wing's condemnation of the left. Driven by their thoroughly bureaucratic compulsiveness, the Khmer Rouge systematically photographed their torture victims before executing them (the victors versus the vanquished, the living versus the condemned).

Finally, the confrontational principle can be used in a strictly calculated context, as in fashion photography, where the model is simply denied her status as a human being. Helmut Newton, the supreme master of late-twentieth-century fashion photography, has on occasion referred to his models as "accessories"—very telling indeed. What this terminology expresses is a perfectly normal functionalism. The model is to the fashion photographer as the dildo is to the masturbator: a device to manipulate at will solely for the user's benefit—in the former for visual appeal, in later for pleasure. The photographer who officiates in the world of fashion must obey an ironclad rule: The model must be subordinated to the rules of the genre, which require a superlative visual product that has nothing to do with fleshing out a human subject but, fundamentally, with playing out fantasies of refinement. The model is literally reified, turned into a strictly decorative object. The photographer is the master, the model his slave. Of course she is a paid slave, sometimes a very well-paid slave, in keeping with a principle that also underpins the sexual economy: whatever produces and guarantees a maximum effect can demand an unfailingly high price.

VII

This isn't to say that ethics do not have their place in the history of photographic portraiture. On the contrary, one has the impression that it's a history fraught with ethics, which isn't as contradictory as it sounds, for ethics manifest themselves in the hidden recesses of history as an absent presence; a promise, a hope, a thing ardently desired. Of course, we mustn't confuse ethics with a concern for the ethical. In much the same way that certain models demand to be respected and to control the nature, use, and circulation of their

image, certain photographers are unfailingly respectful of the individuals they portray. There are aggressive portraits shaped from the tension between model and photographer, and there are peaceful portraits replete with longing for communion, erogenous in intention, as though the photographer were in love with the whole human race—that aggregate of potential subjects.

The model naturally asks himself whether the photographer taking his picture is merely trying to rob him. "Is it really necessary to humiliate me, to steal or hijack my face?" he wonders. Certain photographers would obviously answer no. They would maintain that cameras are primarily tools for creating a more accurate, more honest, less caricatural view of mankind. Clearly, they want to place an equal sign between the model and the photographer and to initiate a genuine dialogue between them, one that comes as close as possible to real life. Their view, in short, establishes a positive bond between all the users of the photographic medium, image creators as well as image consumers. This was in fact the goal of humanist photography, as it was called by nineteenth-century pioneers like John Thomson (*Street Life in London*, 1877) and Jacob Riis (*How the Other Half Lives*, 1890), to the genre's supreme expression, the 1955 Family of Man show under the auspices of Edward Steichen and Carl Sandburg.

The humanistic portrait-taker, from the beginnings of photography to the present, an ambiguous history at best, has always been obsessively careful not to rob the model. Referring to his own portraits, Paul Strand observes, "I like to photograph people who have strength and dignity in their faces; whatever life has done to them, it hasn't destroyed them." In addition to producing a dignified rendering of their human models, the photographers in this school sought to restore something that the modern age in its genocidal madness, its habit of subjecting everything to the commercial logic of the media, is increasingly calling into question: the simple right to be not just a picture (which is easy) but a living presence participating in the world corporeally as well as visually. In the early twentieth century, Edward S. Curtis took pictures of Native Americans in the newly established reservations. He was not the first photographer to do so—the "savage" has always been a popular photographic subject among the "civilized." Although he was white, a member of the victorious culture intruding on the territory of the savage, Curtis was able to garner pictures of authentic dignity (in the root sense of the word, worthiness). He believed the Native Americans deserved to be portrayed for what they really were, and he wanted his pictures of them to be circulated widely so as to inform ordinary American citizens about the greatness of a civilization many of them held in contempt. His portraits of Navajos, Sioux, and Apaches have no other aim than to show the Native American cultures' genius for living fully, not just pretexts for exciting the curiosity of fairground

idlers or even, on another level, anthropologists. He recognized an urgent need to restore these cultures' rightful place in history. The demeanor of the chiefs, shamans, and warriors that Curtis captured on film are noble, hieratic, and remote; perfect replicas of the poses in Europe's royal portraits. They are elaborately dressed and decorated, and have donned their ceremonial regalia, ritual implements, and weapons after the Western fashion.

Research into Curtis's methods casts some light on a frequent flaw of humanist photography— its stealthy instrumentalization and, in the worst cases, complete dispossession of the model. (This is commonly the case with the so-called compassionate photography of the late twentieth century, particularly in the work of its most recent exponents, Sebastião Salgado and Olivieri Toscani, who exploit human misery to sell humanitarian aid or sweaters.) The first item of note is that Curtis's Native Americans never saw their pictures, or, if they did, it was much later, on receiving postcards of themselves from friends or acquaintances. Second, at the time when Curtis was photographing them, the Native Americans were beginning to integrate into the culture brought by the pioneers, most notably in matters of clothing and equipment. (Admittedly, Curtis does show instances of the Indians' acculturation, but only when it had an impact on their environment, for example in *Village at Arrest Bay, Nimkish Tribe*, and *Electric Poles, Nunivak Tribe*). Although the Native Americans he photographed actually wore jeans, shirts, and felt hats, he portrayed them in traditional garb, a guise that was by then already unfamiliar to them, except on the increasingly infrequent occasions when they dressed for tribal ceremonies. All of this betrays Curtis's penchant for the aesthetics of folklore, which he further accentuated by setting up scenes that grouped costumed individuals who would not normally have been found together. The result is a series of photographs that read like bizarre ritual scenes, staged expressions of the photographer's fertile imagination.

The problem is that the dispossession that Curtis perpetrated—a modest one, to be sure, and one that is never insulting to its subjects—is reversible. To show Native Americans wearing their traditional garments, to inform viewers about their unique culture, and describe its particulars in matters of clothing and rituals is a way of paying homage to them. It's a respectable visual plea in favor of difference and the right of Native Americans to exist. But to stress their specificity, as Curtis did, while neglecting to show their tribes' integration, was to reinforce the viewer's belief that Native Americans had their own, irreducible singularity. This was the leaven of social alienation, of an insidious segregation that turned people who were different into outcasts, transforming the "other" immersed in his separate culture into a savage who could never be acculturated. Thus, in spite of himself, Curtis upheld a mythical representation of the Native

American world—the kind of intangible representation that is fated to end up as a footnote in the history books. At the time of the Civil Rights movement in the 1960s, a number of Native Americans argued that instead of fostering a recognition of the "otherness" embodied by the Native American in the mind of most turn-of-the-century white anglo-saxons, Curtis's work basically confirmed the American people's belief in their backwardness. Moreover, it provided missionaries with ammunition to attack the animistic paganism of the unconverted tribes, thereby helping justify the federal government's policy of apartheid.

The model is usually threatened with dispossession and is rarely in a position to do anything about it. There are several reasons for this, having first to do with technique and production. The subject simply does not have full control over the framing, printing, and circulation of his photographic image. Second are reasons of aesthetic concern: the portraitist, who appropriates the model's body through the image, also sets the scene of the portrayal and thus facilitates a particular visual appearance. There is, of course, no law stating that the subject has no say in controlling the image and the uses it is put to, however, the history of photography offers few examples of the model's wishes actually being respected. As a rule, the artistic aspirations of the photographer limit their scope and validity. The photographer who has been raised to the level of a demiurge does not readily permit his vision to be questioned or compromised. William Eugene Smith was notoriously inflexible about retaining control over his pictures in all circumstances and was willing to release them only at his own pace, even when this meant they would look outdated (his reportage on Philadelphia, begun in the mid-1950s, was published as a portfolio in 1964). The vital thing was that they were his pictures—nothing else mattered to him. He would brook no discussion of their look or content, of the fact, say, that the women in his Spanish Village resemble ancient sun-parched goddesses, or that the victims of mercury pollution in Minamata are astonishingly like the Christs and pietàs of classical Western art.

Getting back to Curtis's Native Americans—several of his subjects were contacted years later, considerably older but with excellent recall of their experiences with the photographer. According to one account, most of those photographed reacted to the pictures with great amusement. All of them remembered the white photographer with his bulky apparatus and nervous ways. Some reported that Curtis actually paid reluctant individuals to pose for him, like ordinary studio models. It was even rumored that he himself had made the costumes worn in his shots of the Navajo *Yebechai* dance—a ceremony forbidden to foreigners. This is hardly dignified behavior; indeed it turns the whole undertaking into something of a caricature—although the Indians obviously found it amusing enough to dress up in the old way and pose in Curtis's tent. Their merriment at what they regarded as a charade is significant, and is actually a good deal

more cruel than it seems. Stripped of its old-fashioned monumentalizing and its grotesque folklorizing, Curtis's enterprise could almost be viewed as a practical joke, one of those hoaxes that delight image makers (whether they're photographers or not), those unrepentant manipulators and panderers to the modern world's craving for the spectacular.

VIII

Domestic, a group of portraits by Julie Moos, received considerable attention at the Whitney Museum 2002 Biennial of American art. Comprised of a number of medium-sized prints using the same composition, the portraits featured a pair of same-sex individuals dressed in ordinary clothes, facing the lens and pictured side by side against a neutral, light-toned background reminiscent of that used by the pioneering French portraitist Félix Nadar. On the level of appearances, there was little to learn from these thoroughly nondescript pictures. It later came to light, however, that Moos had shot her double portraits after gaining admission to affluent homes and permission to photograph the homeowner with a domestic employee. Employers and employees fill the exact amount of space in the frame and are identically positioned. What is striking about the *Domestic* series isn't the physical aspect of the models, but something else: the photographer's cool scrutiny of social inequality. What Moos's portraits in fact reveal, in an unruffled, unpoliticized manner, are the kinds of class relationships that exist in any society, even in an egalitarian Western culture (if not chiefly in Western culture). As if weary of conflict, Moos takes pains not to exaggerate the differences. What arises instead are the latent conflicts beneath the surface.

To stretch the analogy, one might be tempted to say that the portraits intensify the inherent tensions between social classes present in every society, whether contemporary or traditional. The portraitist and the model are never equal. The possession of wealth and domestic authority, it seems, can only be apportioned in unequal terms. Similarly, the portrait genre creates an inequality between its two main protagonists—and this holds true for the self-portrait also, as we will see. The self-portrait relies on distance placed between the portraitist and his own image, and his willingness to see himself as someone else—a stranger in his own eyes. The reason for this fundamental inequality would appear to be ontological rather than social in nature: if the human being constructs himself by identifying with others (I'm human because I'm like them), the self he shapes arises from an experience of difference, thus of separateness (I'm human because in their eyes I'm not like them—being human means belonging to a species where it's possible for me to be unique). The photographic portrait, inasmuch as it is a privileged means of identifying with the human

species, is the natural vehicle for the joint endeavor to identify with others, as well as to differentiate one-self from them. It allows me to recognize that I'm both like and unlike other human beings, regardless of which side of the lens I happen to be on. In front of the lens, I provide an appearance of the species inasmuch as I'm both like others (I'm their human brother) and unlike them (I'm a brother but no one else is like me). Behind the lens, I fashion the appearance of the species from a general standpoint (a visual discourse on humanity), as well as from the particular viewpoint of my own vision.

<div align="center">✻</div>

Seeking to define how animals in a given species recognize each other, whether capable of speech or not, and at what point the mechanism of reciprocal recognition can be said to occur, certain biologists have postulated the existence of a natural principle of homomorphism. The other is a shape, hence an image. To perceive the image of the other is to acknowledge his shape and thereby recognize the features of my own shape; to identify with his nature and then to recognize myself as belonging to the same species (the other who is both with me and like me). Conversely, to display my shape—hence my image—to the other is to give him the same experience of being alike, with the same consequences. The image in this case is both a statement and a force of attraction, an erotic element. I'm drawn to the other when I'm drawn to his image.

To the model, the portrait's force of attraction is virtually irresistible; it's impossible to ignore it—even for Arnulf Rainer when he scribbles or smears dirt on pictures of his own face. To deface or besmirch one's own likeness is to proclaim that one is by no means indifferent to it, and that in spite of everything its spell can't be denied. Under the spell of a representation of myself, I gaze at myself, but my gaze isn't altogether happy. The portrait raises a doubt in me, causing me to wonder, "Is that really me in the picture?" Here, the principle of homomorphism functions imperfectly. When I'm portrayed, I recognize myself within the community of all human beings, frozen in a human appearance and attitude. But at the same time, I recognize that my appearance in the image could mislead others if they confuse it with me. Surely I'm not just an image?

<div align="center">✻</div>

Now we must acknowledge that the portrait's gaze (*le regard du portrait*)—to borrow the title of Jean-Luc Nancy's short but substantial treatise on portraitology—is at once entrancing and inquisitorial, seductive and supercilious. The moment he stops experiencing the ecstasy of posing and strikes a pensive attitude, the model becomes aware of this. Once left alone with his own thoughts in front of the portrait, the area his gaze covers is a vicious rather than a virtuous circle. Richard Avedon, a most disenchanted portraitist (his *Writings* prove that in the end he does not truly believe in the portrait), chronicles the revealing reaction

of Secretary of State Henry Kissinger posing in front of the camera. "Be kind to me," requests the man who determined U.S.—if not world—diplomacy under President Nixon. That master of manipulation, observes Avedon, was visibly uncomfortable at being manipulated for his portrayal. "He said, 'Be kind to me.' What did he mean? What does it really mean to 'be kind' in a photograph?" Deep down, Kissinger had long stopped believing that a person can be captured, in terms of significance, in the way that Edward Weston meant when he naively defined the photographer's role as such: "to reveal the individual before his camera, to transfer the living quality of that individual to his finished print." Weston, so sure of his ability to capture the soul, continued thus, "not to make road maps but to record the essential truth of the subject; not to show how this person looks, but to show what he is."

However frequently the illusion endures—and it reveals itself most of the time to be indestructible—the illusion the model clings to regarding the portrait's positive value is just as often trampled by the photographer himself. Painting experienced this ruinous cycle long before photography. It entered an era of uglification (Goya), loss of self (Van Gogh's *On the Threshold of Eternity*, depicting a man sitting prostrate in a chair, head in his hands), torpor (Munch), dispersed visual bearings (the Cubist portraits of Picasso and Braque), demolished representation (Artaud), and disfigured figuration (Bacon). The same holds true for writing in the physical-psychological portrait that became increasingly elusive and designated less and less as the modern age unfolded, from *The Picture of Dorian Gray* to Maurice Blanchot's *Thomas the Obscure*, and Camus's *The Stranger*, among countless other examples. Treading on the heels of these writers, many photographers dealt no less brutally with the photographic portrait. Consider Avedon's stark, unsparing, shot-by-shot account of death's progress on his ailing eighty-year-old father's face: one feels that though a face can always be captured and the human body's "faceness" (*visagéité*, as coined by Gilles Deleuze) can always be celebrated, none of this of any help. But it does help us to understand that, like the body, the image, too, harbors death.

Photogeneity is the photographer's excuse. There is no hope; whatever happens, you will always be mortal, so you might as well look your best—a pearl (the body) in a jewel case (the frame of the image). As for the rest, listen to Plato and give up any hope of actually being embodied in the image. Many contemporary photographic portraits strive to cease fashioning semblances, to shatter "homomorphism" and rid us of it for good. For instance, Michelangelo Pistoletto in his *Objets en moins* series mounted on a mirror; seeing them, I see myself both in them and in spite of them in a disturbing optical clash. Patrick Tosani photographs me from above or below, and the result is that I cannot see or recognize myself. Anne Deleporte's photographic portraits are emptied of all substance by cutting out the subject's face so that all

that's left is a hole. Were Pierre and Gilles to take my portrait, they would cast me as Adam or Eve, Saint Sebastian or a Bolshevik-era hero. Can't I simply be shown as I am? The answer in these cases is no. The body's image merely refers to a void; it cultivates repulsion or voiceless neutrality; it violently rejects all possibilities of identification—doing so in a provocative, nihilistic manner. It's as though whatever constitutes attraction, from a harmonious composition to the choice of a beautiful subject or a particularly legible image, had been set aside, all for the benefit of qualities each more brutal than the next: ugliness, obscenity, vulgarity, and recklessness. The immediate consequence is the model's lowered status, a regression of his or her identity, a deficit of humanity.

IX

What never fails to strike the viewer about negative portraits is their power to attract as they repel; despite the fact that they injure, despite the fact that they insult humanity as a whole. Displays of perfection are boring when too obvious, but a presentation of human dereliction catches the eye and excites our curiosity. Through a cathartic inflection of the intellect and senses, I accept myself as I really am when I behold myself at my worst, until sooner or later I become jaded (enough glamour! enough ugliness!). The corollary of my weariness is that I begin to hunger for a fitting portrait, a portrait that really suits me, really defines me, even if it means foregoing the aesthetic approach altogether.

It was Xenophanes in the sixth century B.C.E. who framed the concept of *theoprepes*, or the "fitting," elaborating it from qualities the gods were thought to embody (even though poets like Hesiod and Homer, carried away by their unrestrained imagination, attributed to them all that is reproachful among men—theft, adultery, deceit, and all other lawless acts). The "fitting," then, is that which corresponds to me by nature, not through representation.

A handful of photographers have experimented with making "fitting" portraits by rigorously forcing themselves to banish from the model's picture everything connected with aesthetics (the pursuit of beauty), as well as ethics (the pursuit of dignity). One example is Michel Séméniako's series entitled *Negotiated Portraits* (1983), a very unusual attempt to reinstate the subject's own image of himself. Séméniako set out with the intention of answering a number of commonsense questions that are often asked but only seldom inspire a real effort to solve the problems they raise. How does a madman portray himself? How does a resident of a modest neighborhood in a nondescript city—someone immersed in a mediocrity that is simultaneously geographic and personal—represent himself? What about the electrician at work?

31

What is his mental picture of himself once he has removed his anonymous street clothes and slipped into his work clothes?

Séméniako's answer to such questions flouts the rules of the genre inasmuch as it deprives the photographer of his own tools. He places himself at the service of the model, asking him questions, helping him define his viewpoint, suggesting this or that way of representing himself, but without dictating his own views. Like the Saint Martin of legend giving his cloak to a shivering pauper, he offers his camera to individuals lacking in representations of themselves. Setting up his studio in a psychiatric hospital, a nursing home, factory, or office, and opening it to whoever approaches him wanting to compose an image of himself, the photographer inhibits his own capacity to generate an image and suppresses his own creative potential. Yet his self-imposed impotence, his refusal to conceive an image of the other (or even wishing to conceive it), produces a portrait just as surely as the demiurgic approach. Only it's a "fitting" portrait, one closer to truth—or, in other words, one more like than unlike the truth of the self inventing itself in the picture—one closer to his own measure ("Man is the measure of all things," says Protagoras), according to his circumstances and his changing self.

*

The "fitting" portrait is a self-portrait par excellence. Thanks to it, the model becomes a portraitist, and vice versa. There is no exchange of skills or visual purposes other than those the model negotiates with herself. This would appear to be the basis for an ideal homomorphism. After all, when I portray myself all I require is to be able to identify myself. Even if I claim to speak for humanity as a whole (one of the two main objectives of the self-portrait is to be meaningful from the standpoint of the human species in general, the other is to be meaningful from one's own standpoint). I'm aware of the fact that in my image I alone comprise the whole of humanity, though admittedly I require a viewer, which complicates everything and relativizes what I thought was my freedom to picture myself.

Not for nothing is the practice of the self-portrait fascinating. The viewer (the spectator) experiences anew the fascination that nourished the self-portrait's inception, the solipsistic spell that takes hold of the photographer when he becomes his own model. With Herbert Bayer, I represent myself nude with an amputated arm. With Claude Cahun, I undergo strange metamorphoses, slipping in and out of different life histories, different awarenesses. With Alix Delmas, I see myself daydreaming, seated or wedged on a shelf in an anonymous setting without really knowing what I'm doing there. With Raoul Haussmann, I stand naked in the midday sun, my back to a column. I am Brancusi in his studio; Brassaï before an enlarger in his

darkroom. I play the game of multiplying myself with Oscar Rejlander and his double self-portrait *Rejlander the Artist Presenting Rejlander the Volunteer* (1871). Of the latter, Marc Mélon remarks, "Art bows to Patriotism and both sacrifice themselves to the glory of the Empire; the Artist and the Soldier are heroes and the combination of the two uniforms constitutes the most elaborate form of public-spiritedness. The explicit morality of this message springs from the doubling of one of the figures of the representation—Rejlander himself—producing an illusion that shatters the homogeneity of the reality." I can even play at tripling myself with Lartigue's photograph of himself in the act of painting the background of the self-portrait he is in the process of making. Better yet, I can relatively safely risk atomizing, scattering, losing myself. In the 1980s, Cindy Sherman shot several hundred different views of herself as a student, a starlet, a cleaning woman, a middle-class housewife, a lady in a classical painting. In the end, she even produced a portfolio of herself as she really looked (*The Real Cindy*), leading one to wonder whether the real Cindy Sherman actually exists.

Produced by the thousands, yesterday, today, and tomorrow, the self-portrait is an inescapable genre; it's the least unexpected kind of portraiture there is. My self-portrait is a figuration of someone who does not have—or does not yet have—a figuration but will find one. Or, if he doesn't find it, he will all the same find something else, a notion or daydream of himself. Of course, this is a strange way of proceeding, this endeavor to obtain a "fitting" picture of oneself by hoodwinking oneself, by blindly distancing oneself again and again from the conventional, inevitably boring self-representations that deprive one of the pleasure of reinventing oneself. It's an experience.

Epilogue

Are we to conclude that the only acceptable type of portrait is the experimental portrait? Most likely the answer to this is yes. And if so, the model should be admonished; his gaze redirected. True fascination arises from what perplexes us, not from what comforts us; it reflects what is to come, not what is. The only thing that matters in us, the only thing that counts coming from us, is whatever throws the settled and the established fact into question, thereby offering our lives and faces a new opportunity. The alternative is conventionality.

<div style="text-align:center">✳</div>

Agitation, experience, hope, loss, change, thought—in short, life. How can a portrait contain all this? Pain, bliss, migrations, bereavements, conquests, talents and skills, the pulsing of flesh—life itself as it comes to you. It is impossible for this profusion to be held in the mere picture of a body. You mustn't expect it to

happen any more than you can expect the characters in a film to leave the screen—like the characters in Woody Allen's *Purple Rose of Cairo*—and embrace the spectators in the movie theater, or slap us in the face. Any more than you can expect Hamlet, lying dead on the stage in a cardboard castle in a faux Denmark, to really be dead. The established portrait is, in short, of no interest, or its interest is strictly anecdotal, purely theatrical. It's limited by the fact that it belongs to a past that has been subsequently recomposed. The model knows this perfectly well, for he himself has organized the whole charade. But is being aware of it enough for him to change his point of view? This is far from certain.

For in all likelihood the model couldn't care less that the portrait proves nothing, that its endless duplications and mass productions merely demonstrate that it is impossible—impossible to find, inaccessible, always needing to be redone. No doubt this will forever be the case; for it's exciting to gaze at oneself in a picture or gaze at the bodies imprisoned in it. Besides, the portrait you look at has the advantage of being there; it's a record to consult, a story about you, deceptive but nonetheless composed—a portable legend.

*

Should the portrait then be banned in the hope of discouraging the subject's flagrant self-admiration or the viewer's incessant ogling of pictures of human faces and bodies, whether his own or somebody else's? You might as well ask the United Nations to ban mirrors on the grounds that they delimit the territory of false appearances. The portrait is as necessary a genre as it is a false one.

When viewed through the prism of the human hunger for portraits, portraitology is powerless. It can only confirm this fact: The more the portrait's existence, nature, and vocation are degraded, the more intently we look at it. Not in order to forget but, paradoxically, to seek some compensation in it. We look at the portrait that deceives us because life confirms us. Is it really our lot to be made of paper as well as flesh? Are we really eternal hostages to the Face? It would seem that we are, whatever the critics say. We the portrayed, we the perpetual narcissists.

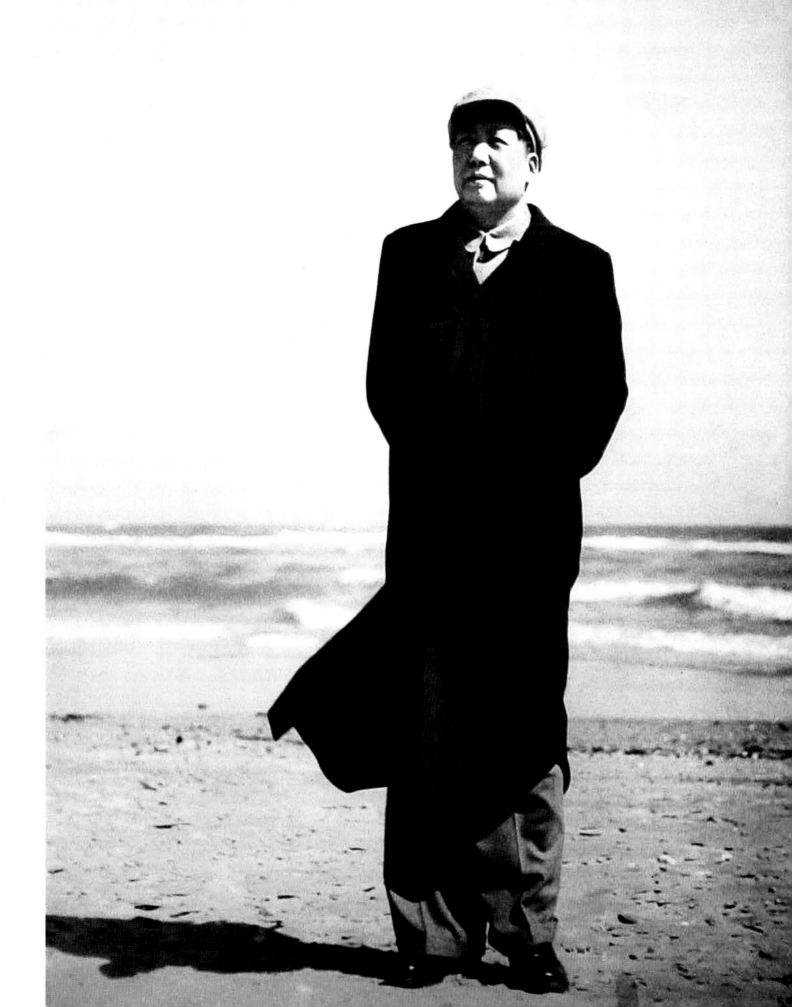

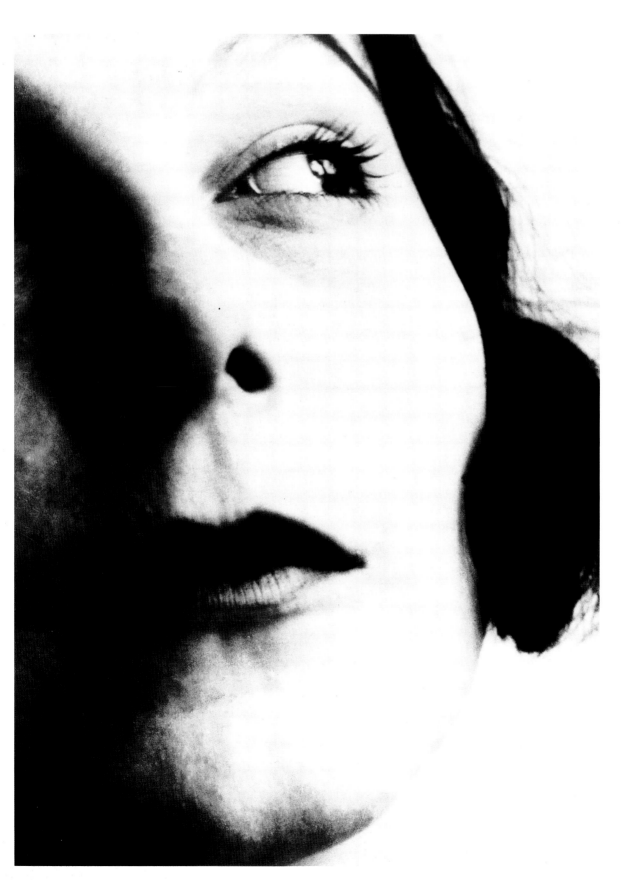

LÁSZLÓ MOHOLY-NAGY
PORTRAIT OF ELLEN FRANK,
C. 1929.
FACING PAGE:
HEINZ LOEW
AND EDMUND LOLLEIN
PORTRAIT AND SHADOW
OF PROFILE, 1927–1928.

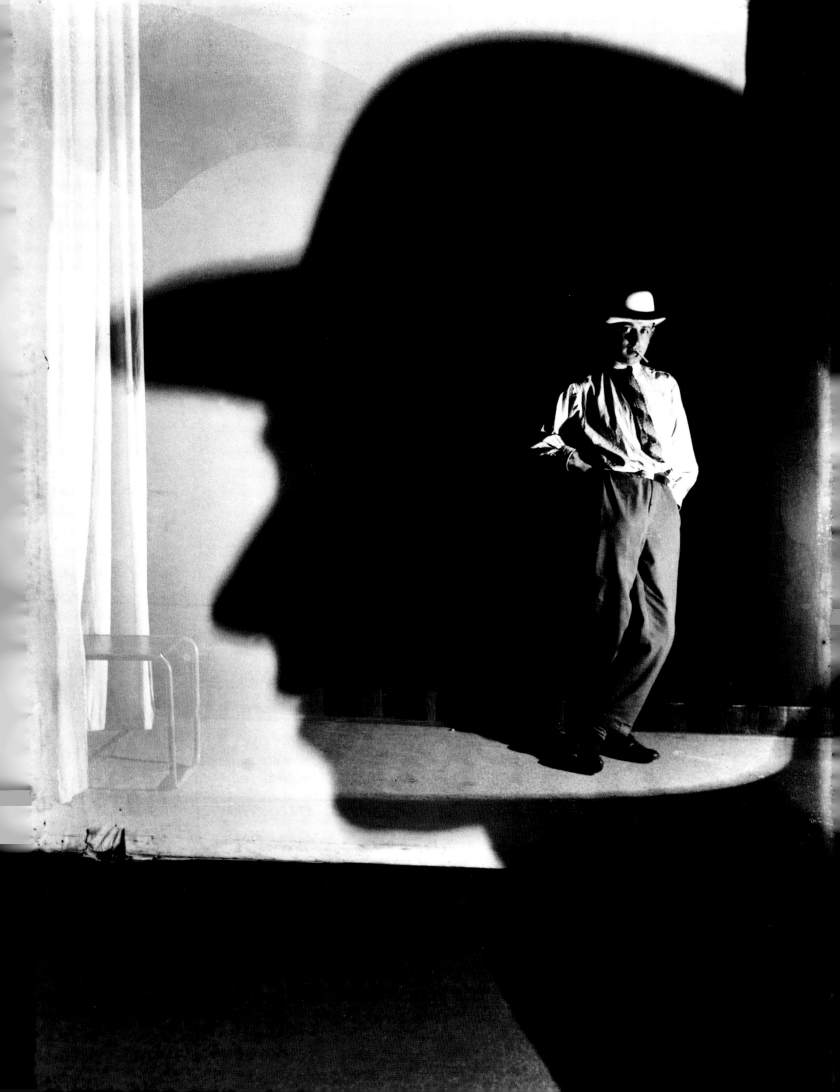

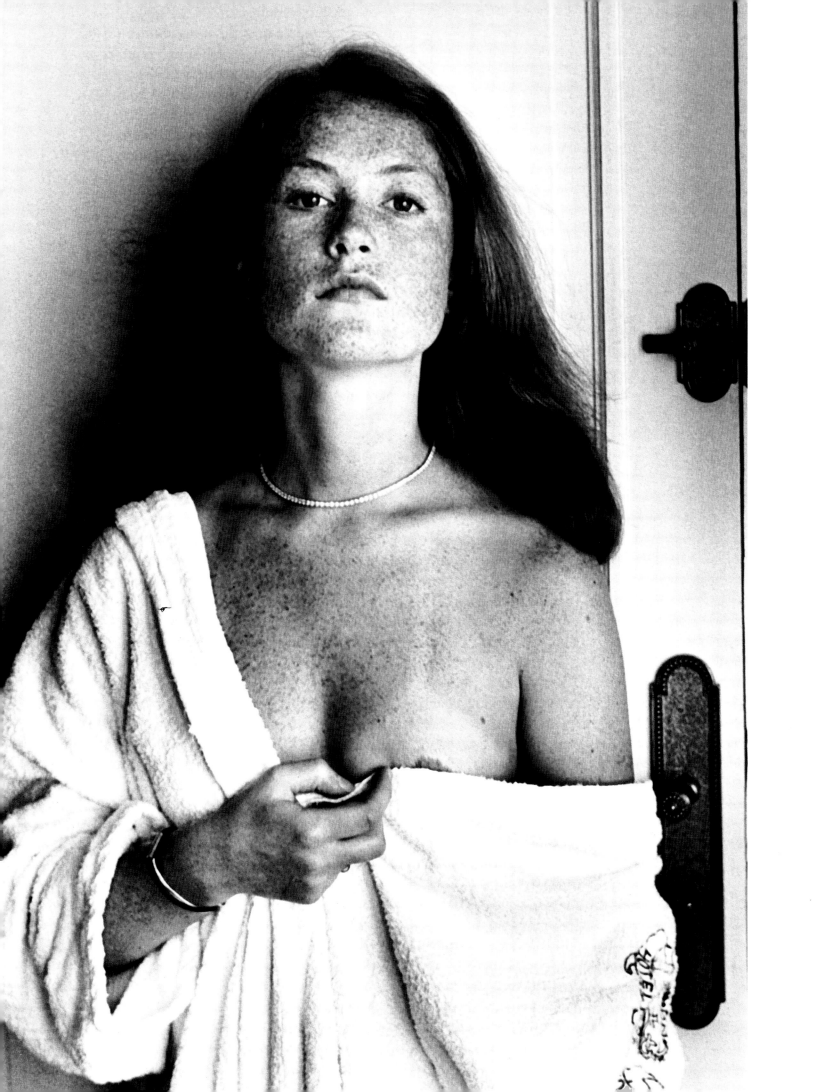

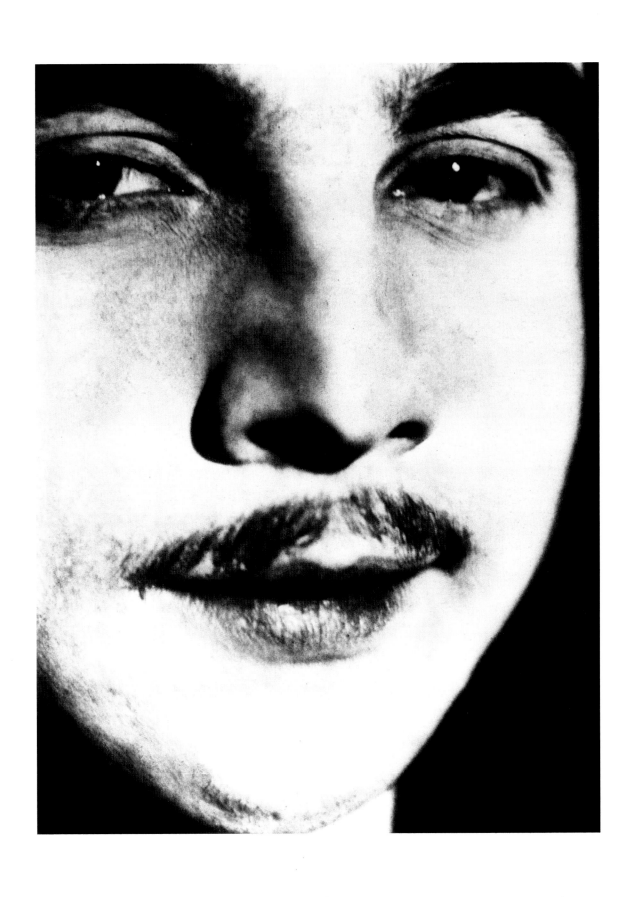

PAUL CITROËN
PORTRAIT OF UMBO, 1928.
FACING PAGE:
HELMUT NEWTON
ISABELLE HUPPERT AT THE CARLTON HOTEL, CANNES, 1976.

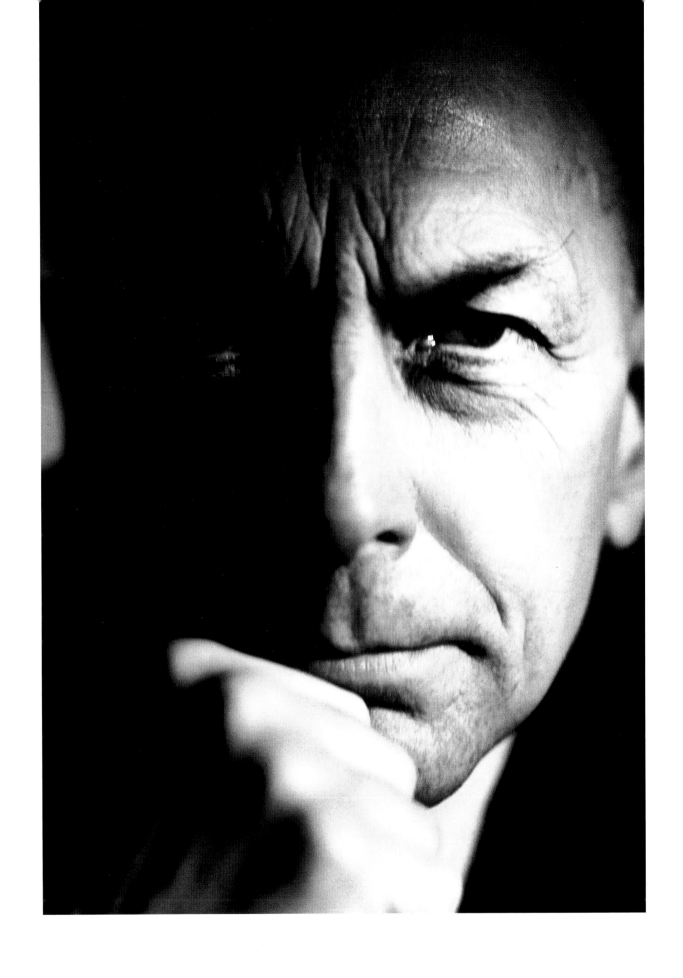

PAUL FACCHETTI
HENRI MICHAUX, 1950.
FACING PAGE:
PATRICK TOSANI
PO 37, 1985.

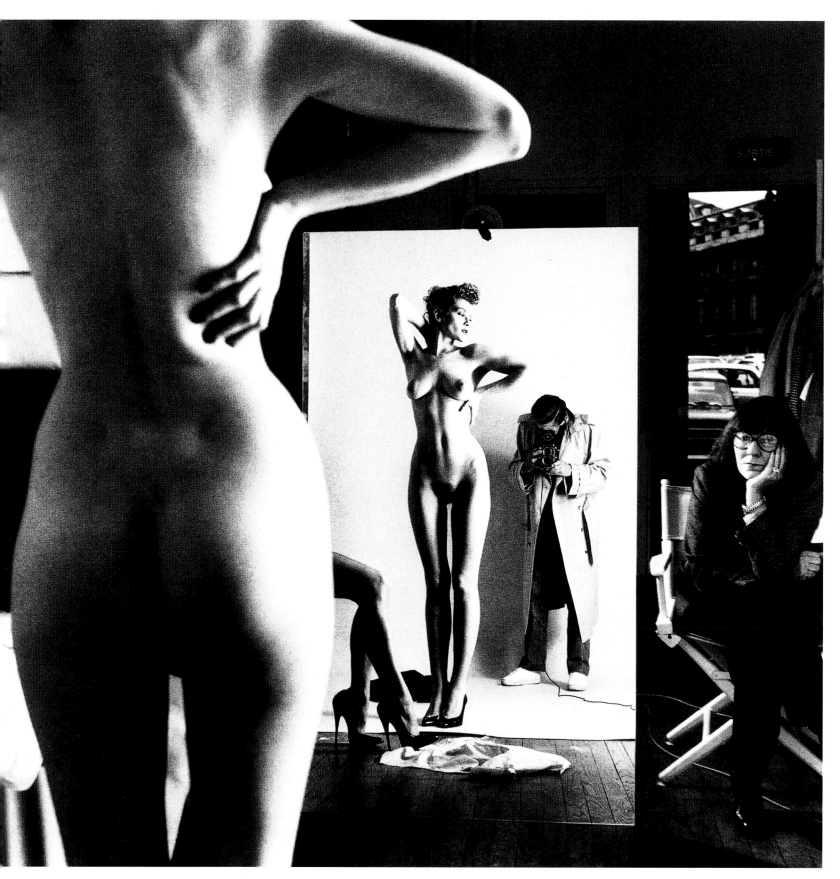

HELMUT NEWTON
SELF-PORTRAIT WITH HIS WIFE JUNE AND MODELS, PARIS, 1981.
FACING PAGE:
KONRAD RESSLER
BERTOLT BRECHT, 1927.

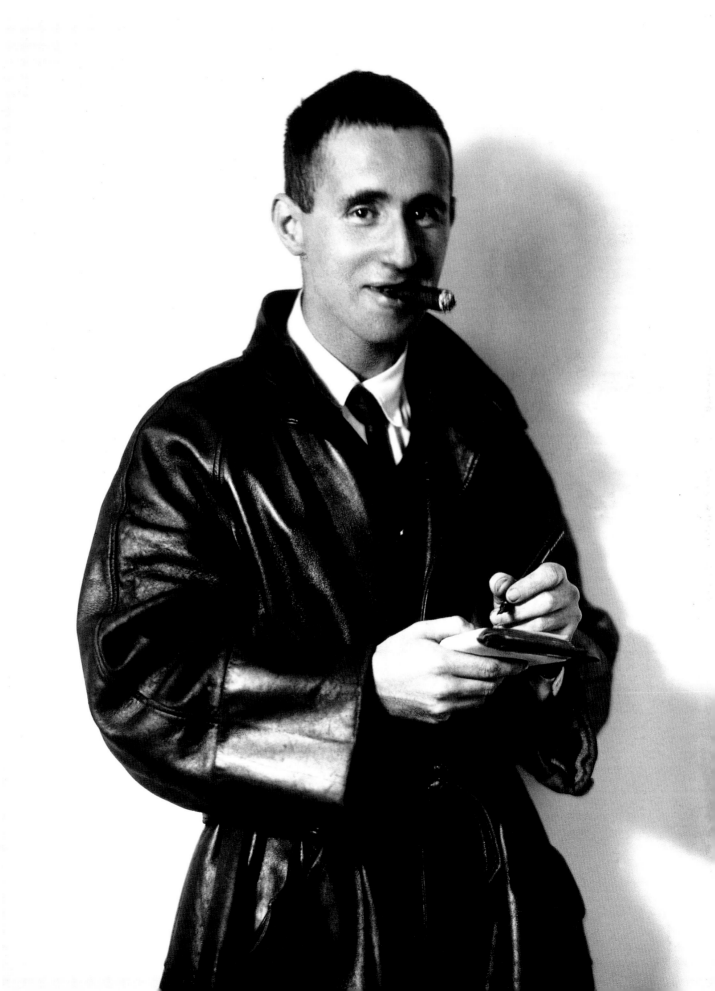

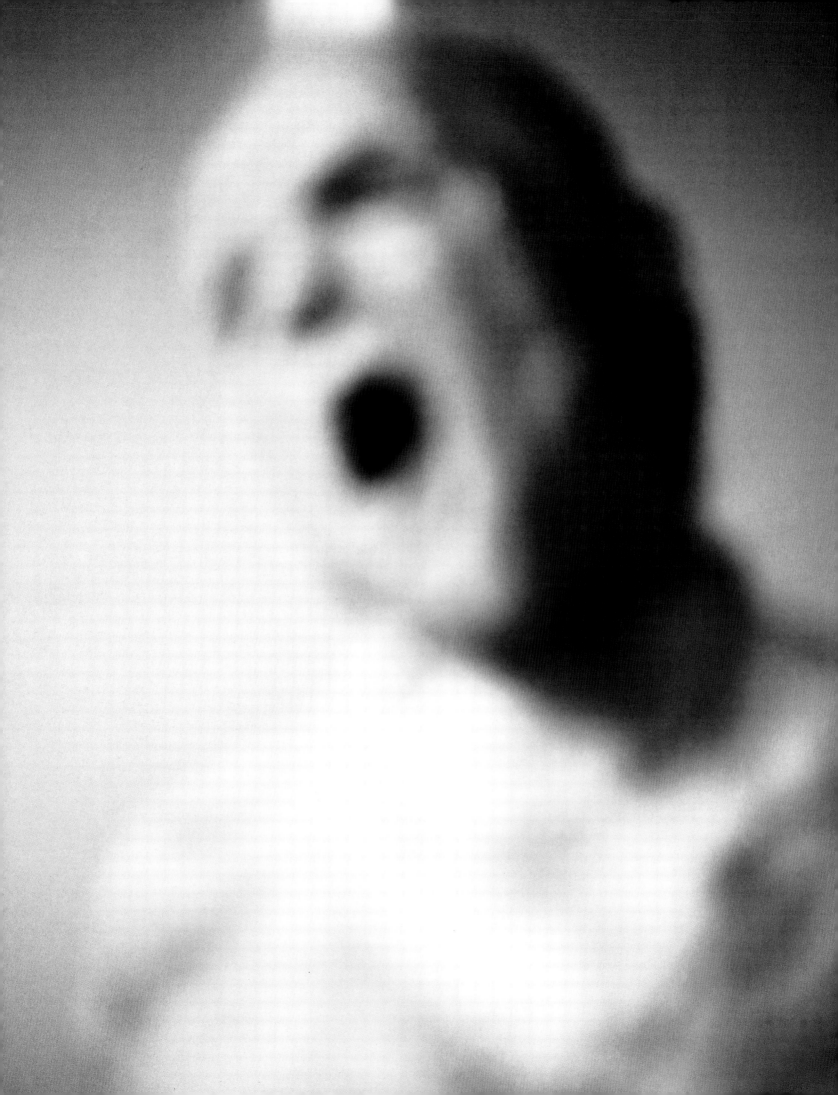

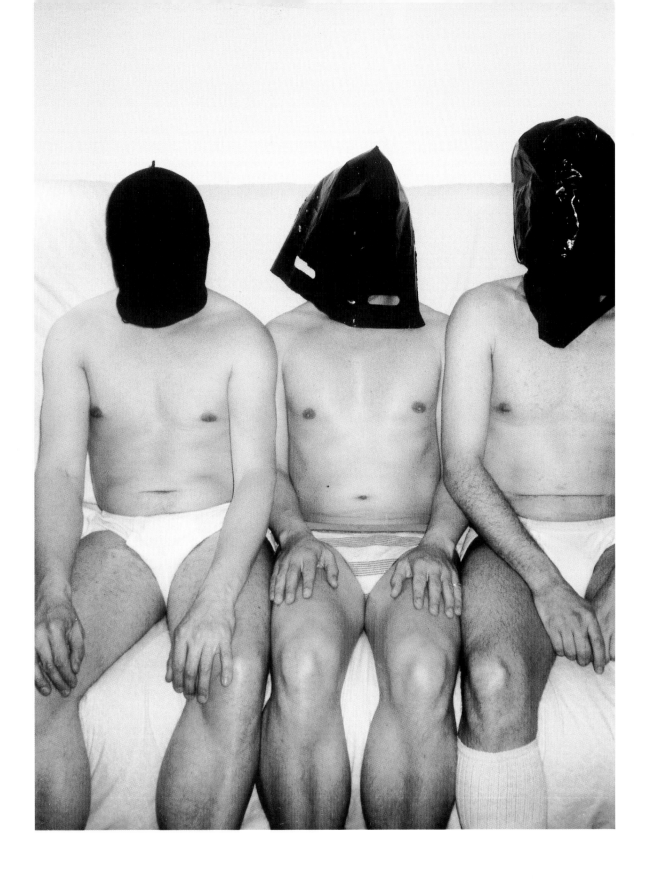

GEORGES TONY STOLL
LES TROIS FRÈRES (THE THREE BROTHERS), DECEMBER 1997.
FACING PAGE:
ROBERT GLIGOROV
SELF-PORTRAIT, 1998.

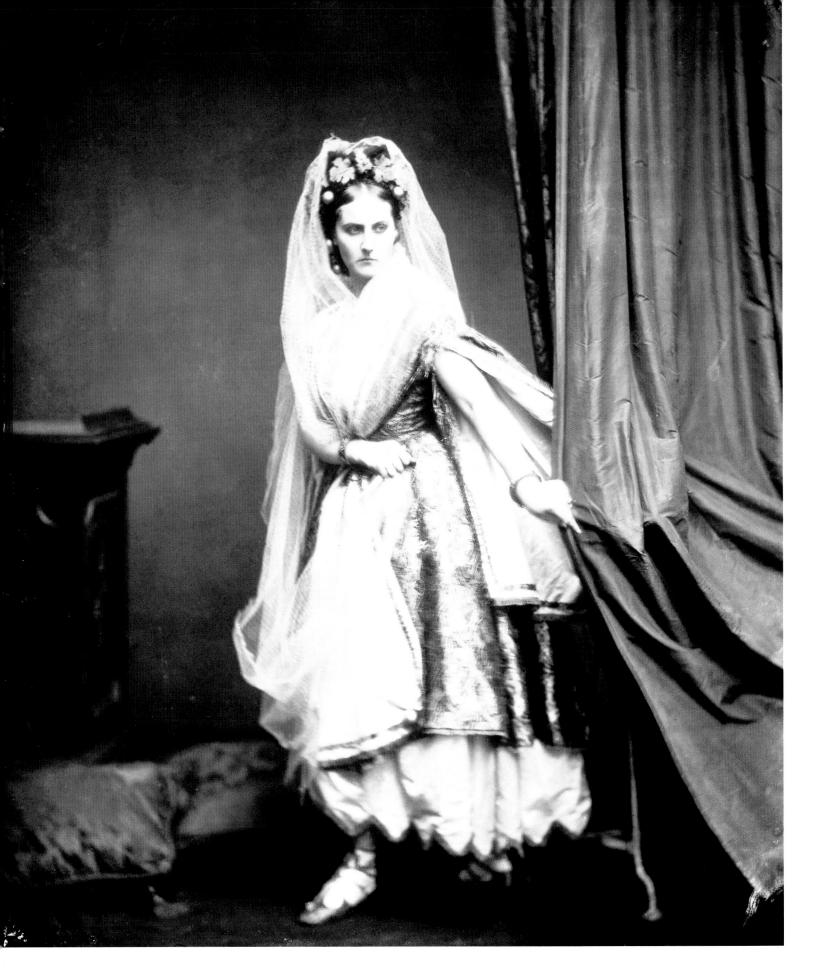

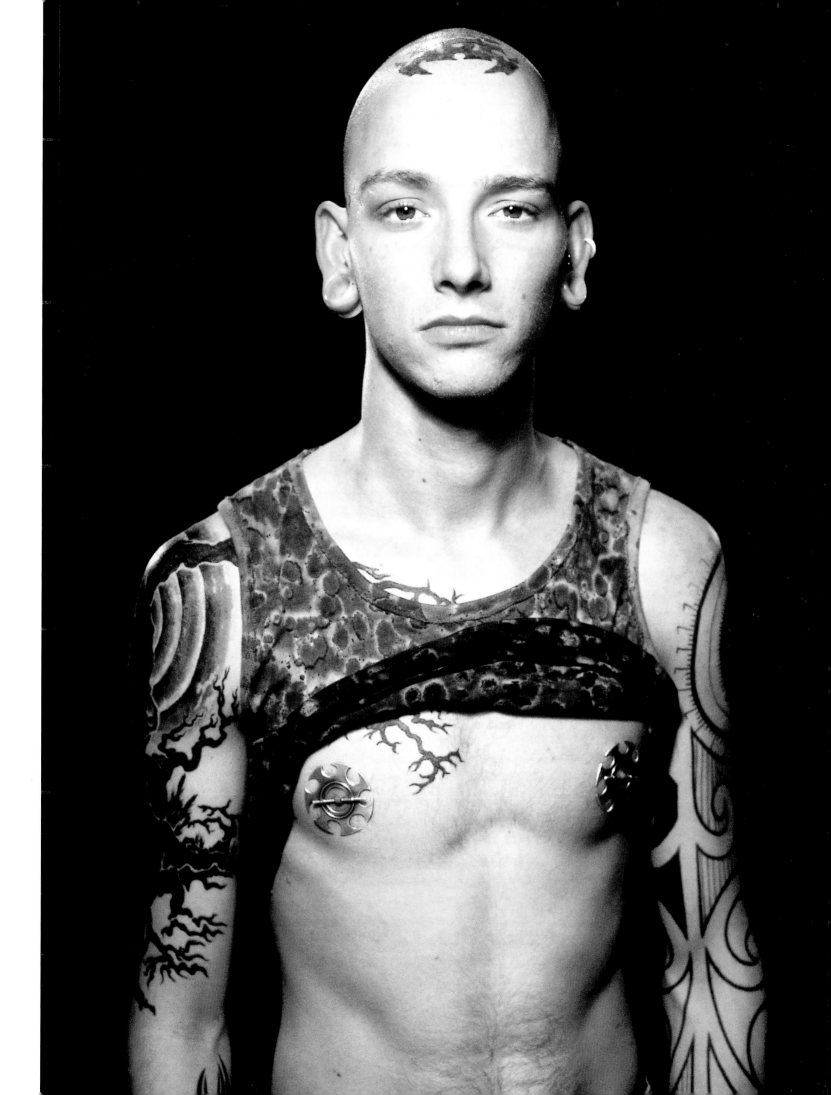

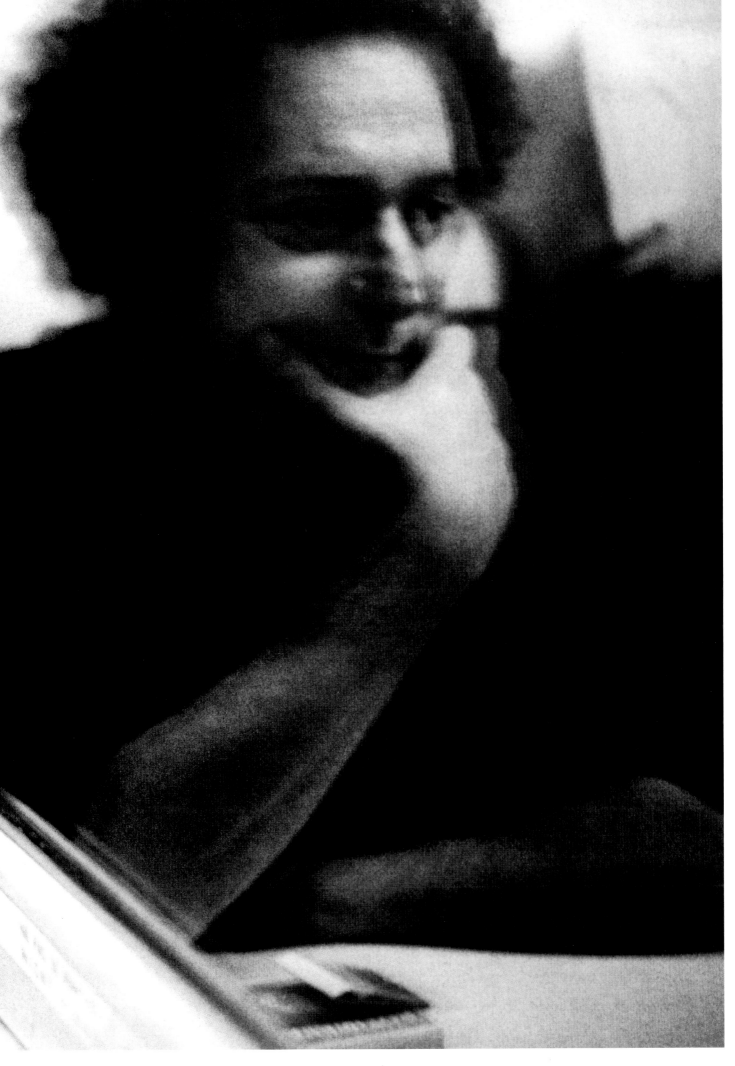

49

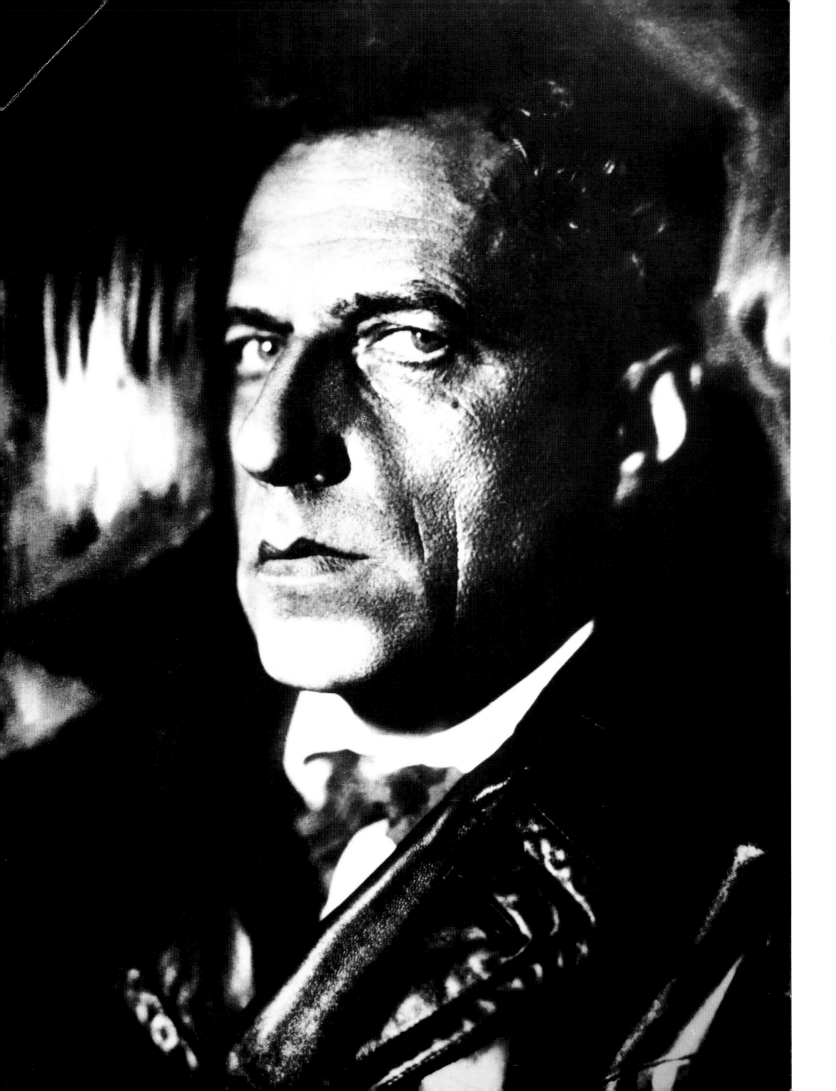

MARC TRIVIER
THOMAS BERNHARD, AUSTRIA, 1983.
FACING PAGE:
MIKHAIL NAPPELBAUM
MEYERHOLD, 1932.
FOLLOWING PAGES:
LEFT: **GISÈLE FREUND**
MARCEL DUCHAMP, PARIS, 1939.
RIGHT: **RINEKE DIJKSTRA**
MONTEMOR, PORTUGAL, MAY 1, 1994.

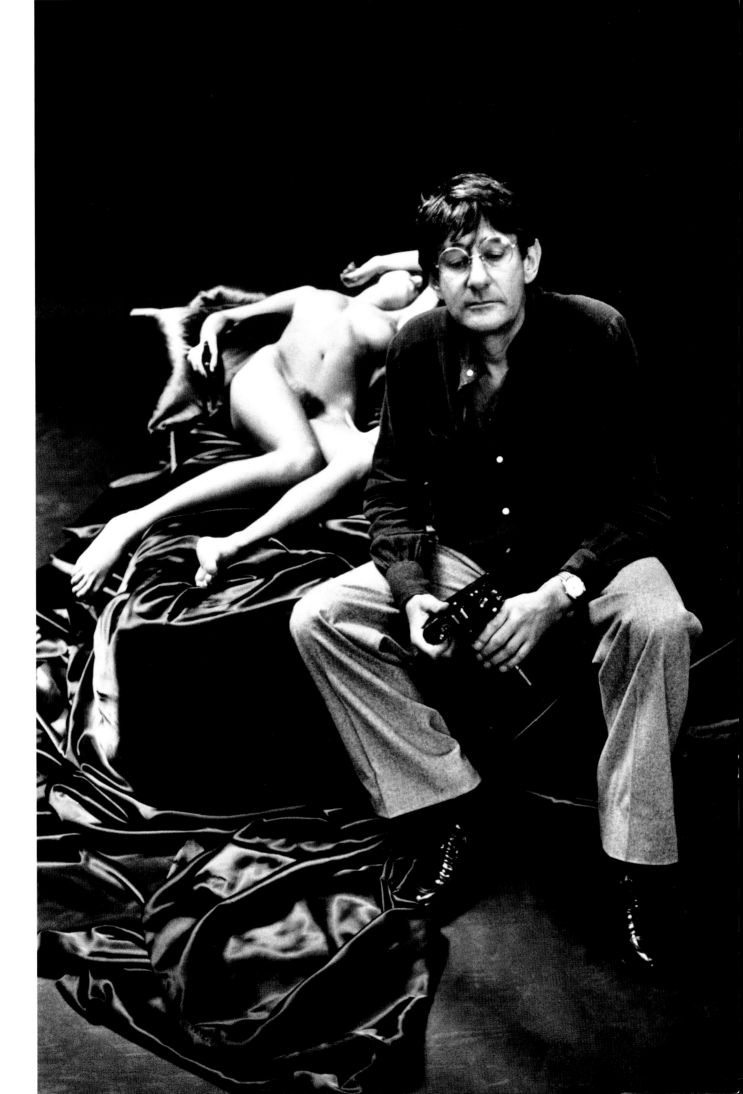

60

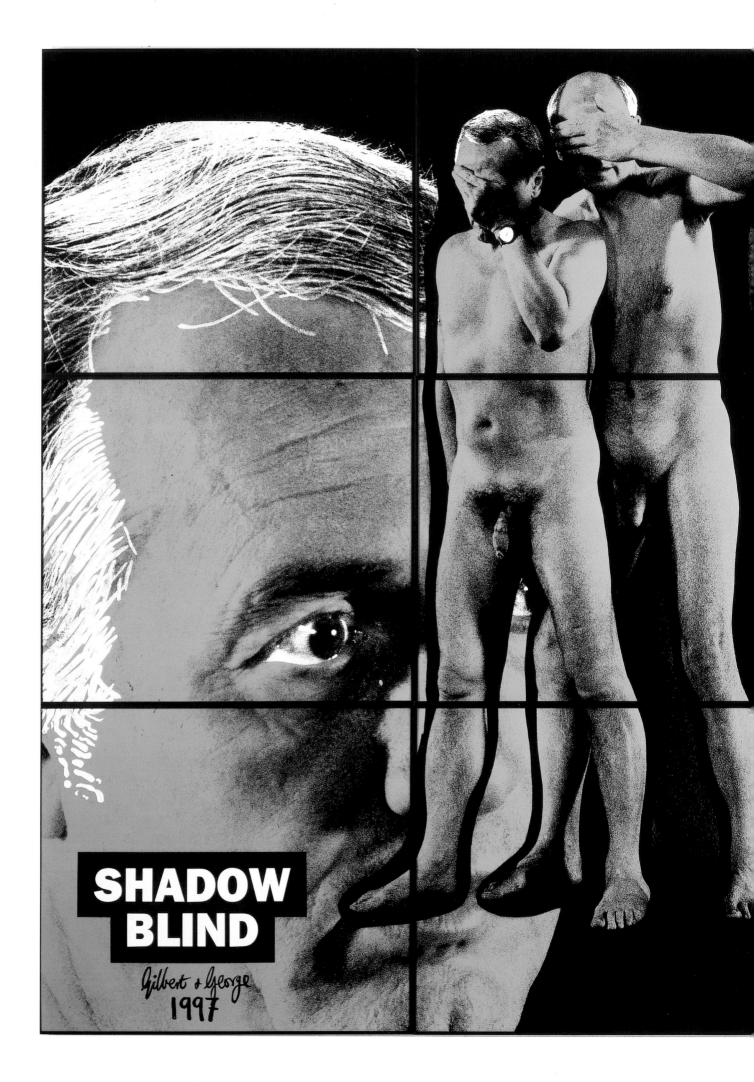

SHADOW
BLIND

Gilbert & George
1997

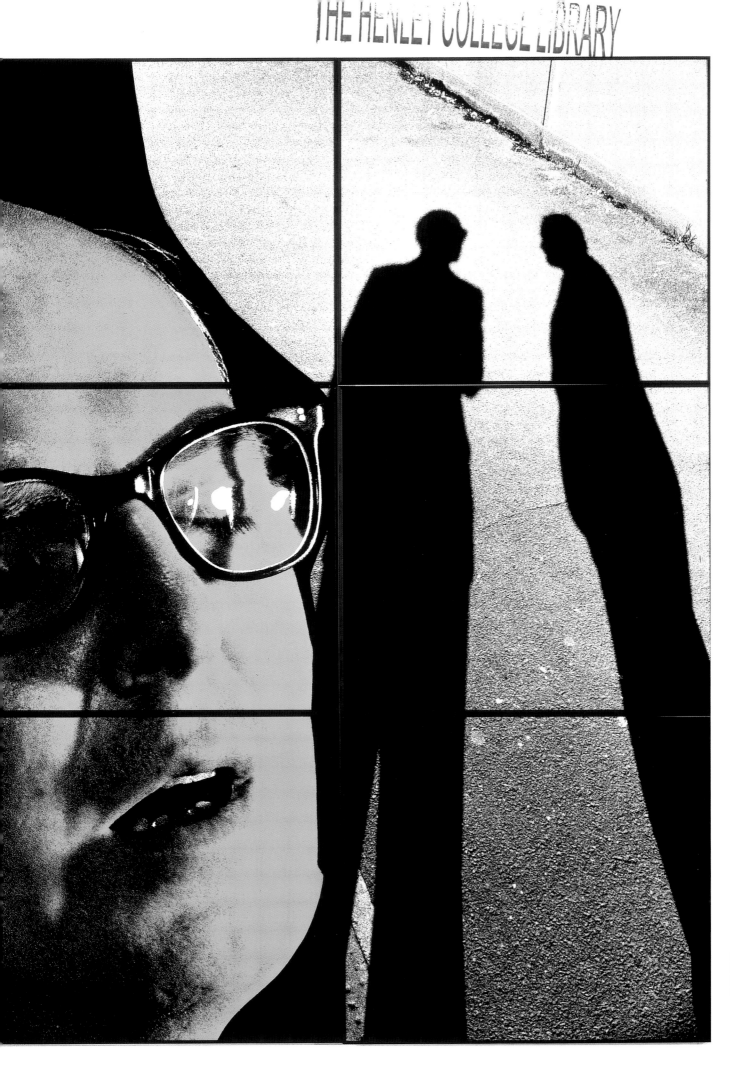

63

GILBERT
AND GEORGE
*SHADOW
BLIND*, 1997.

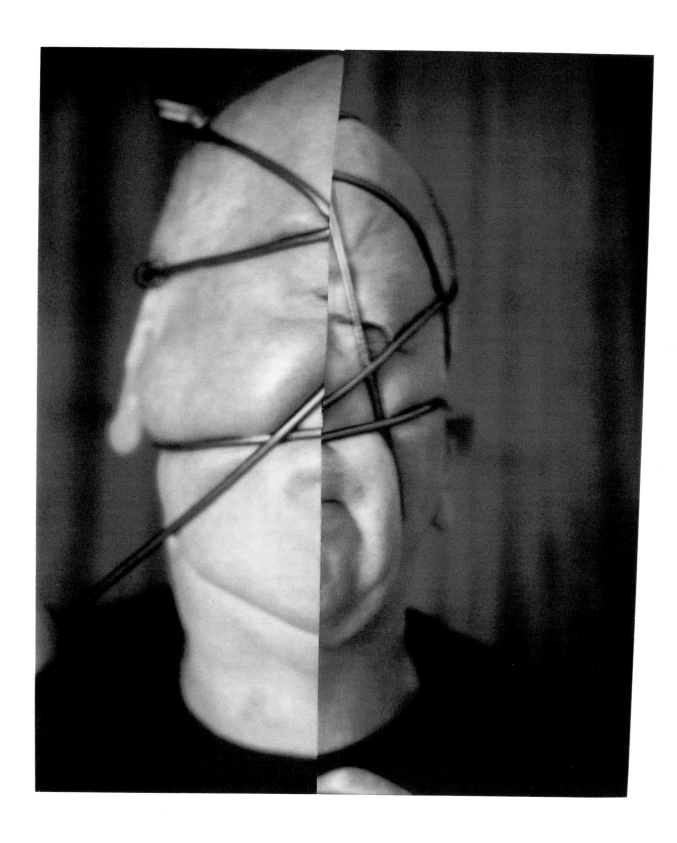

ANNA & BERNHARD BLUME
PRINZIP GRAUSAMKEIT (PRINCIPLE OF CRUELTY), 1996.
PRECEDING PAGES:
LEFT: **ALEXANDRE RODCHENKO**
VLADIMIR MAYAKOVSKY, 1924.
RIGHT: **AZIZ AND CUCHER**
JOHN, 1995.

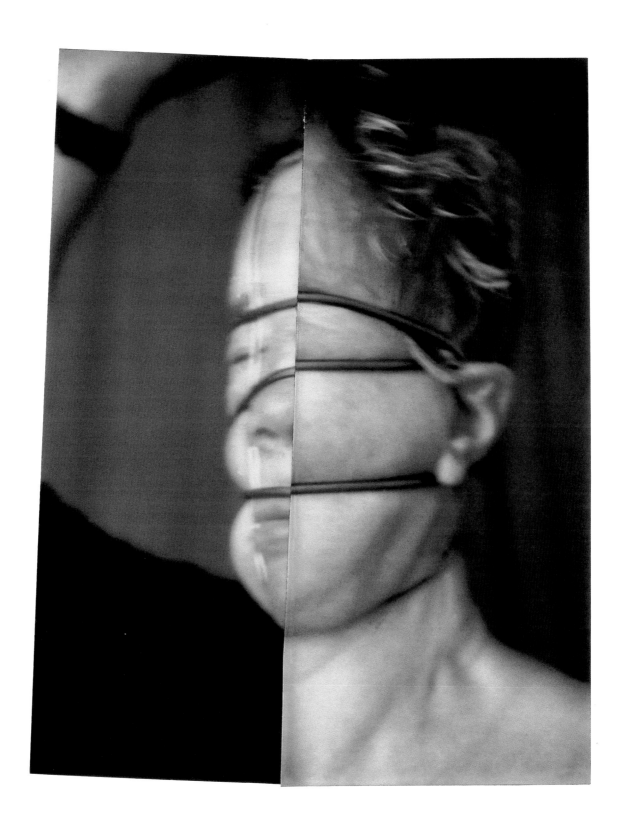

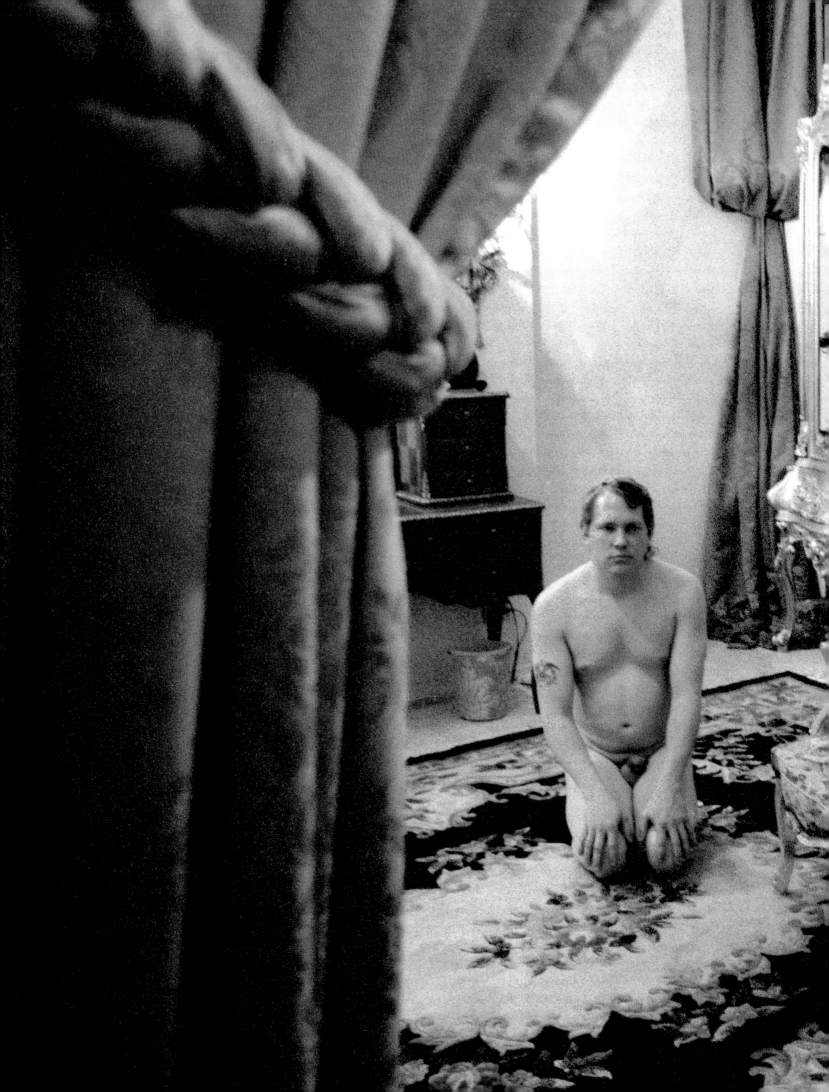

69

SUSAN
MEISELAS
*PANDORA'S
BOX, AWAITING
MISTRESS
NATASHA,
THE VERSAILLES
ROOM,*
NEW YORK, 1995.

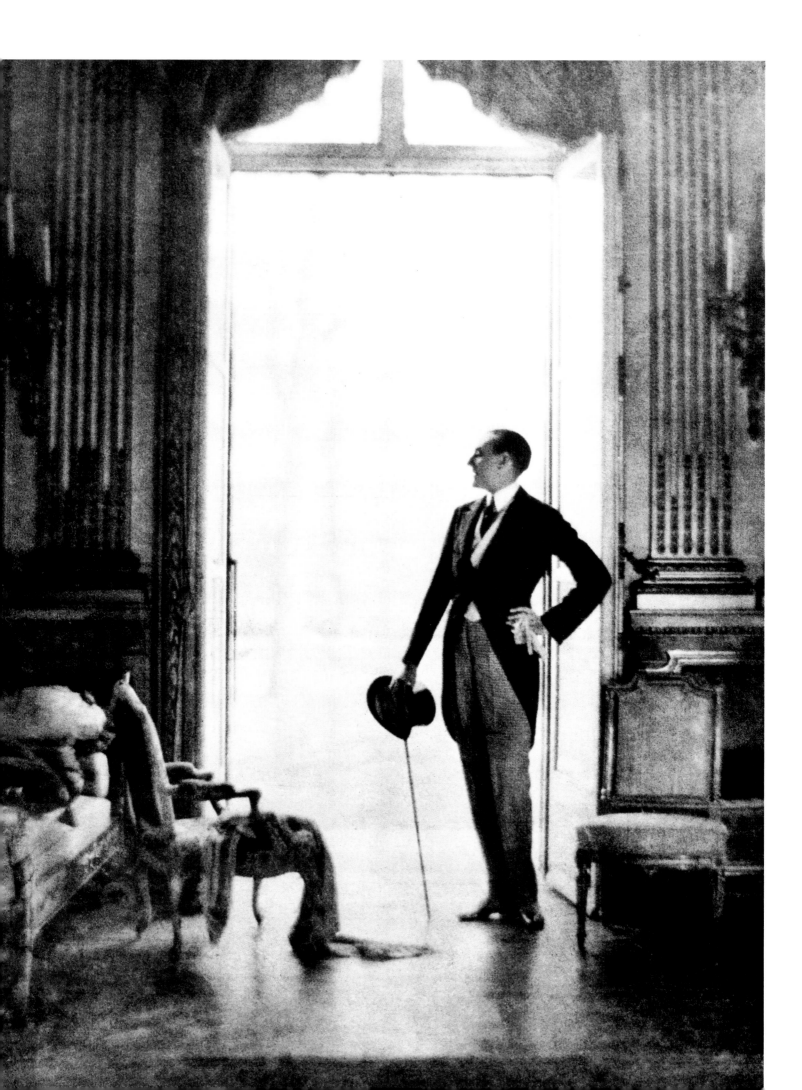

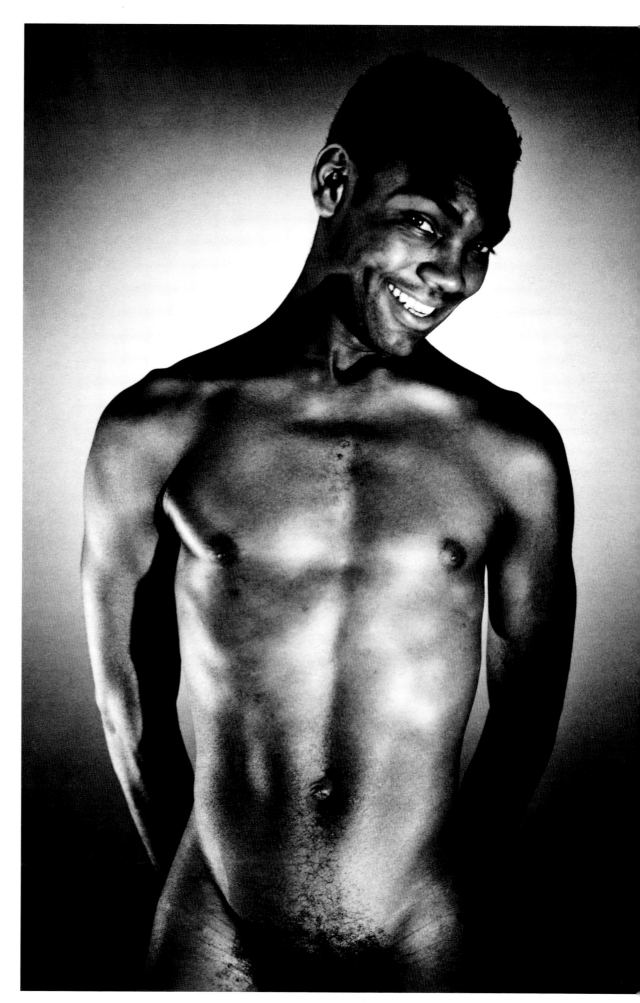

GEORGE PLATT-LYNES
MALE NUDE, 1938.
FACING PAGE:
BARON ADOLPHE DE MEYER
PORTRAIT OF A MAN, C. 1920.

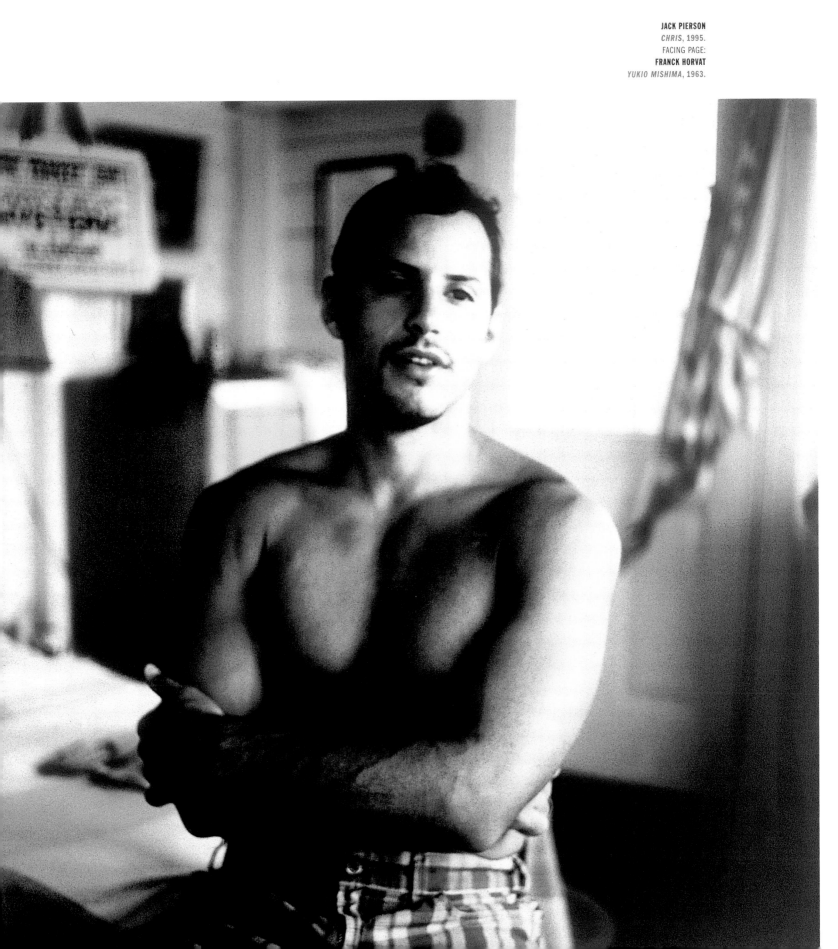

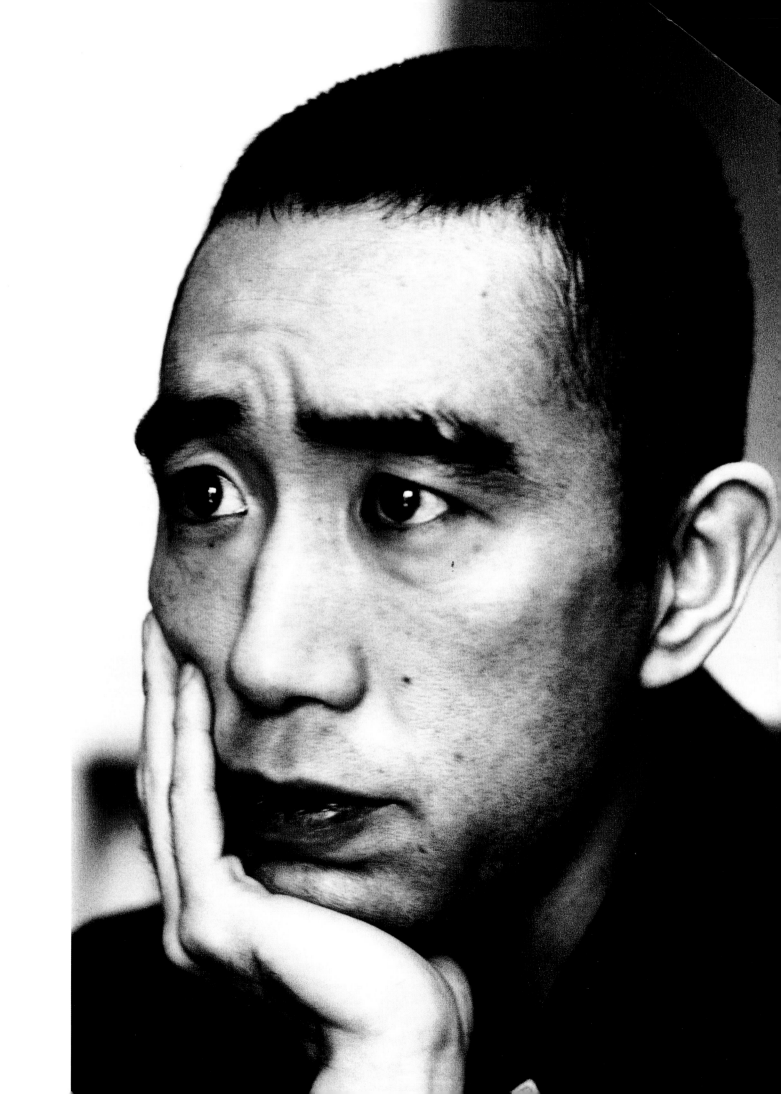

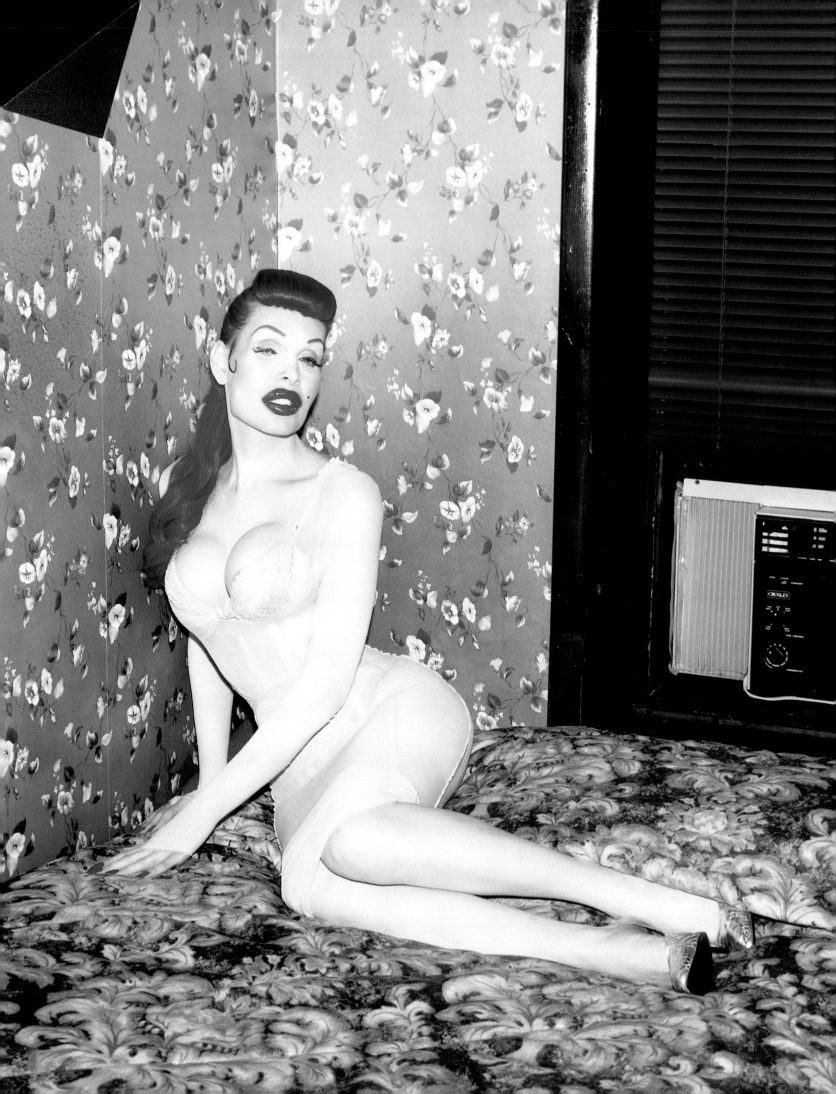

GABRIELE AND HELMUT NOTHHELFER
AMATEURFOTOGRAF AM "TAG DER OFFENEN TÜR"
IN DER SCHULE DER BEREITSCHAFTS POLIZEI
(AMATEUR PHOTOGRAPHER AT "OPEN DAY"
AT THE SCHOOL FOR RIOT POLICE), RUHLEBEN, 1975.
FACING PAGE:
KATHARINA BOSSE
UNTITLED, 1999.

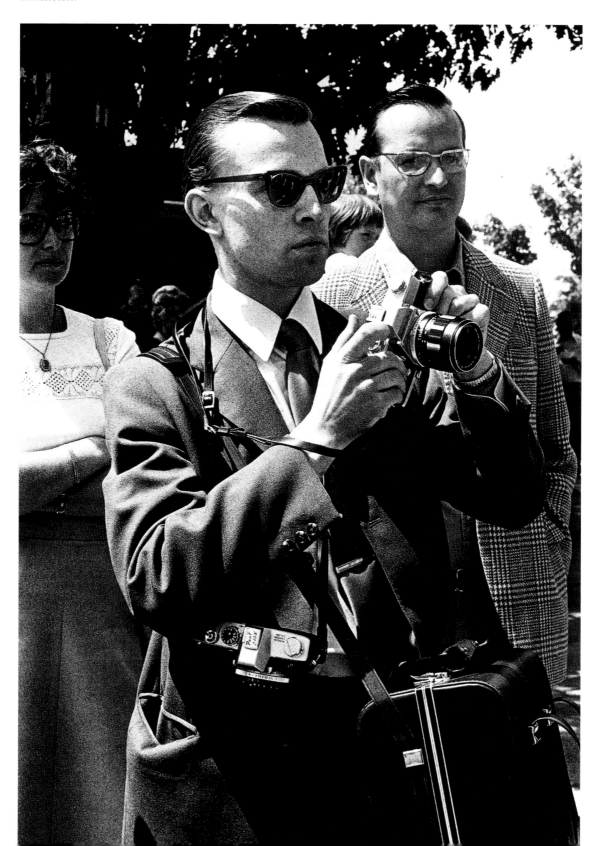

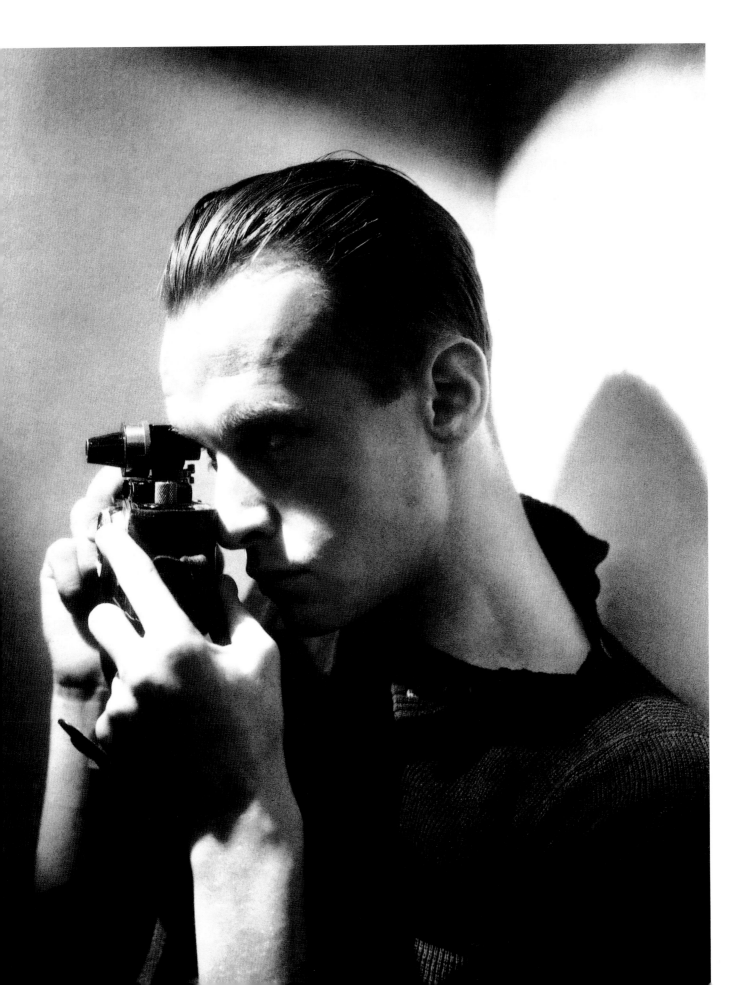

HERVÉ GUIBERT
PATRICE CHÉREAU, 1984.
FACING PAGE:
GEORGE HOYNINGEN-HUENE
HENRI CARTIER-BRESSON, C. 1933.

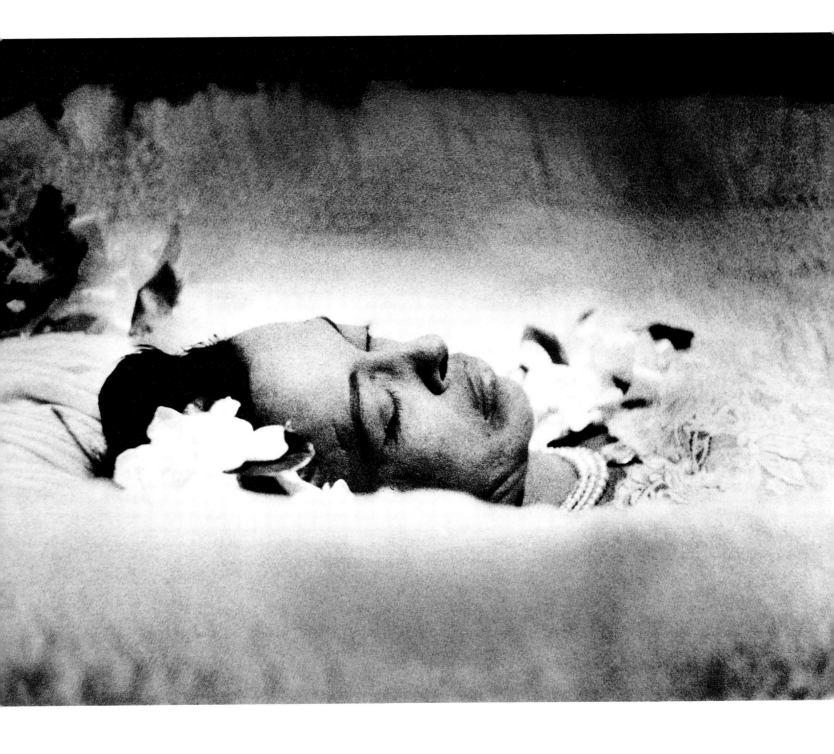

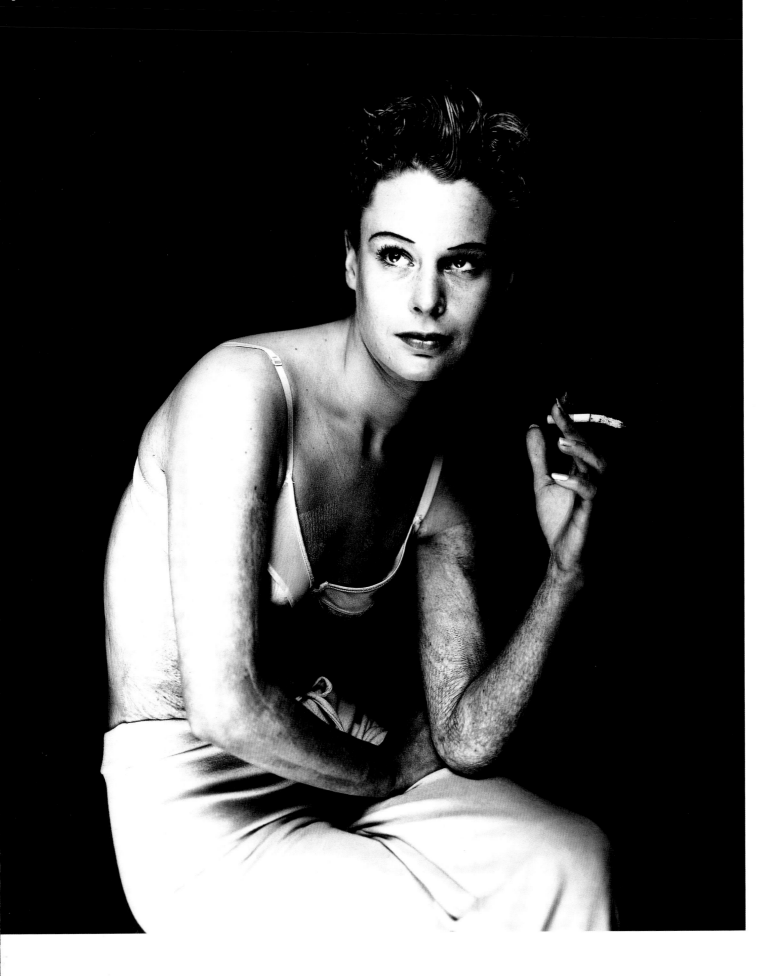

KOOS BREUKEL
MODEL, AMSTERDAM, 1999.
FACING PAGE:
LEON LEVINSTEIN
TIMES SQUARE/42ND STREET, C. 1970.

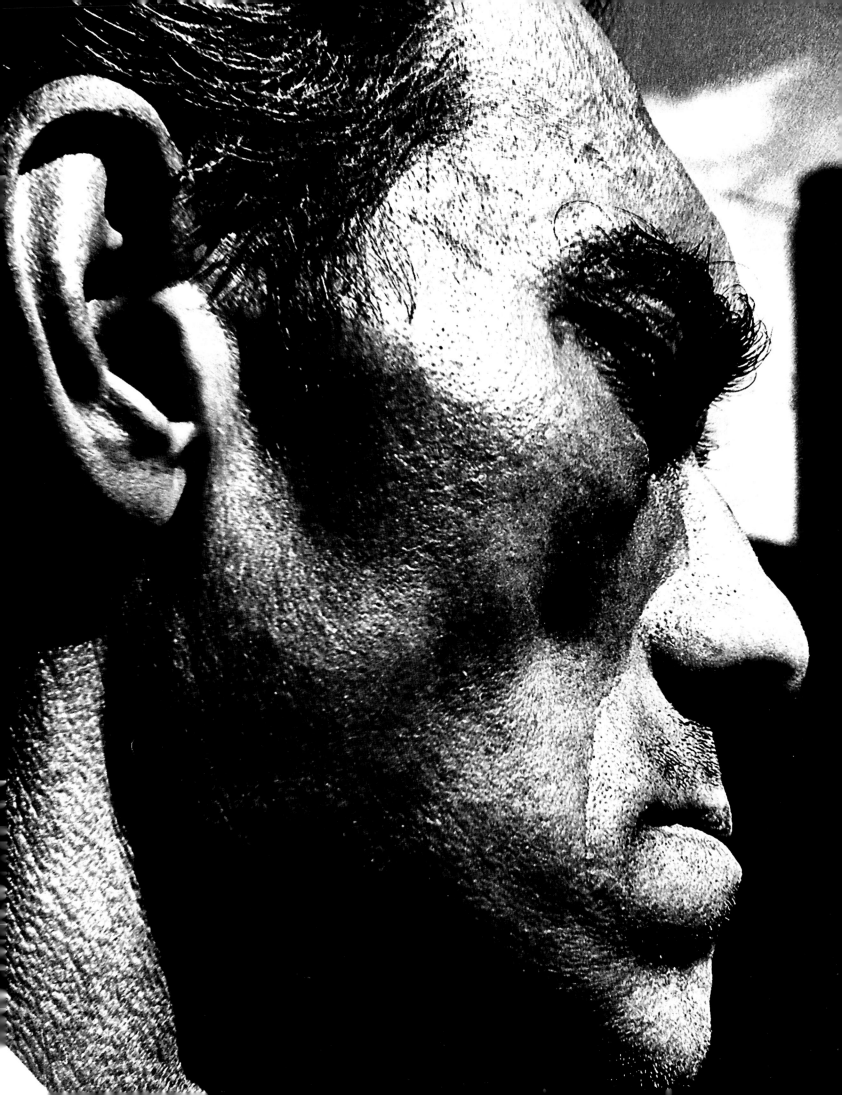

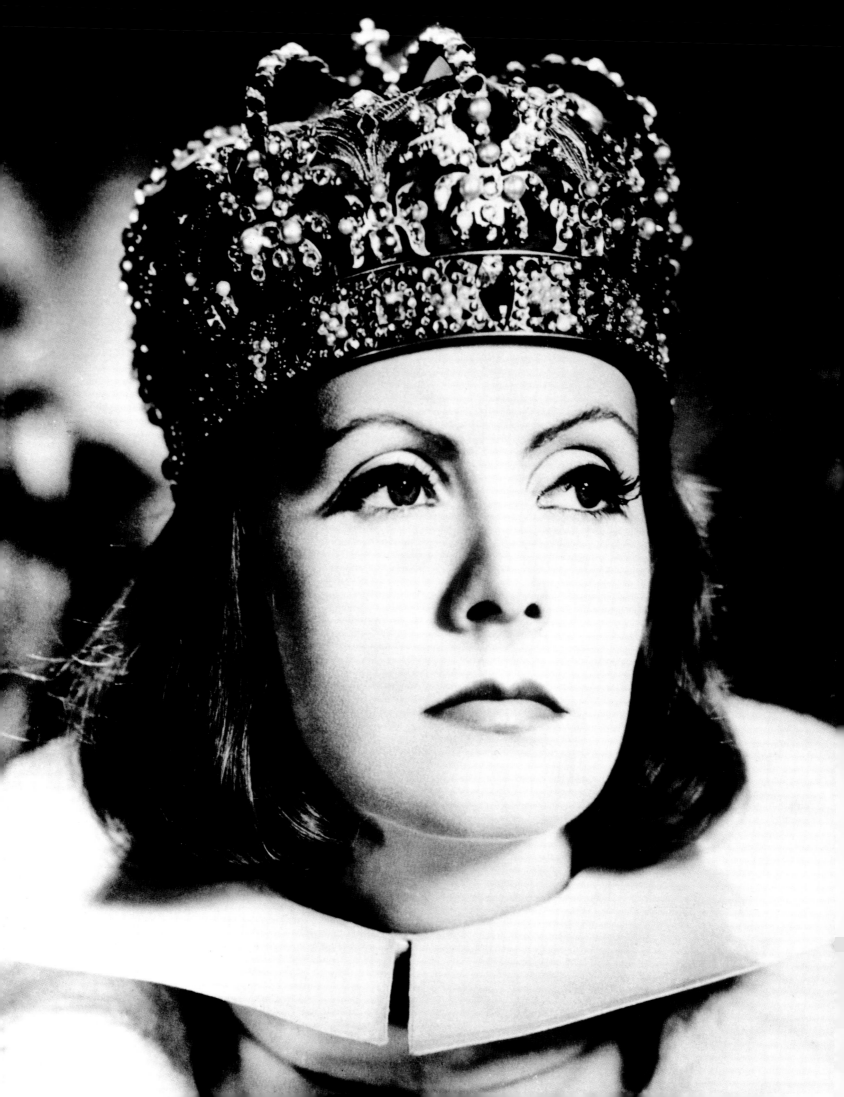

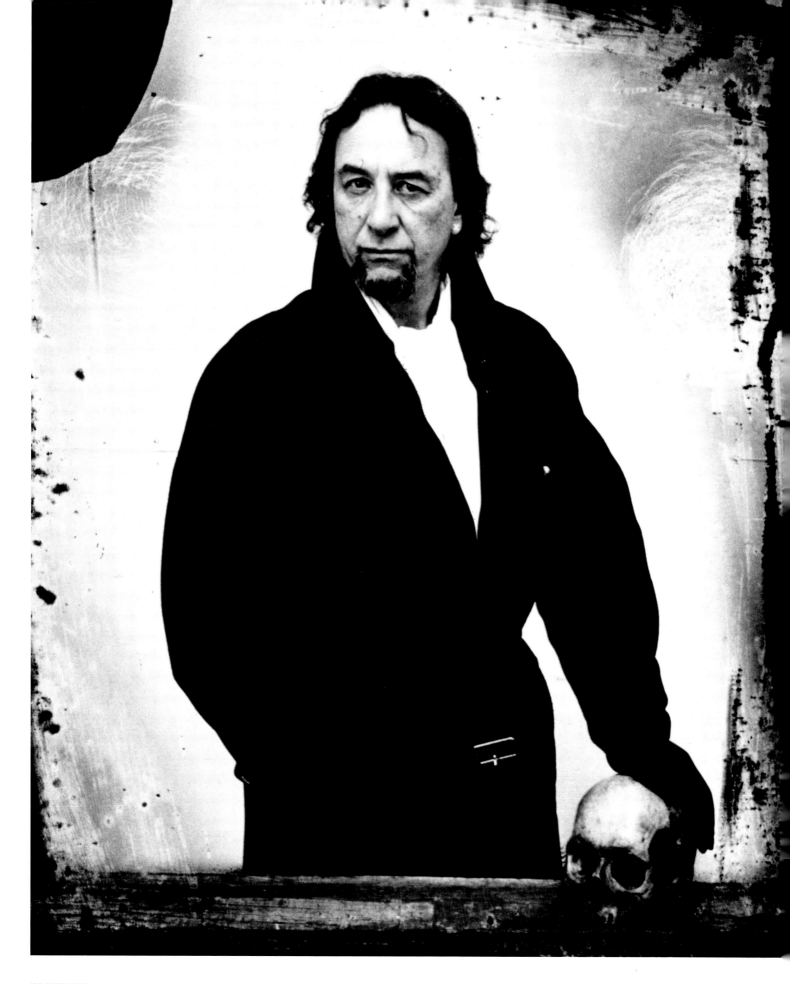

JOEL-PETER WITKIN
SELF-PORTRAIT. REMINISCENT OF PORTRAIT AS A VANITÉ, 1995.
FACING PAGE:
ANONYMOUS *GRETA GARBO IN* QUEEN CHRISTINA,
DIRECTED BY ROUBEN MAMOULIAN, 1933.

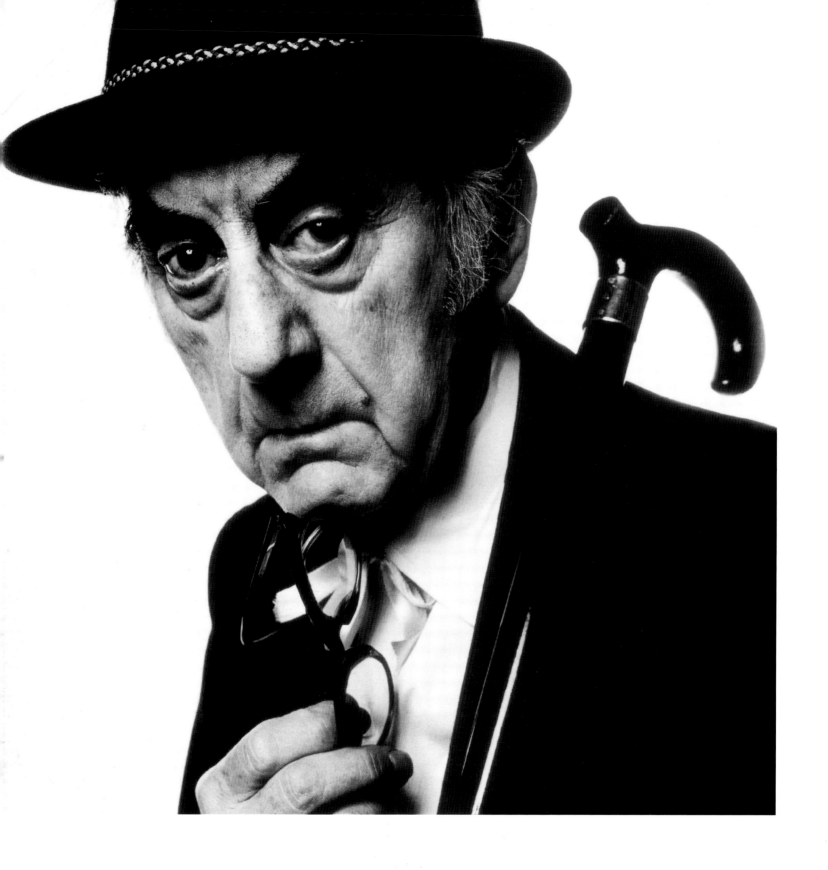

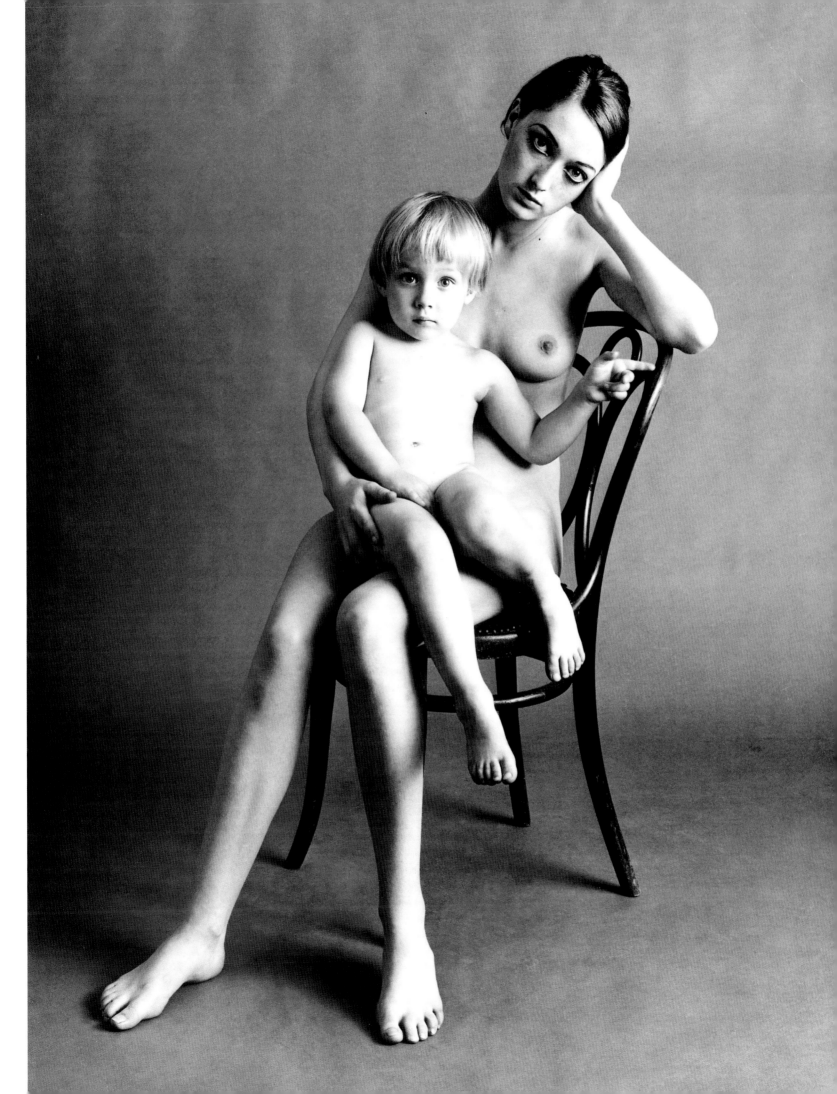

RAYMOND VOINQUEL
LE REPOS POUR MICHEL-ANGE
(REST FOR MICHAELANGELO), 1943.

88

ALFRED STIEGLITZ
GEORGIA O'KEEFFE:
A PORTRAIT, C. 1924.

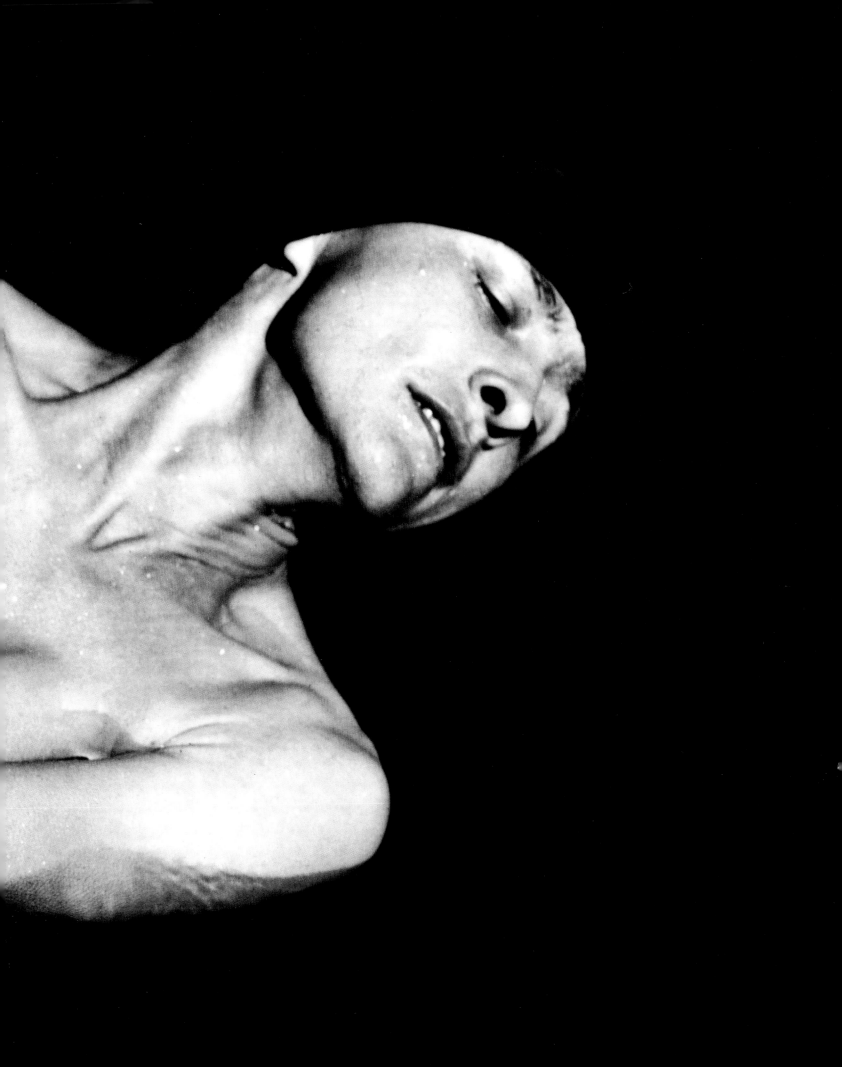

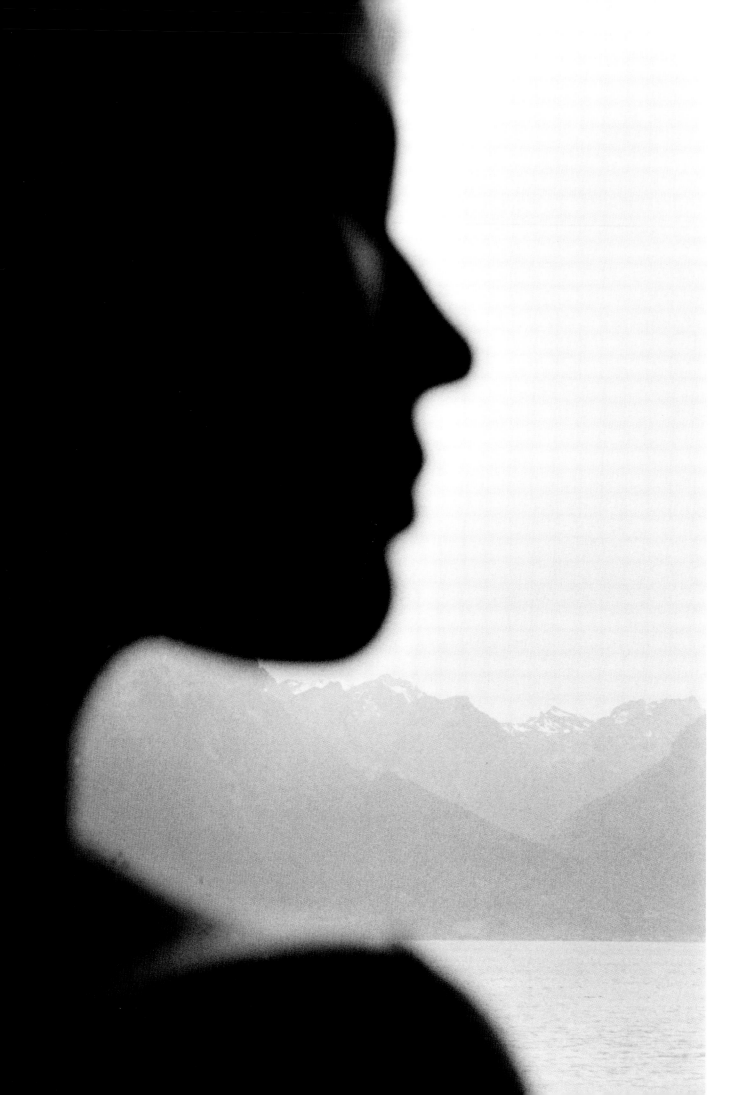

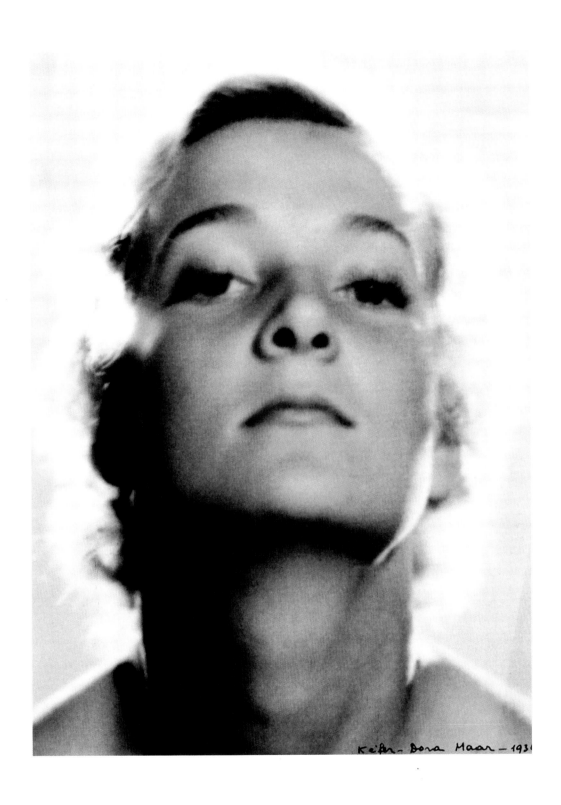

DORA MAAR AND PIERRE KEFER
PORTRAIT DE FEMME
(*PORTRAIT OF WOMAN*), 1934.
FACING PAGE:
PHILIPPE PACHE
SARAH (LE LÉMAN), 1993.

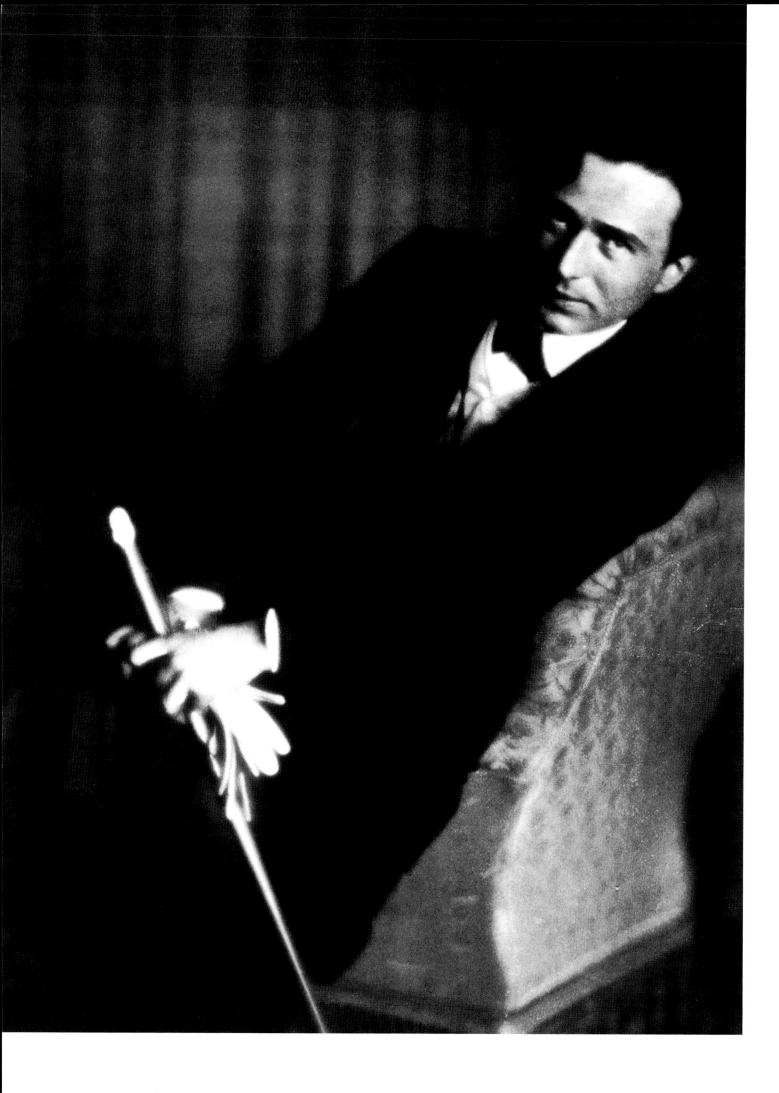

IVAN PINKAVA
ART DÉCO STYLE, 1999.
FACING PAGE:
ROBERT DEMACHY
PORTRAIT OF STEICHEN, C. 1910.
FOLLOWING PAGES:
LEFT: **LEWIS HINE**
ICARUS ATOP EMPIRE STATE BUILDING, 1931.
RIGHT: **MARTIN MUNKACSI**
MARLENE DIETRICH, C. 1936.

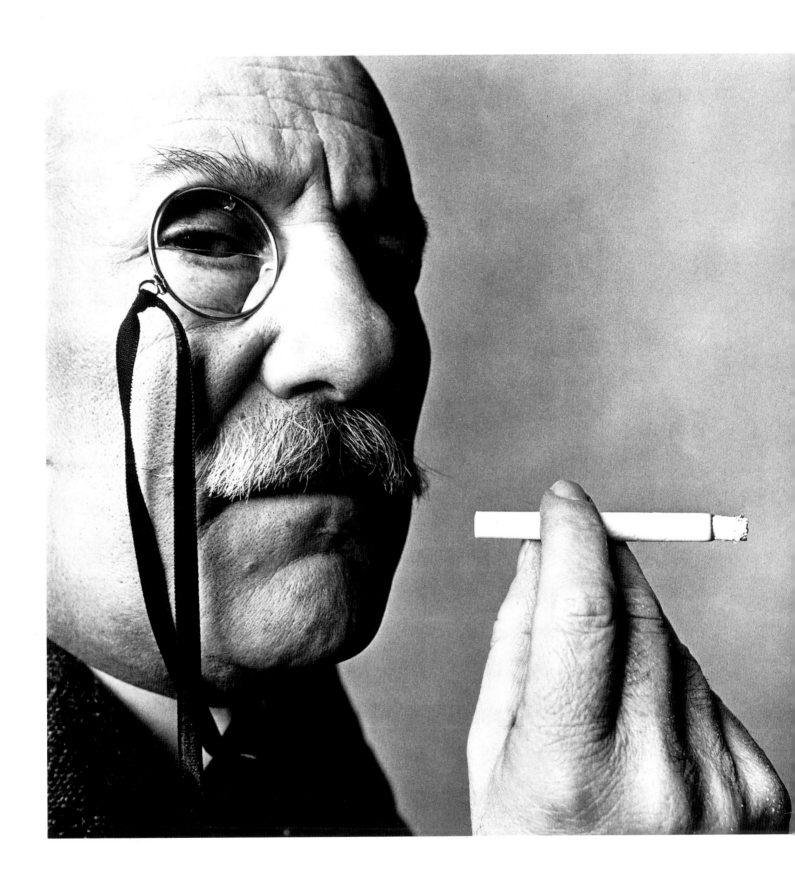

IRVING PENN
BARNETT NEWMAN, NEW YORK, 1966.
FACING PAGE:
HELMUT NEWTON
AVA GARDNER, LONDON, 1984.

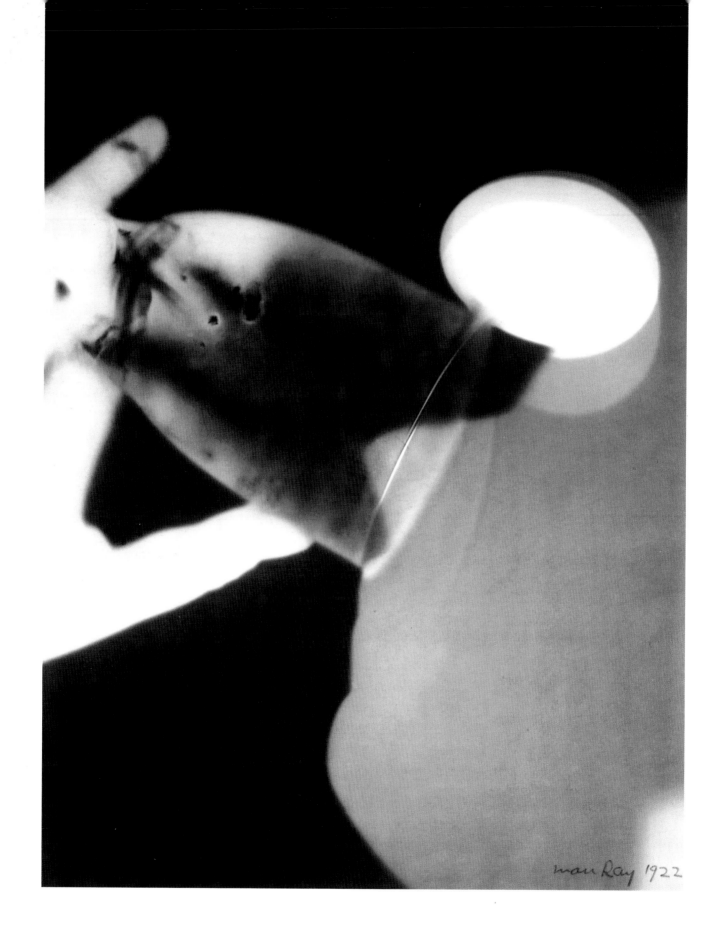

98

man Ray 1922

MAN RAY
RAYOGRAPH, 1922.
FACING PAGE:
ANNIE LEIBOVITZ
ANDRÉE PUTMAN, 1989.

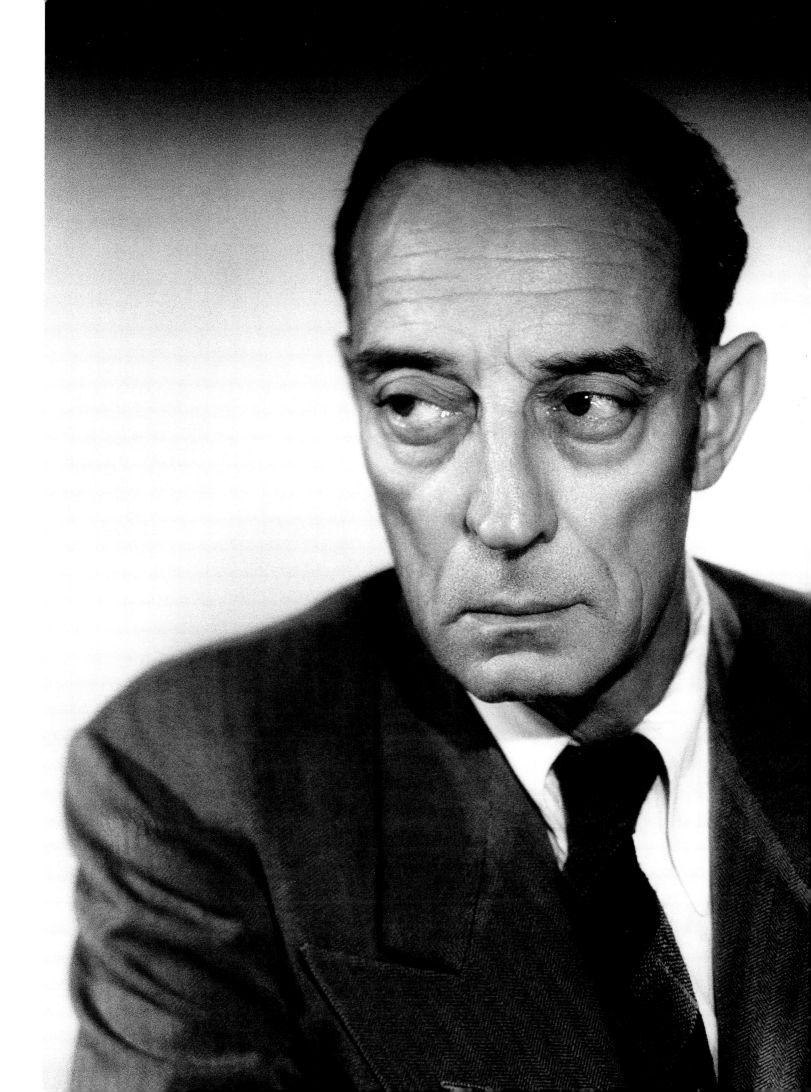

PAUL OUTERBRIDGE
SELF-PORTRAIT, C. 1927.
FACING PAGE:
CINDY SHERMAN
UNTITLED, 1994.

ANTANAS SUTKUS
YOUNG DOCTOR, FROM THE SERIES *LITHUANIANS*, 1967.
FACING PAGE:
MATTHEW BARNEY
CREMASTER, 5: BOCASS EL, 1997.

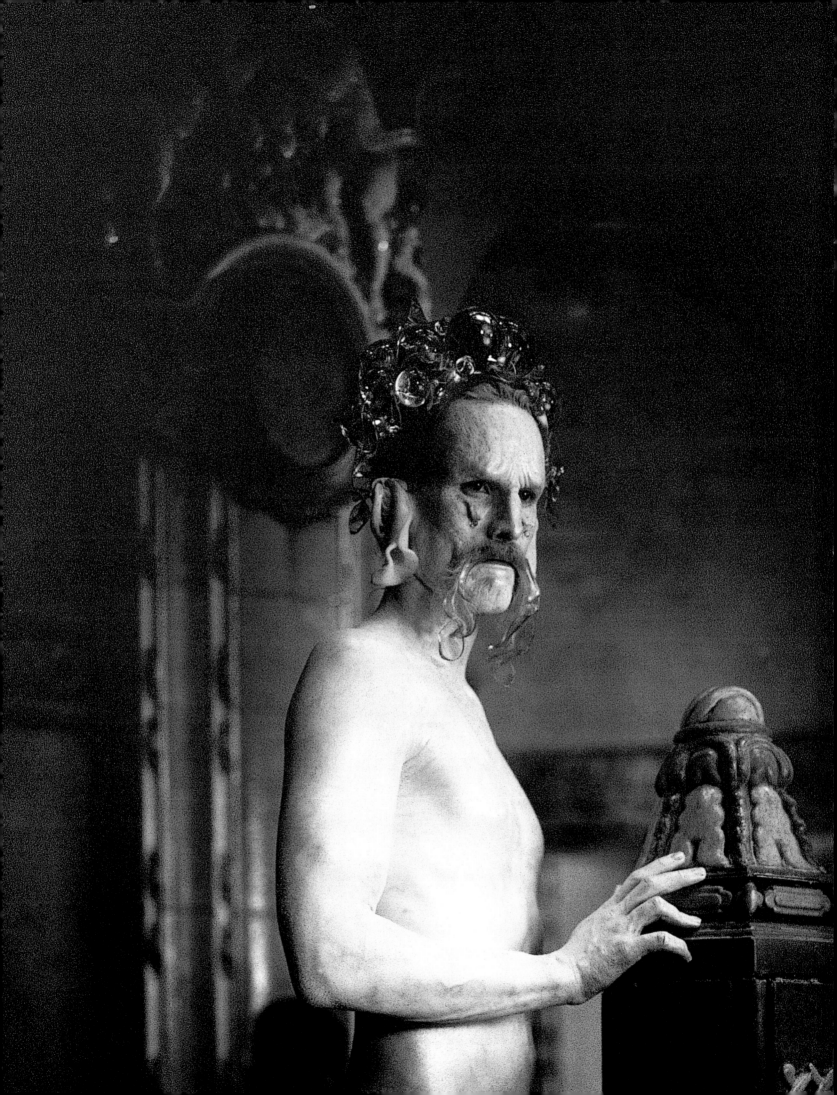

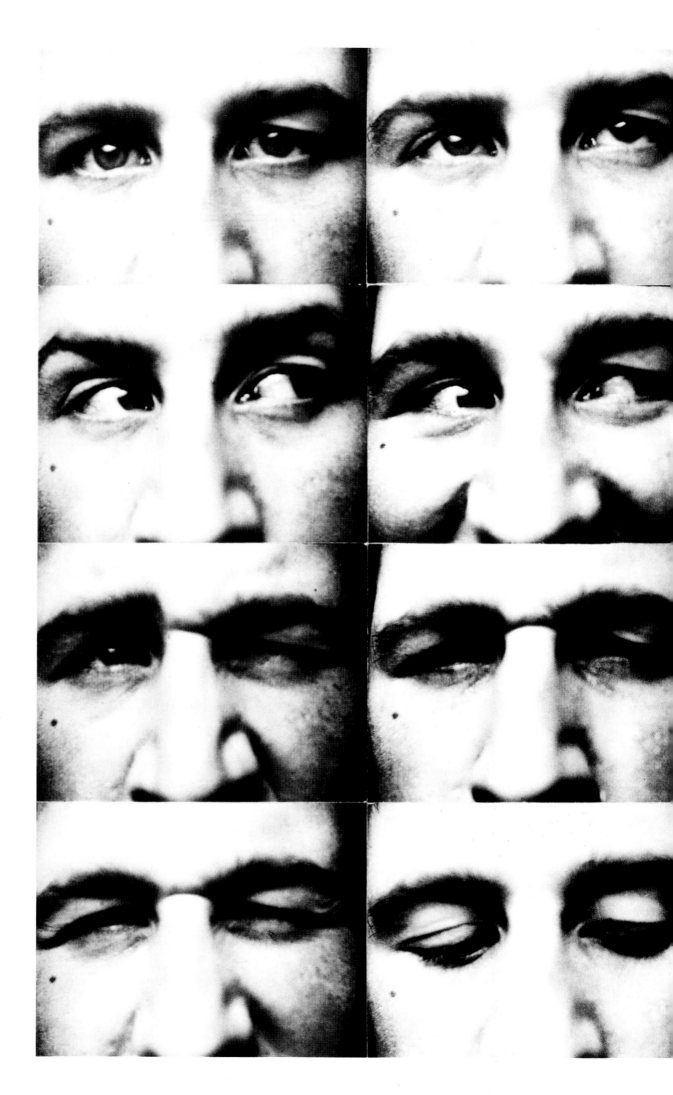

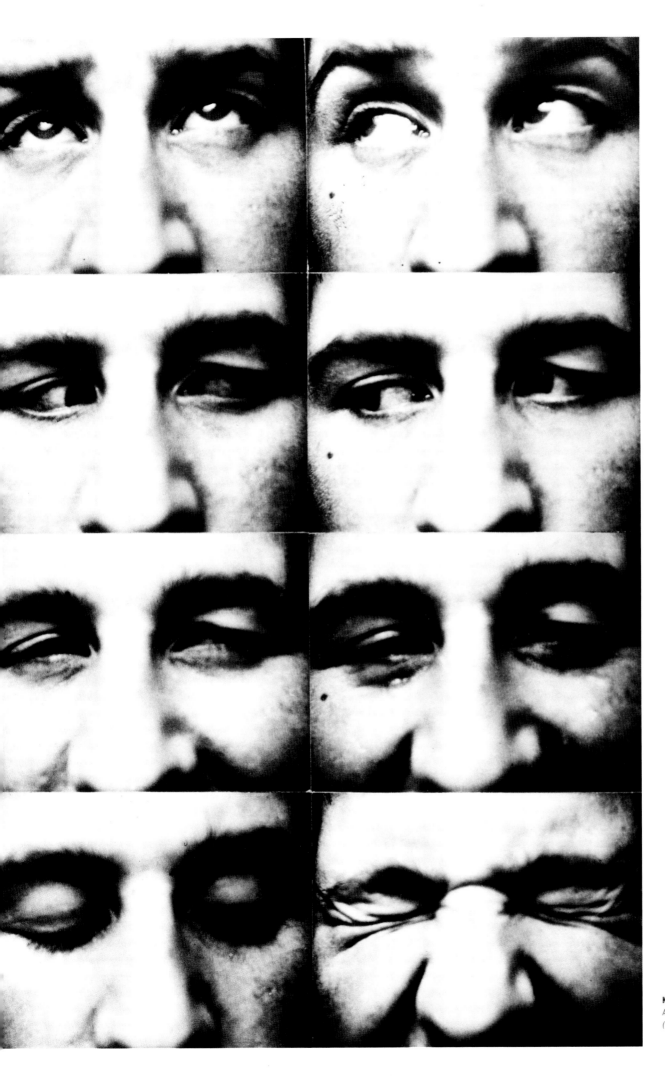

107

KURT KRANTZ
*AUGEN-SERIE
(SERIES OF EYES), 1930–1931.*

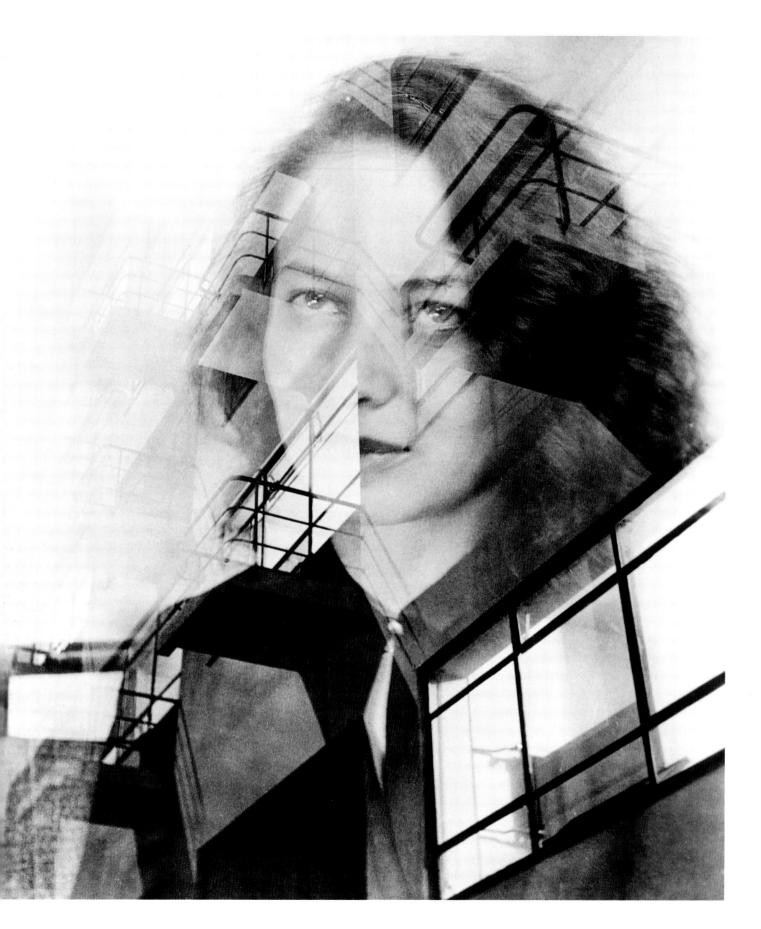

LOTTE BEESSE
PORTRAIT OF OTTI BERGER AND ATELIER, 1930.
FACING PAGE:
HELMUT NEWTON
RAINER WERNER FASSBINDER, MUNICH, 1980.

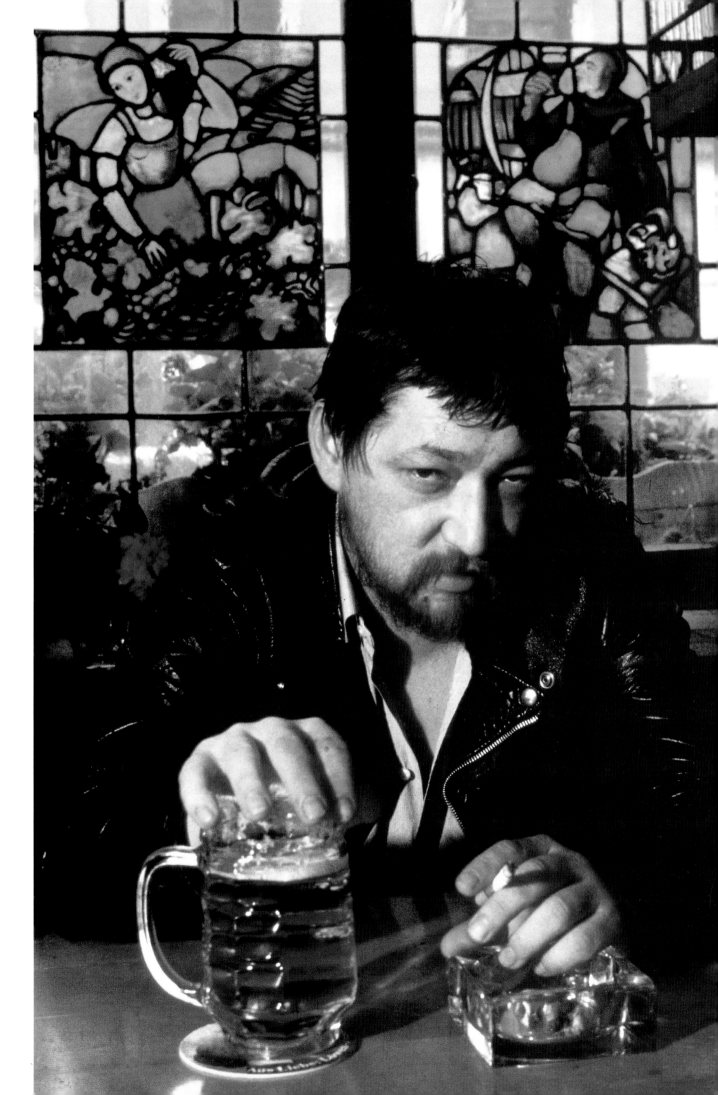

STEFAN WAGNER
*DIE ESSAYISTIN SUSAN SONTAG
(THE WRITER SUSAN SONTAG)*, MUNICH 1978.
FACING PAGE:
ALEXANDRE LEBNIKOV
PORTRAIT FOR A PERFUME, 1928.

110

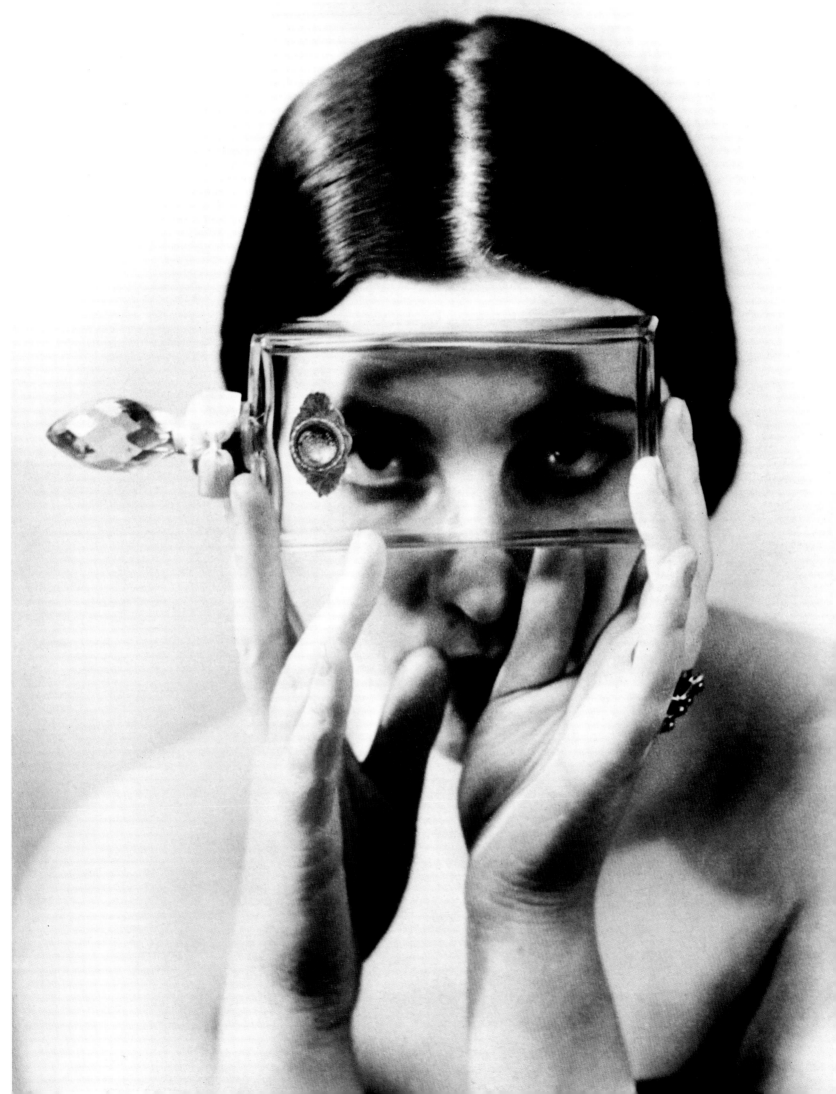

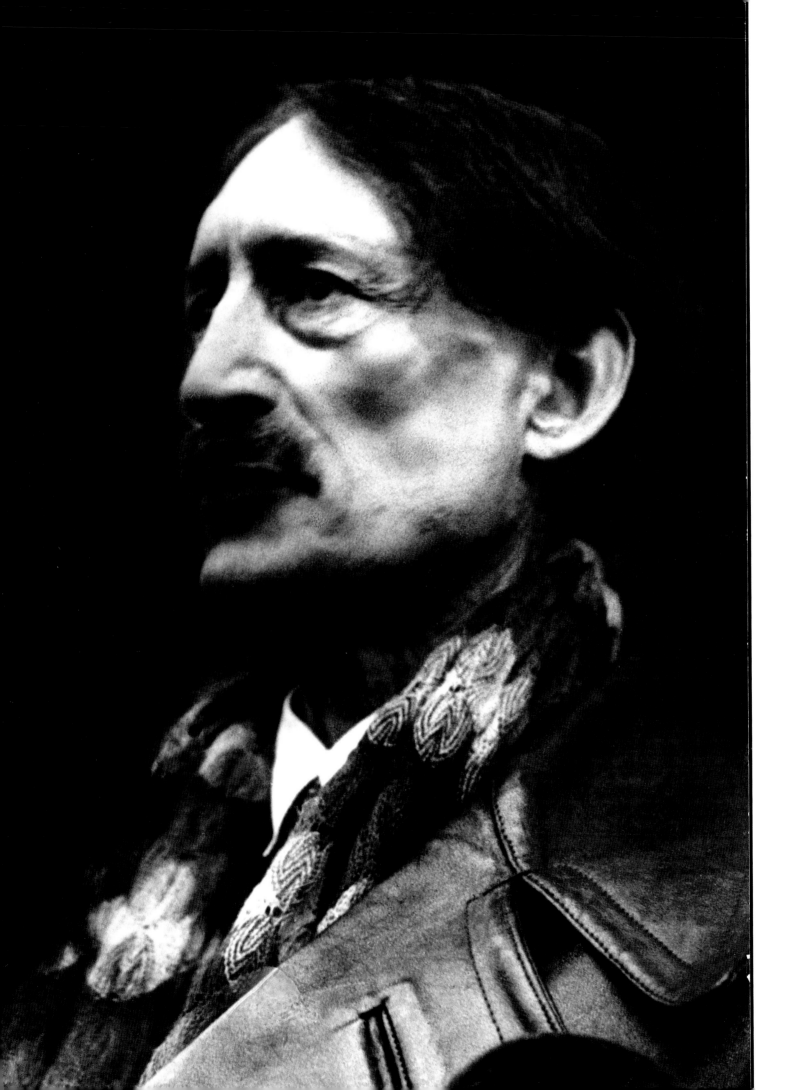

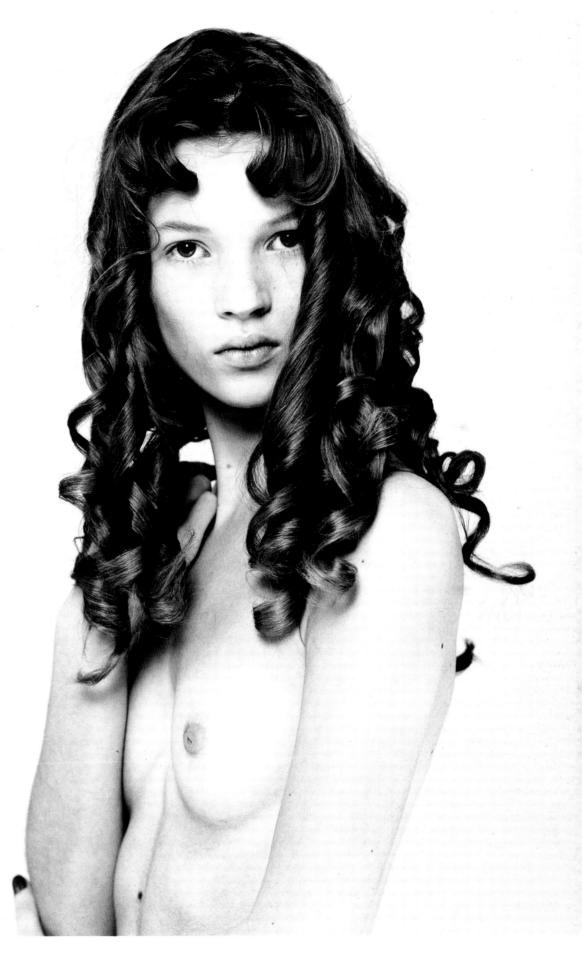

114

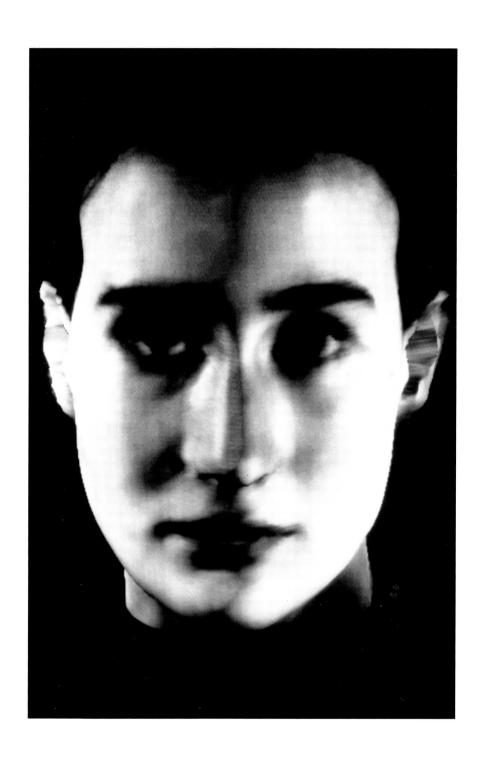

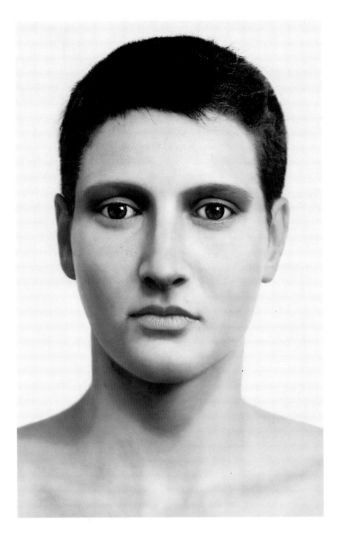

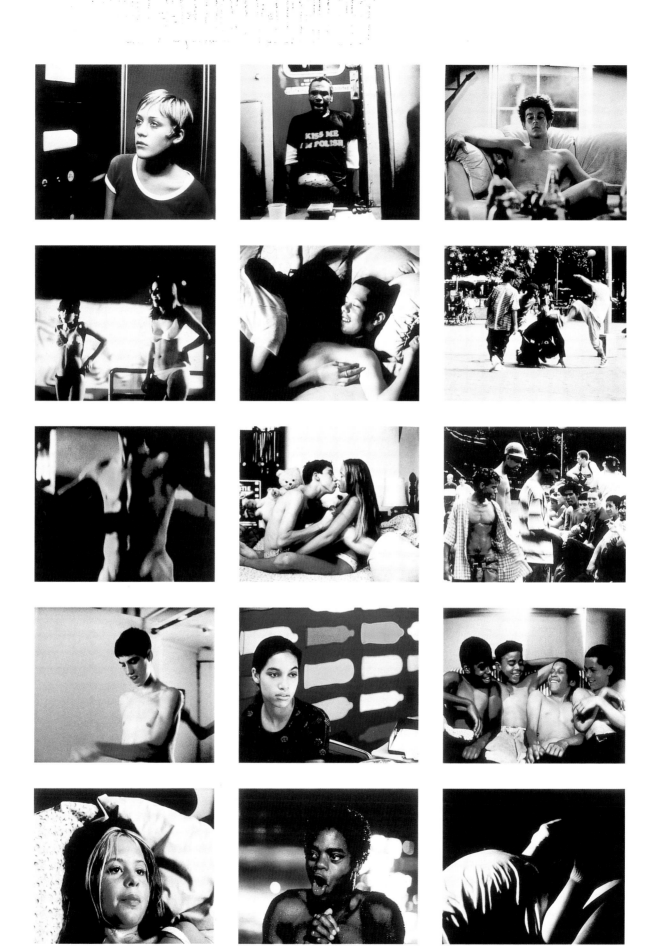

LARRY CLARK *UNTITLED*, 1995.
FACING PAGE: **NICK KNIGHT** *CARLOS LAUGHING*, 1988.

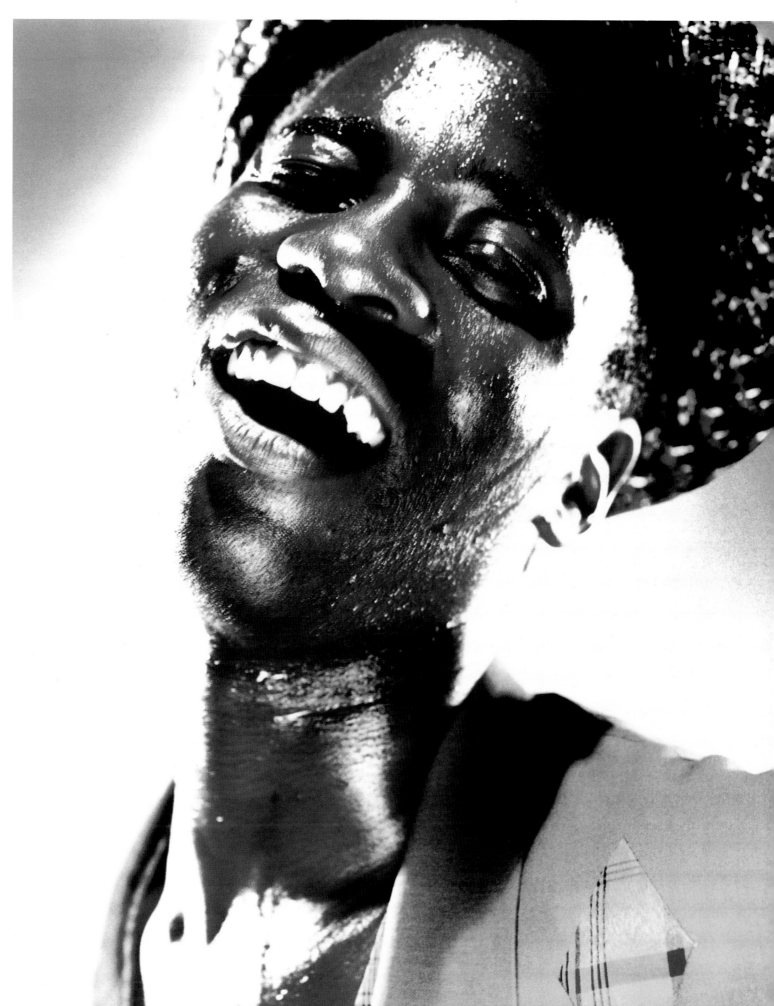

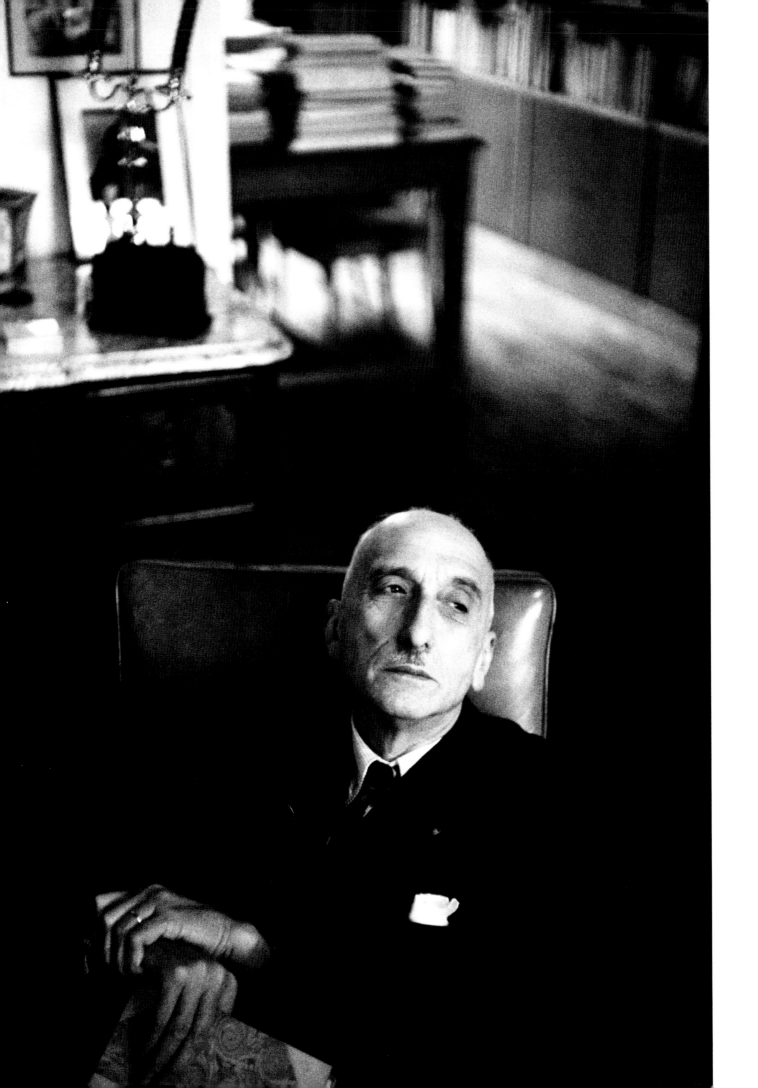

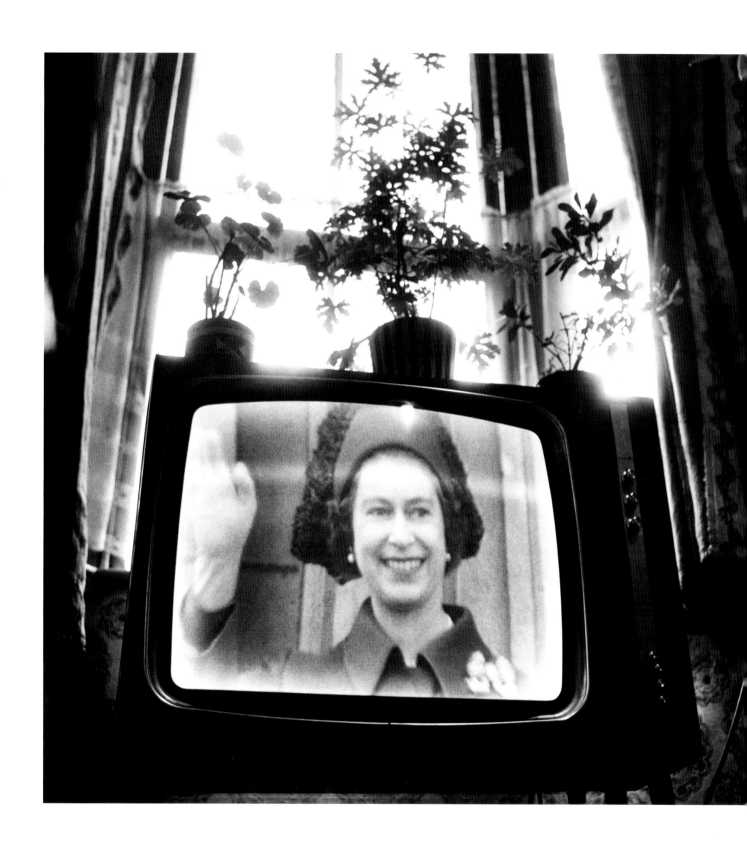

MARTIN PARR
PRINCESS ANNE'S WEDDING,
FROM THE EXHIBITION *HOME SWEET HOME*, ENGLAND, 1974.
FACING PAGE:
HENRI CARTIER-BRESSON
FRANÇOIS MAURIAC, 1952.

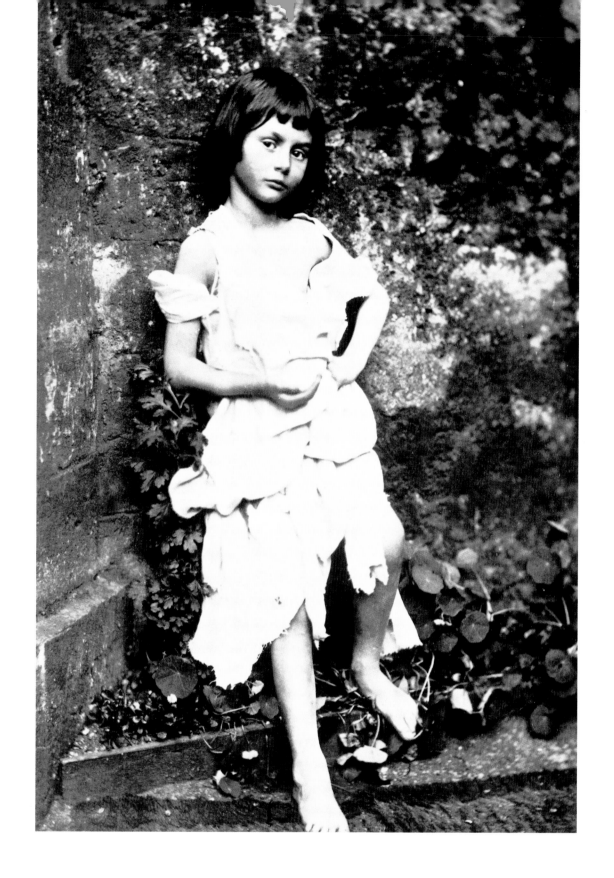

120

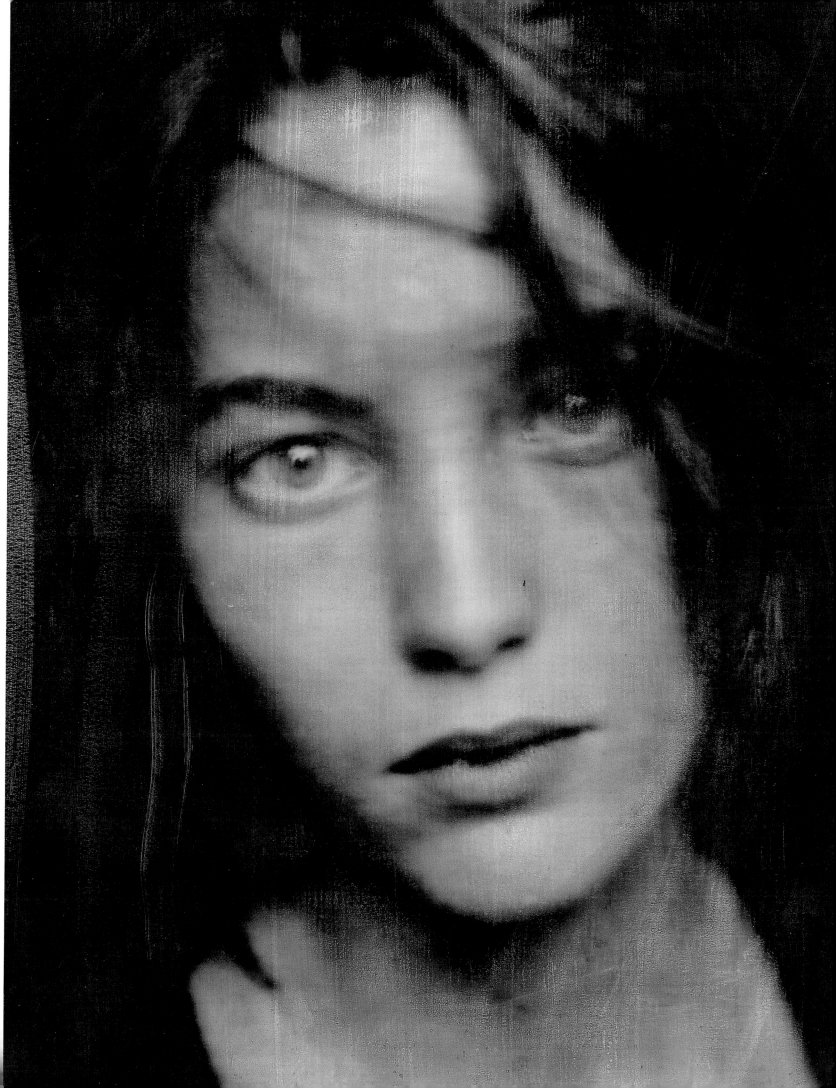

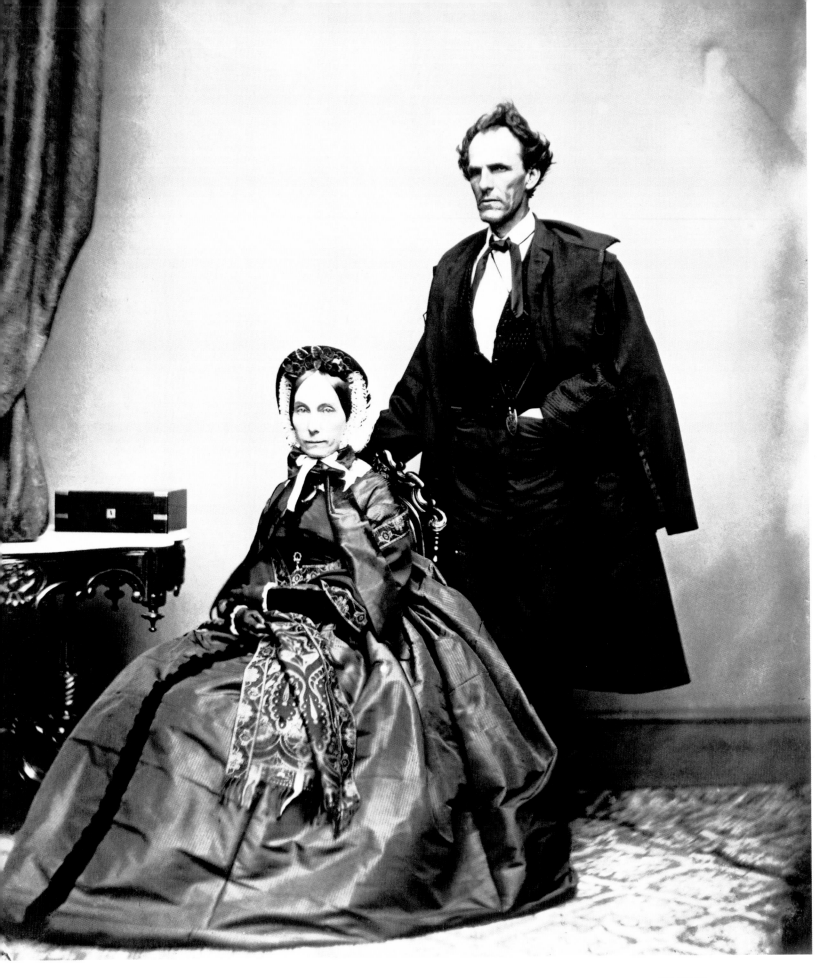

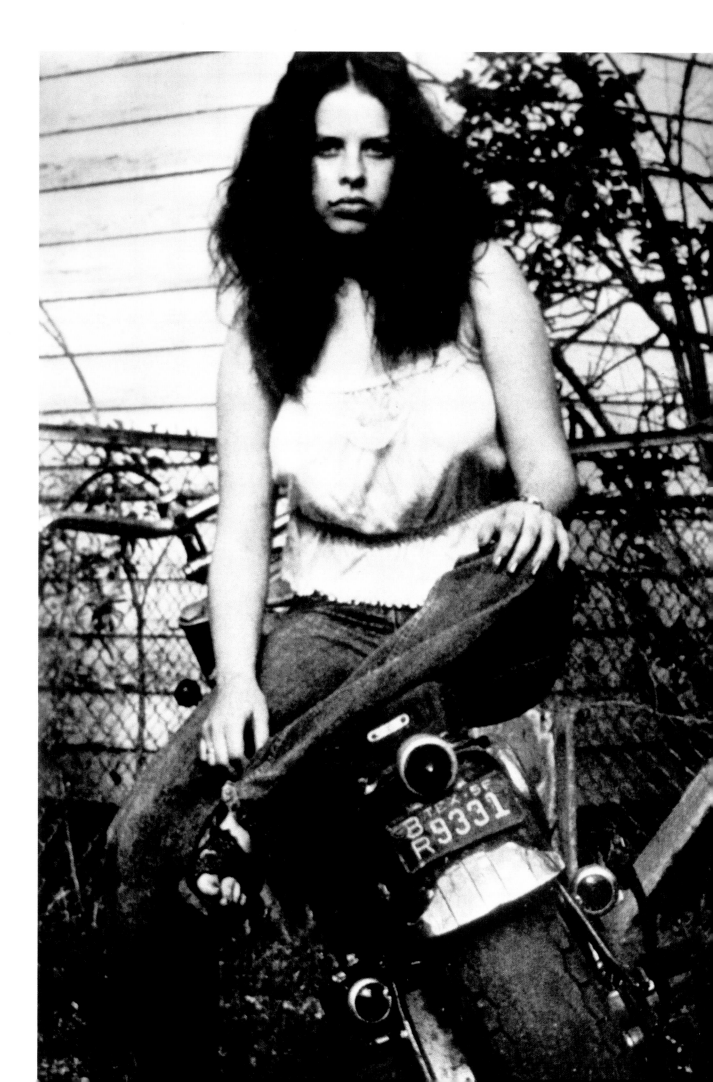

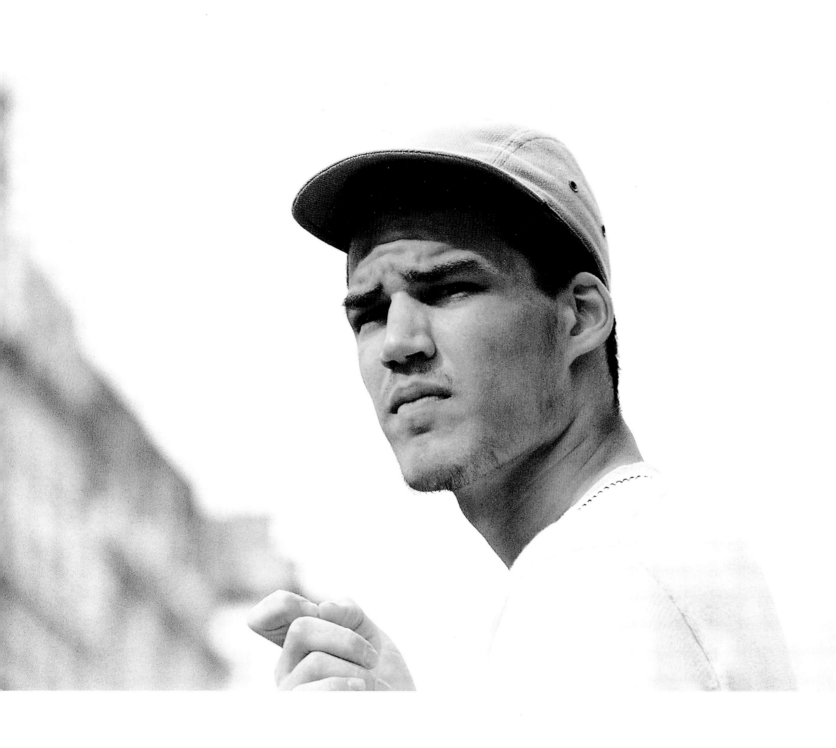

DIETER APPELT
TRACE DU SOUVENIR (TRACE OF THE MEMORY), 1979.
FACING PAGE:
JEAN-BAPTISTE HUYNH
GEORGES DUBY,
FROM THE SERIES *LES IMMORTELS (THE IMMORTALS)*, 1997.

ESKO MÄNNIKKÖ
KHUMO, 1994.
FACING PAGE:
VIK MUNIZ
CHUCK, 2001.

PIERRE ET GILLES
LA MADONE AU CŒUR BLESSÉ. LIO
(THE MADONNA WITH WOUNDED HEART. LIO), 1991.
FACING PAGE:
SAM LEVIN
GINA LOLLOBRIGIDA, 1952.

132

DAVID BUCKLAND
THE MARRIAGE OF ARNOLFINI, 1986.
FACING PAGE:
NATACHA LESUEUR
UNTITLED, 2002.

YASUMASA MORIMURA
TO MY LITTLE SISTER: FOR CINDY SHERMAN, 1998.
FACING PAGE:
ROGI ANDRÉ
PABLO PICASSO, 1936.

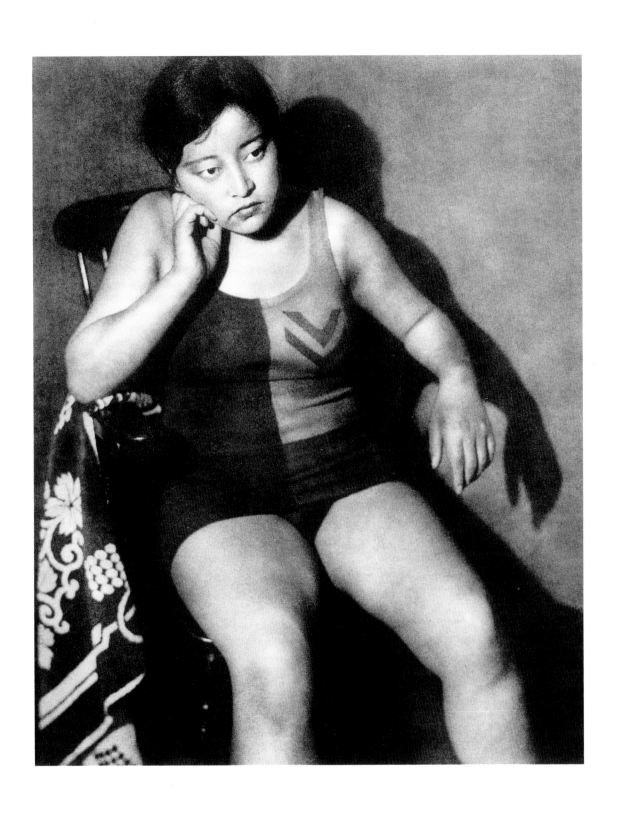

YASUZO NOJIMA
WOMAN, MODEL F, 1931.
FACING PAGE:
ELFRIEDE REICHELT
KANDINSKY, C. 1910.

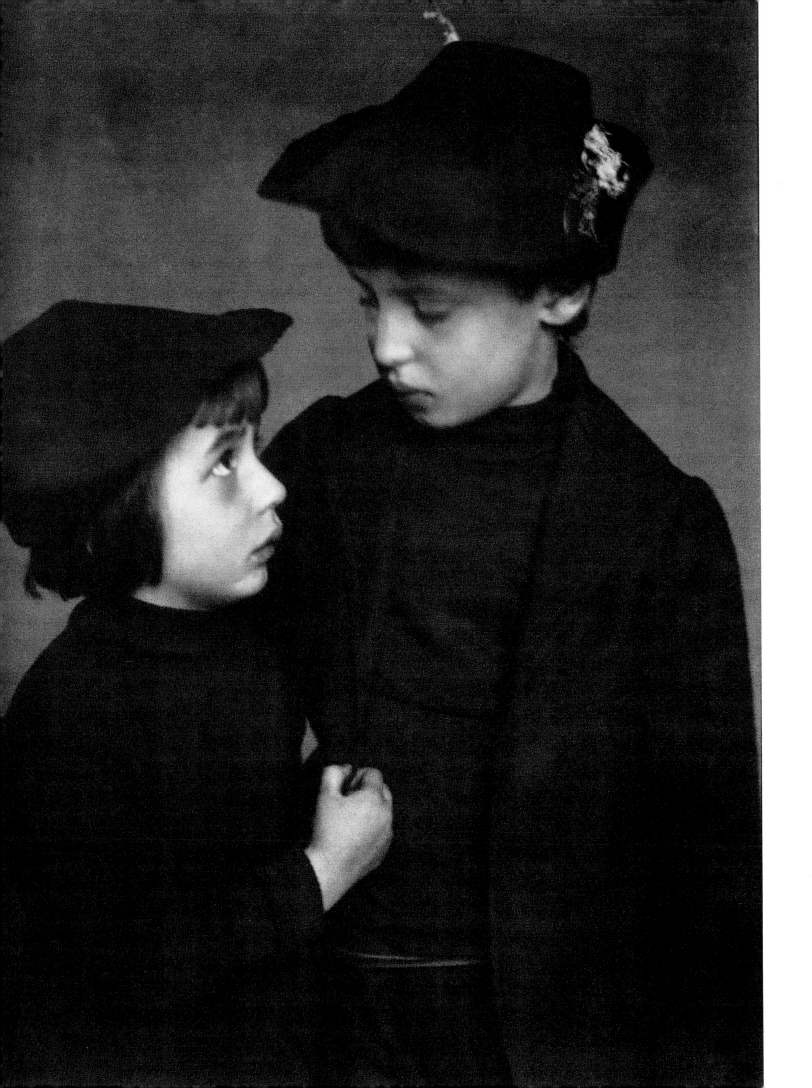

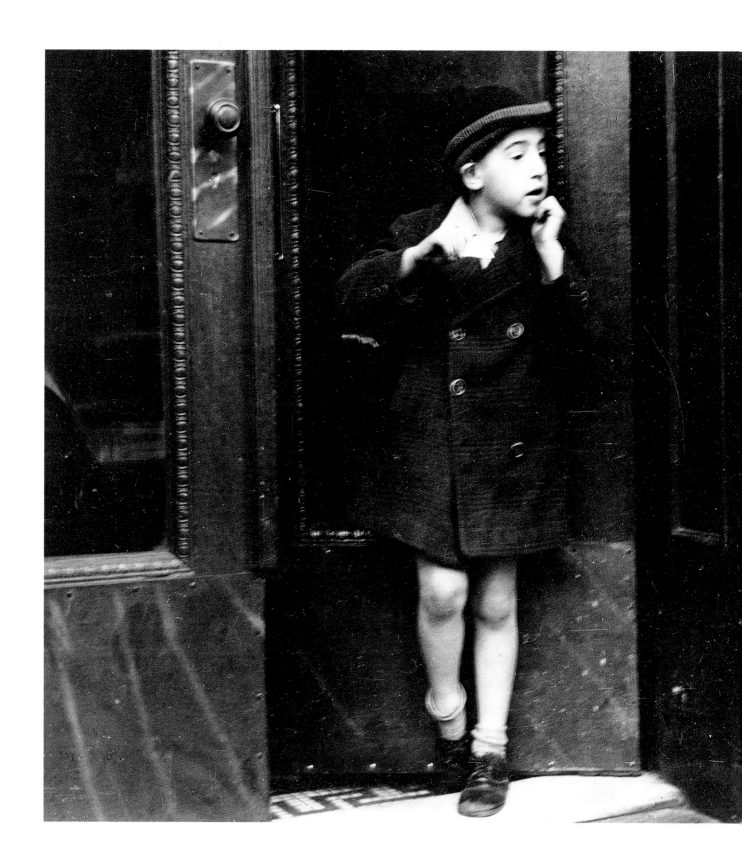

HELEN LEVITT
NEW YORK, BOY IN DOORWAY, 1938.
FACING PAGE:
HEINRICH KÜHN
HANS UND LOTTE, C. 1914.

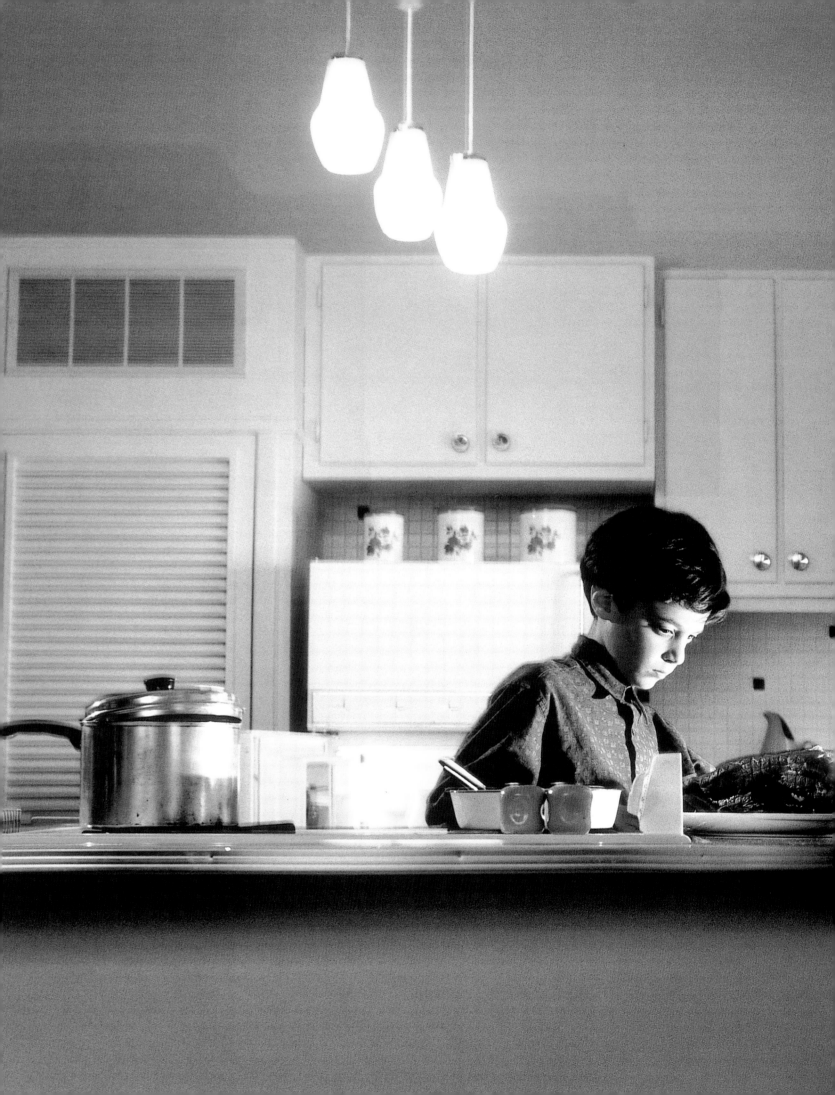

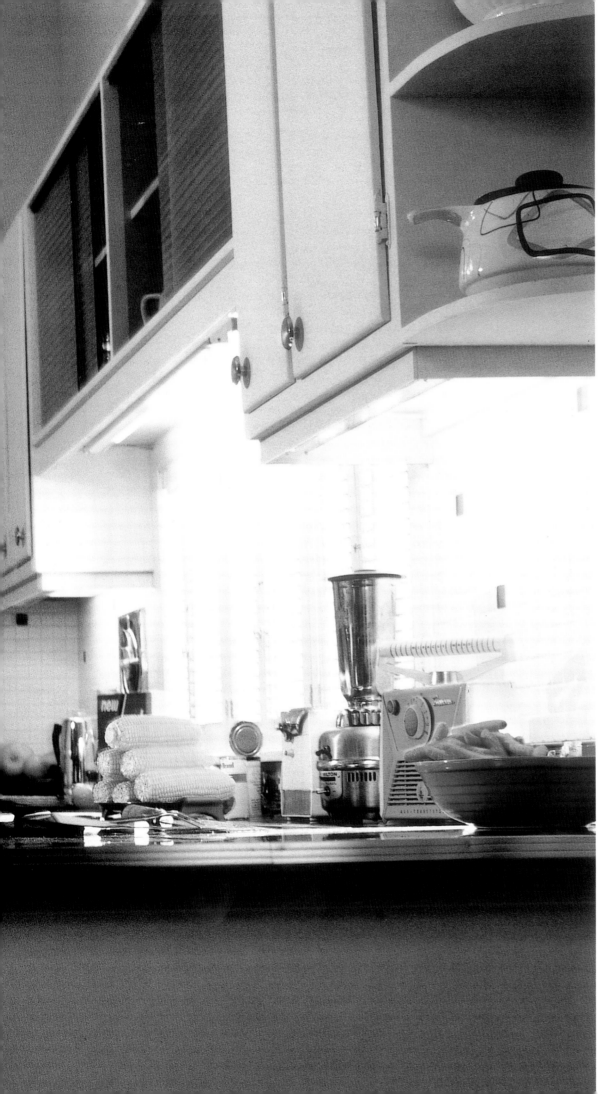

PHILIP-LORCA DICORCIA
BRIAN, 1988.

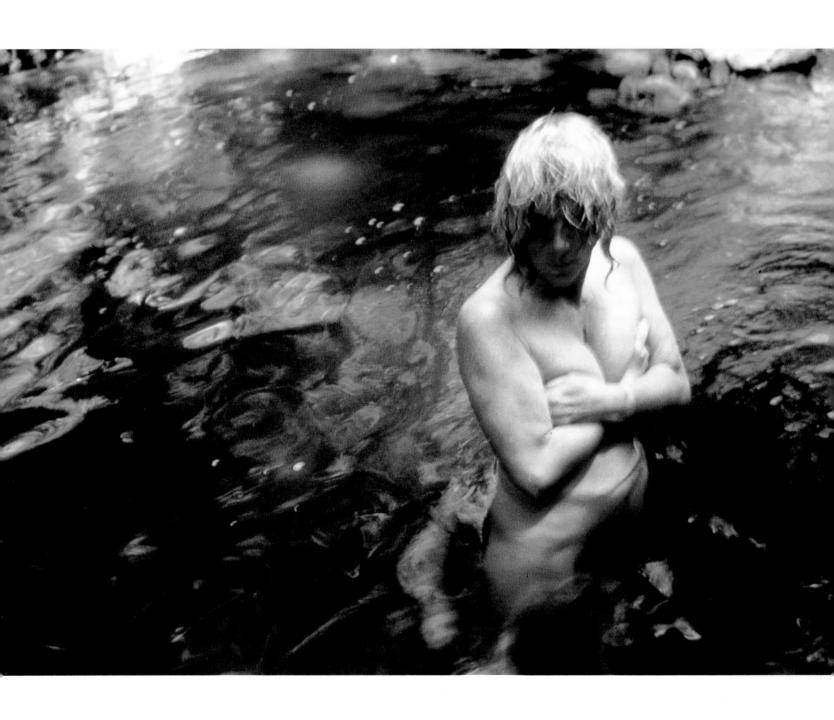

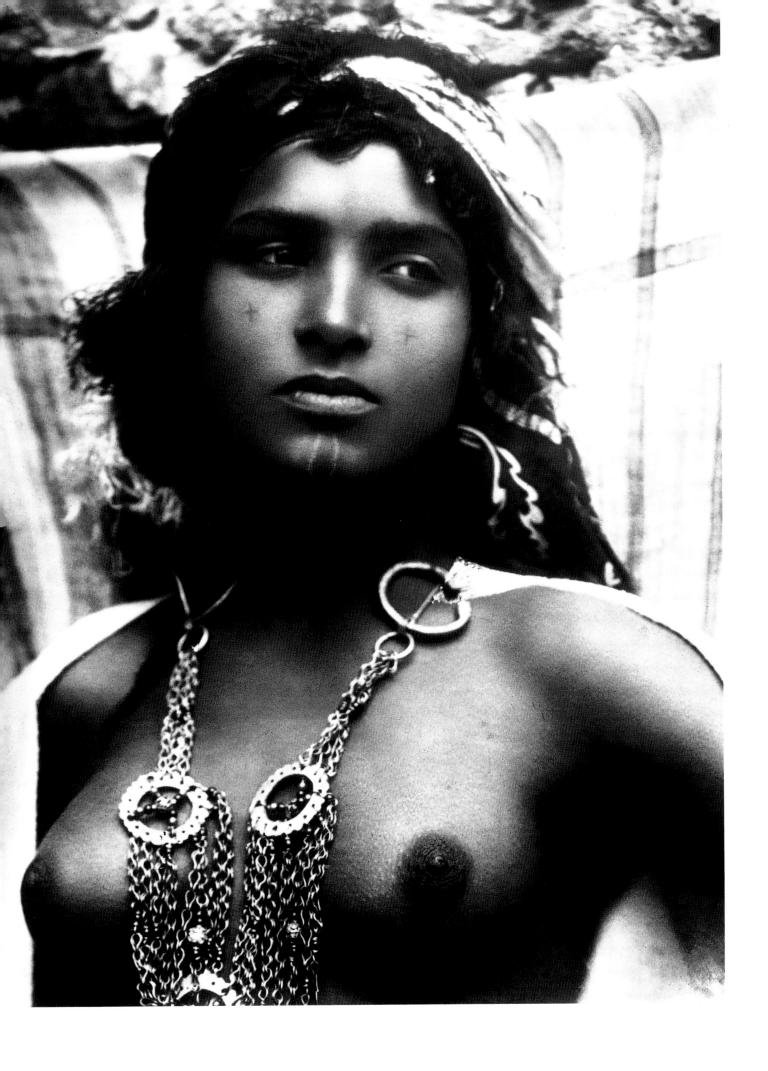

PATRICK FAIGENBAUM
À L'UNIVERSITÉ (AT UNIVERSITY), BRÊME, 1997.
FACING PAGE:
LEHNERT AND LANDROCK
FATHMA, DE LA TRIBU DES OULED NAIL
(FATHMA, OF THE OULED NAIL TRIBE), C. 1900.

rait of the man who looks like Édouard Manet on the anniversary of his death 30 april 1883

duane michals 7/25

DUANE MICHALS
PORTRAIT OF THE MAN WHO LOOKS LIKE EDOUARD MANET
ON THE ANNIVERSARY OF HIS DEATH, *30 APRIL 1883*.
FACING PAGE:
ANDERS PETERSEN
CAFÉ LEHMITZ, HAMBURG, 1970.

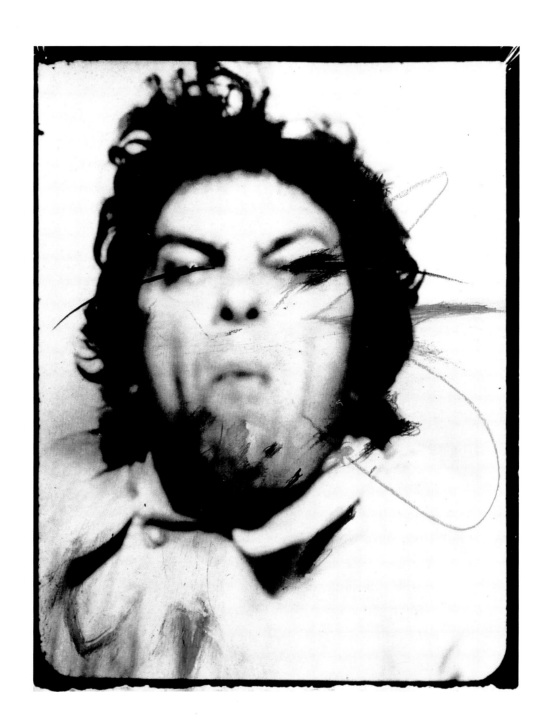

148

ARNULF RAINER
FACE FARCES, 1969.
FACING PAGE: **LISETTE MODEL**
WOMAN WITH A VEIL, 1947.
FOLLOWING PAGES:
LEFT: **LISELOTTE BRANDT-WINKLE**
PORTRAIT, 1937–1938.
RIGHT: **SACHA VAN DORSSEN**
PIERRE MENDÈS FRANCE, 1967.

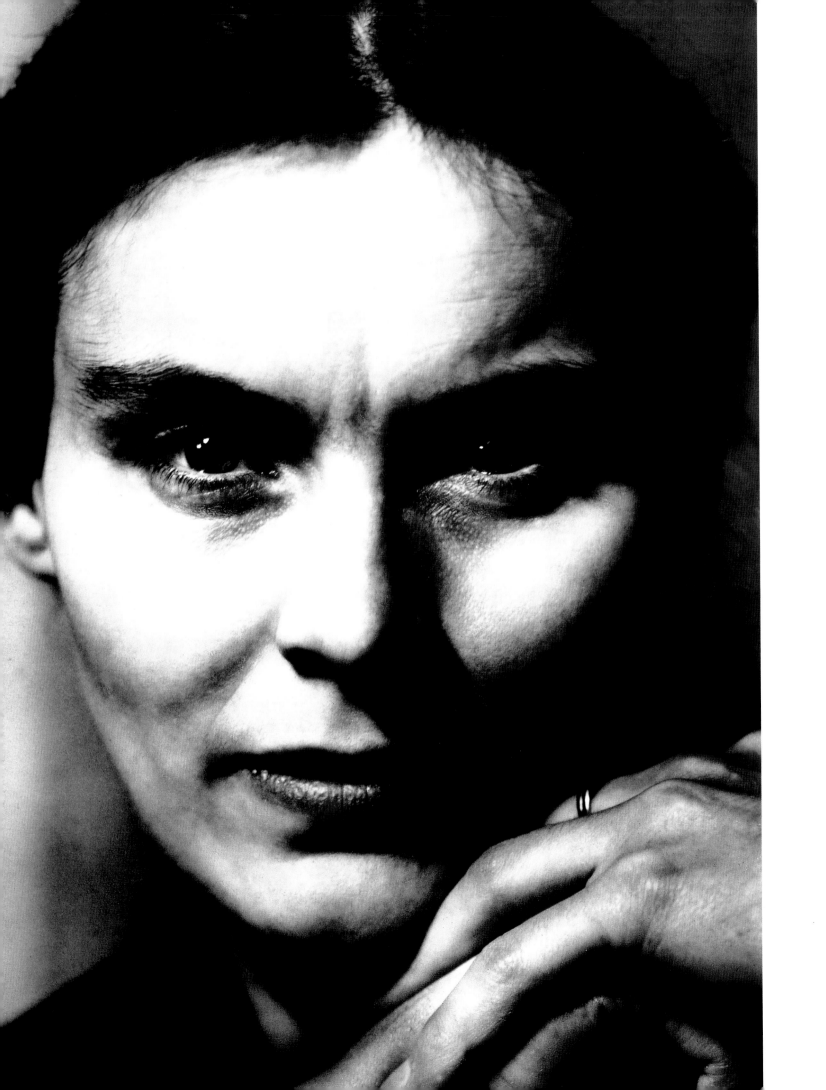

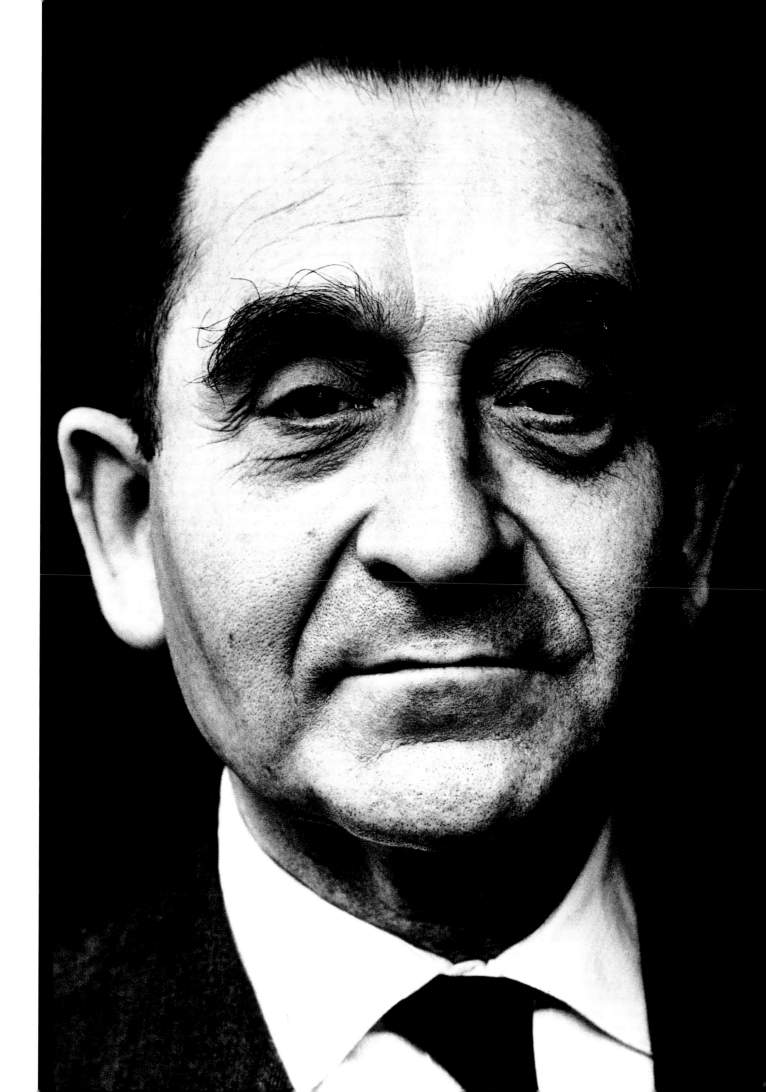

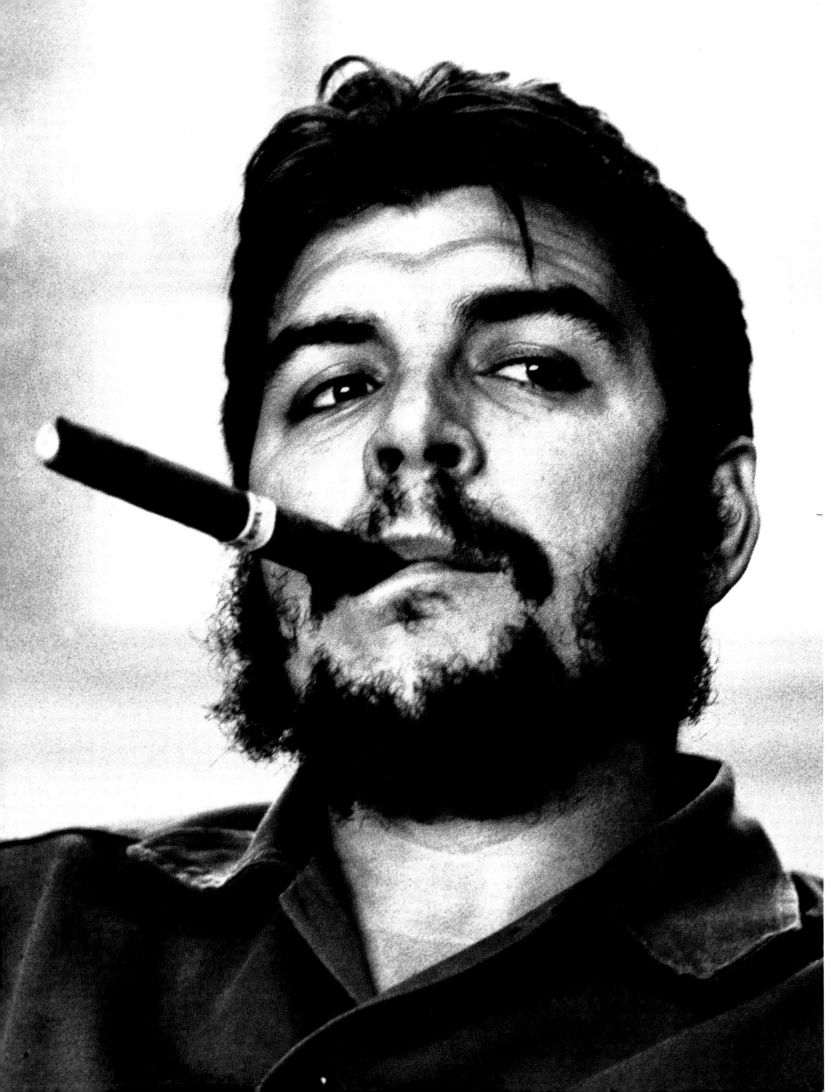

155

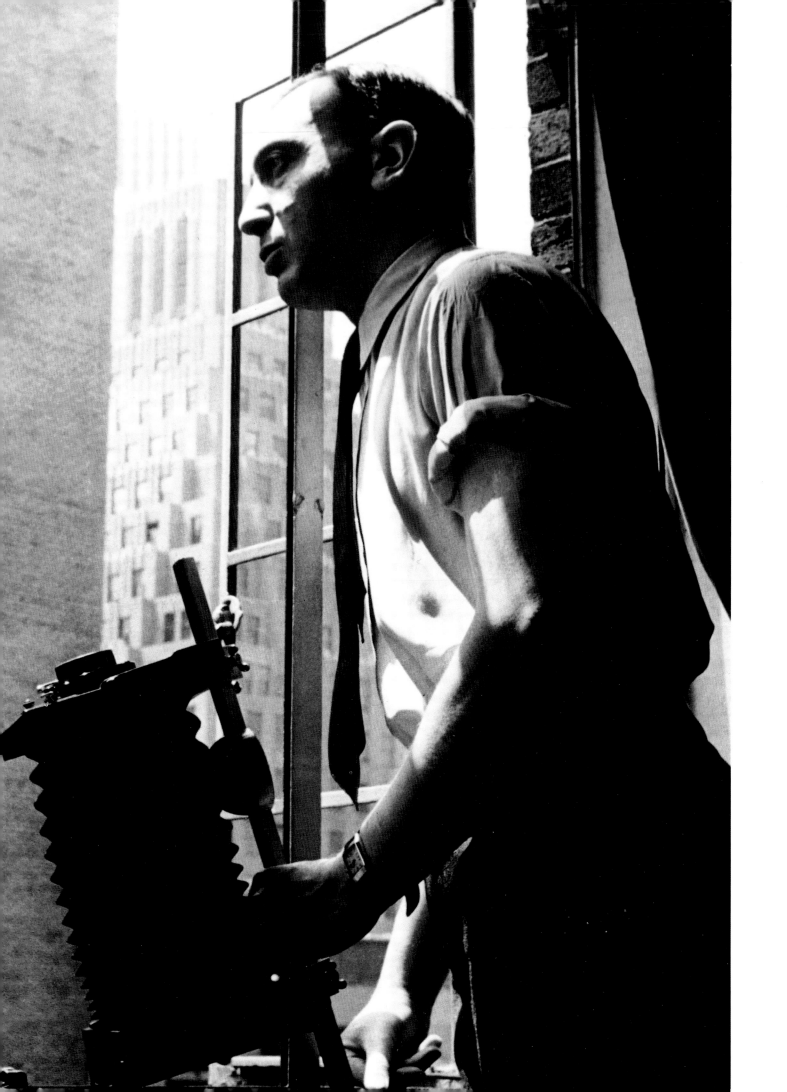

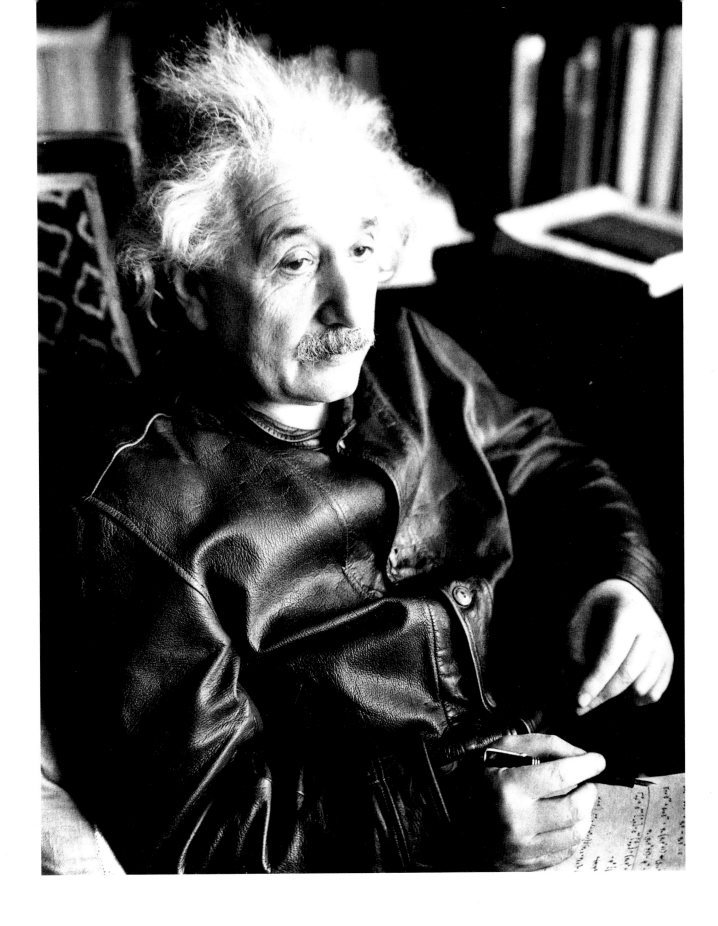

LOTTE JACOBI
ALBERT EINSTEIN IN LEATHER JACKET, PRINCETON, NEW JERSEY, 1938.
FACING PAGE: **ANDRÉ KERTÉSZ**
SELF-PORTRAIT AT THE HOTEL BEAUX-ARTS, 1936.
FOLLOWING PAGES:
LEFT: **DAVID SEIDNER**
SELF-PORTRAIT, 1992.
RIGHT: **IRVING PENN**
DÉCOLLETÉ CHRISTIAN DIOR, 1950.

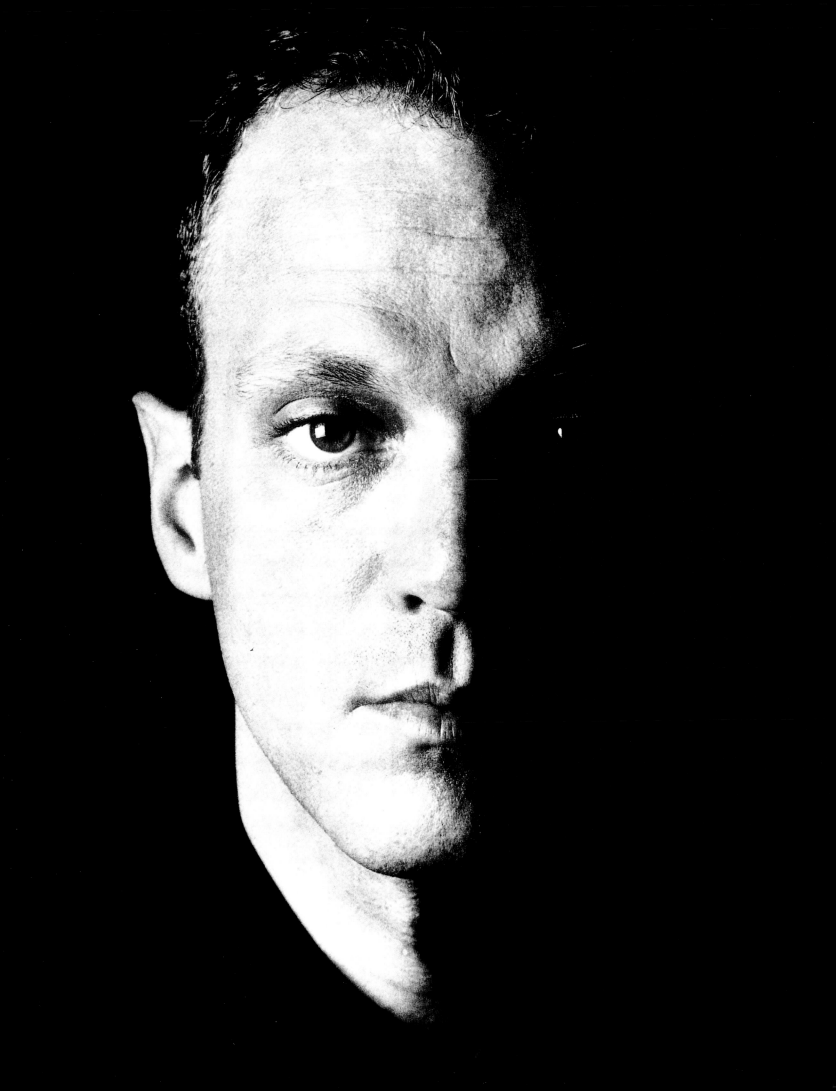

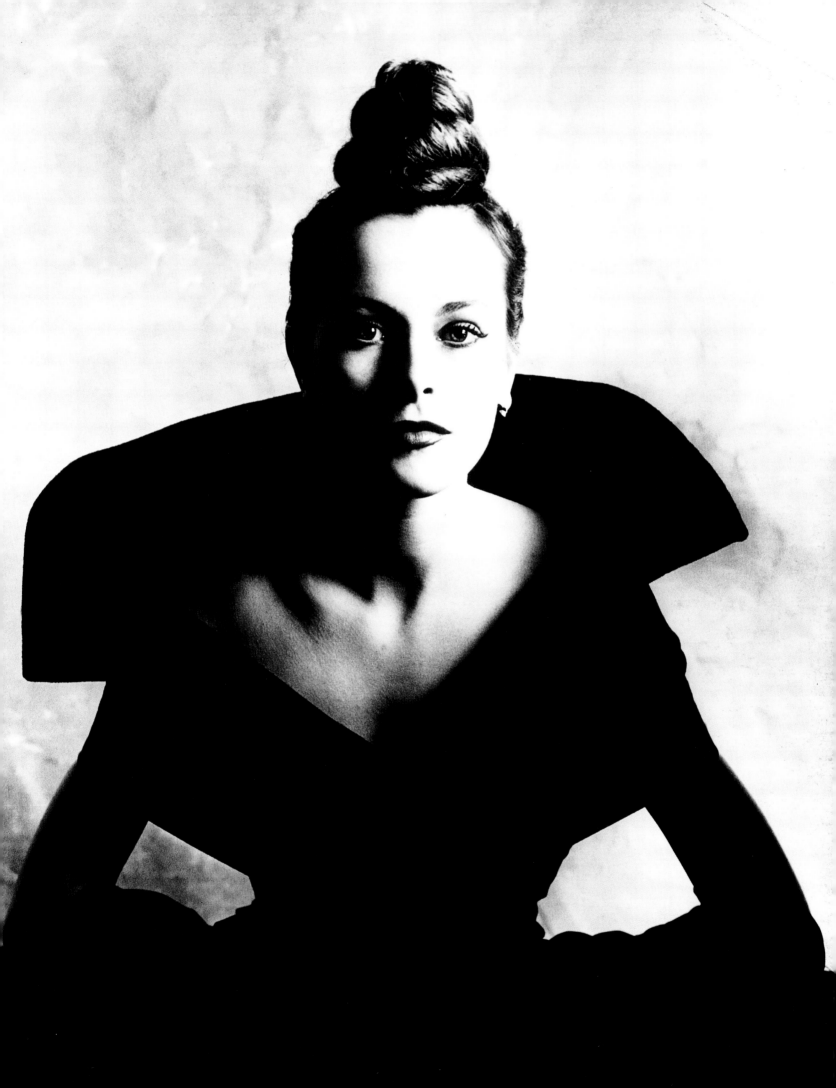

PETER HUJAR
NICHOLAS ABDALLAH, MOUFFAREGE, 1980.
FACING PAGE: **CECIL BEATON**
EDITH SITWELL, 1962.
FOLLOWING PAGES:
LEFT: **NICK KNIGHT**
STEPHEN JONES MILLINER, LONDON, 1985.
RIGHT: **GEORGE PLATT-LYNES**
DALI, NUDE AND LOBSTER, 1939.

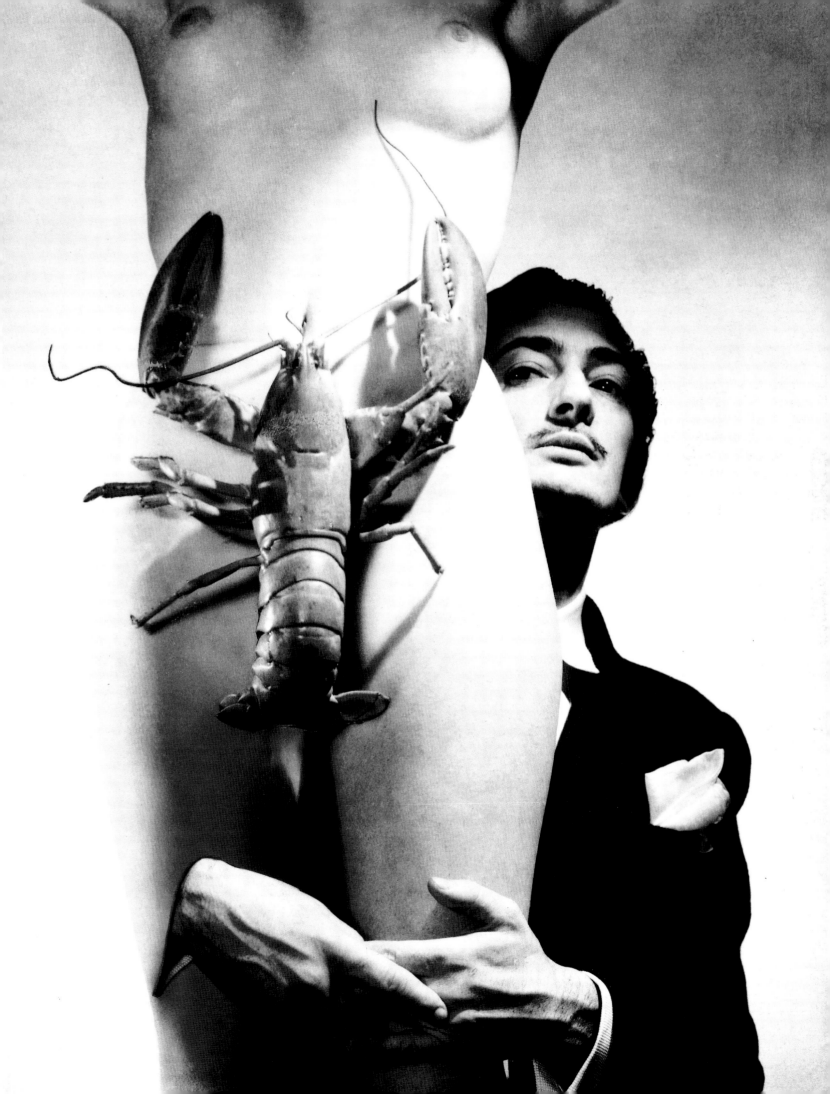

ERIC RONDEPIERRE
STARRING 1 (ANNONCES FILM), 1993.
FACING PAGE:
CLARENCE JOHN LAUGHLIN
THE EYE THAT NEVER SLEEPS, 1941.

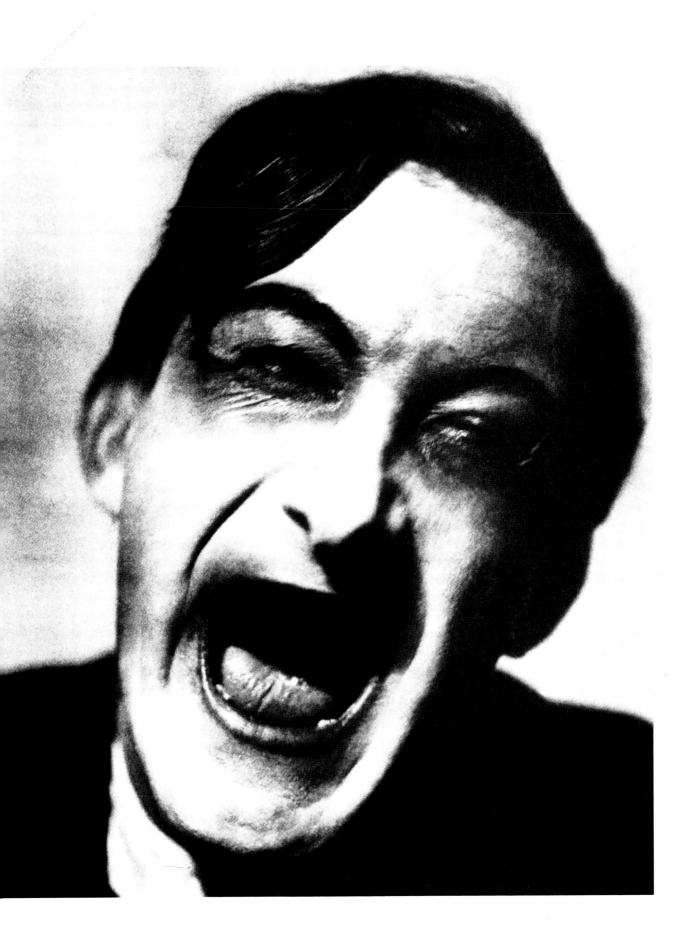

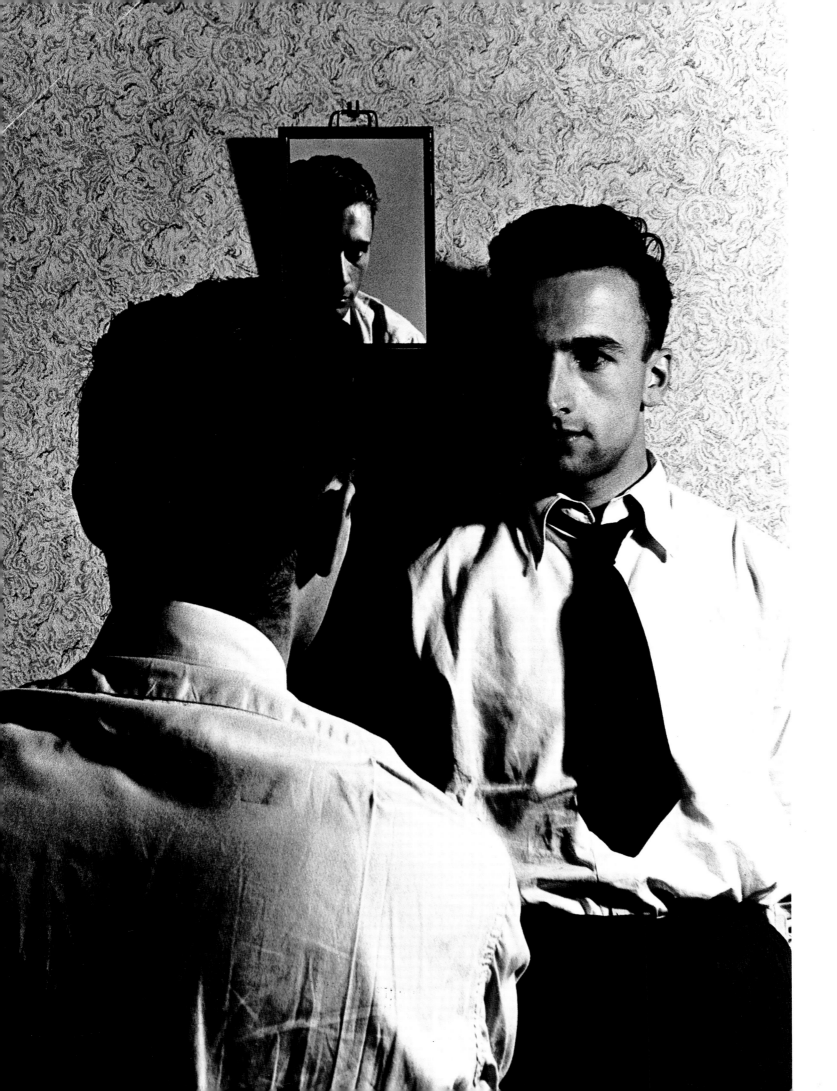

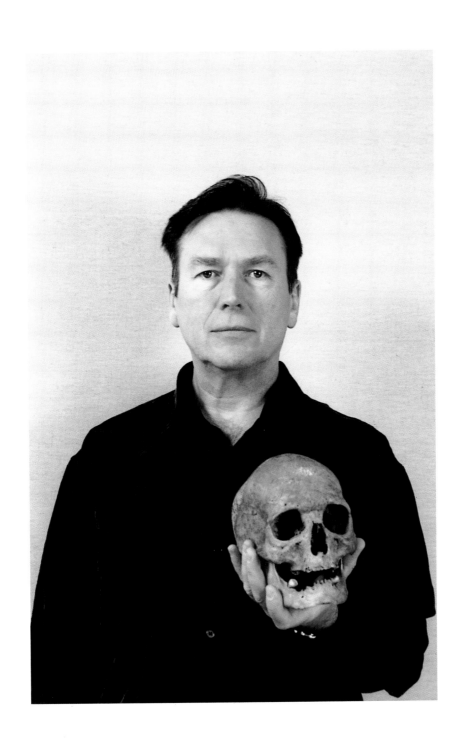

JEAN RAULT
AUTOPORTRAIT AU CRÂNE
(SELF-PORTRAIT WITH SKULL), 1997.
FACING PAGE:
LEO DOHMEN
DIALOGUE, 1957.

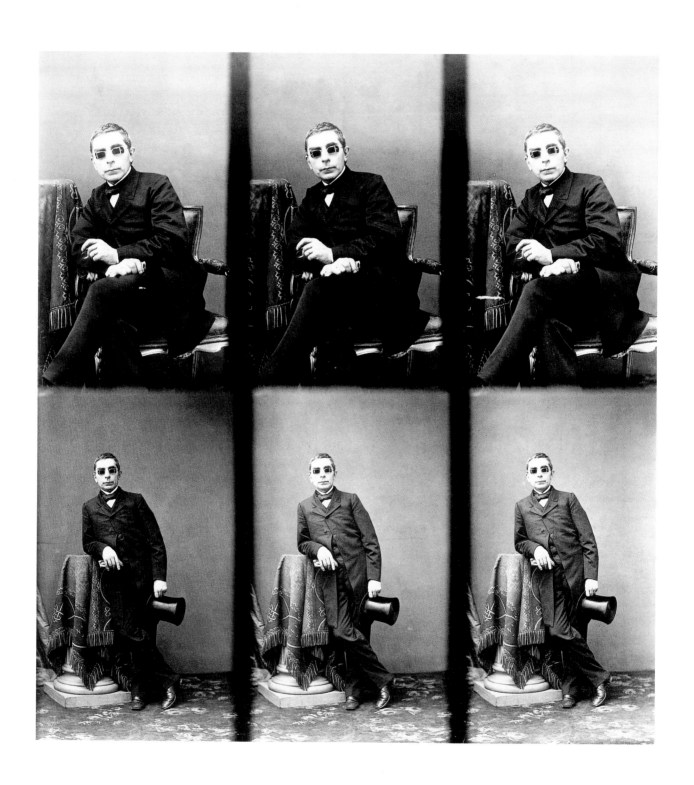

172

174

FRANTISEK DRTIKOL
ALPHONSE MUCHA, C. 1935.
FACING PAGE: **GYULA HALÁSZ (BRASSAÏ)**
MATISSE SKETCHING A NUDE, 1939.

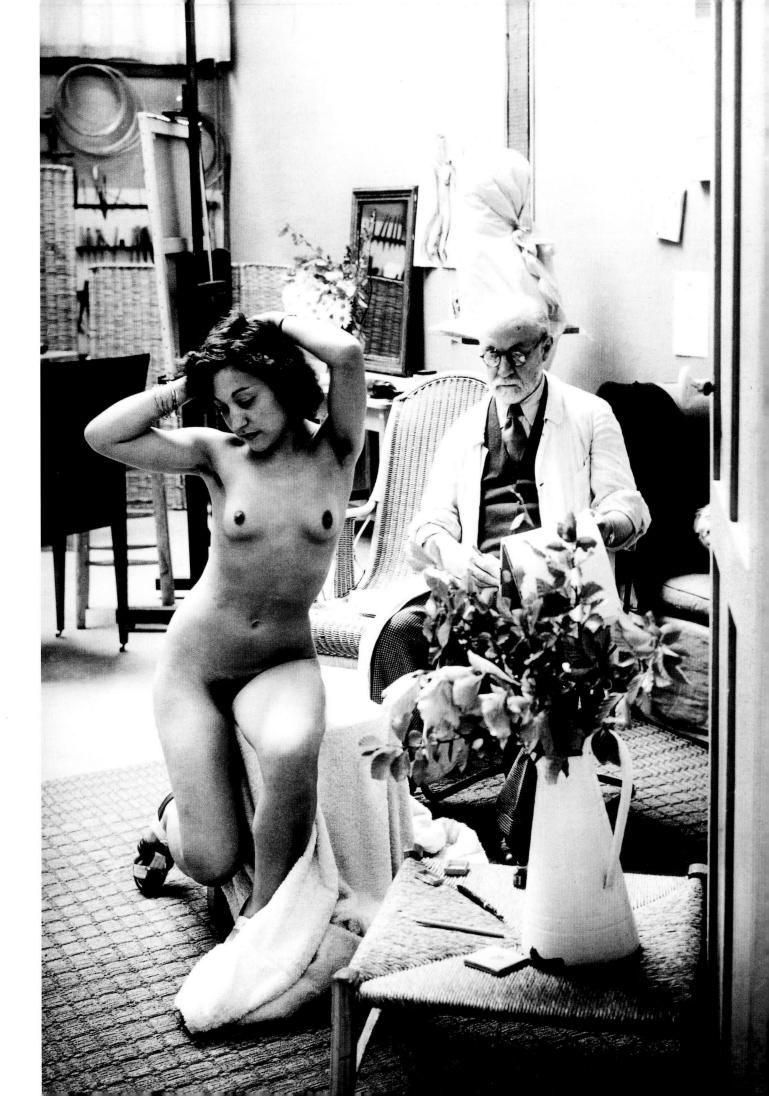

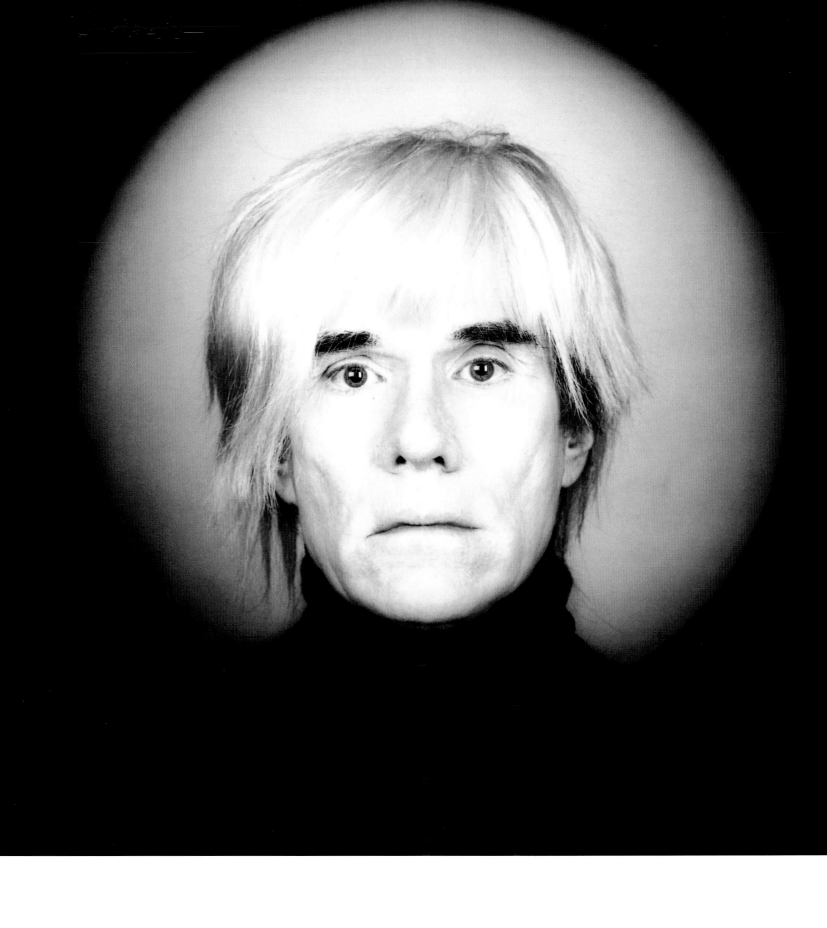

ROBERT MAPPELTHORPE
PORTRAIT OF ANDY WARHOL, 1986.
FACING PAGE: **EDOUARD BOUBAT**
GASTON BACHELARD, 1960.

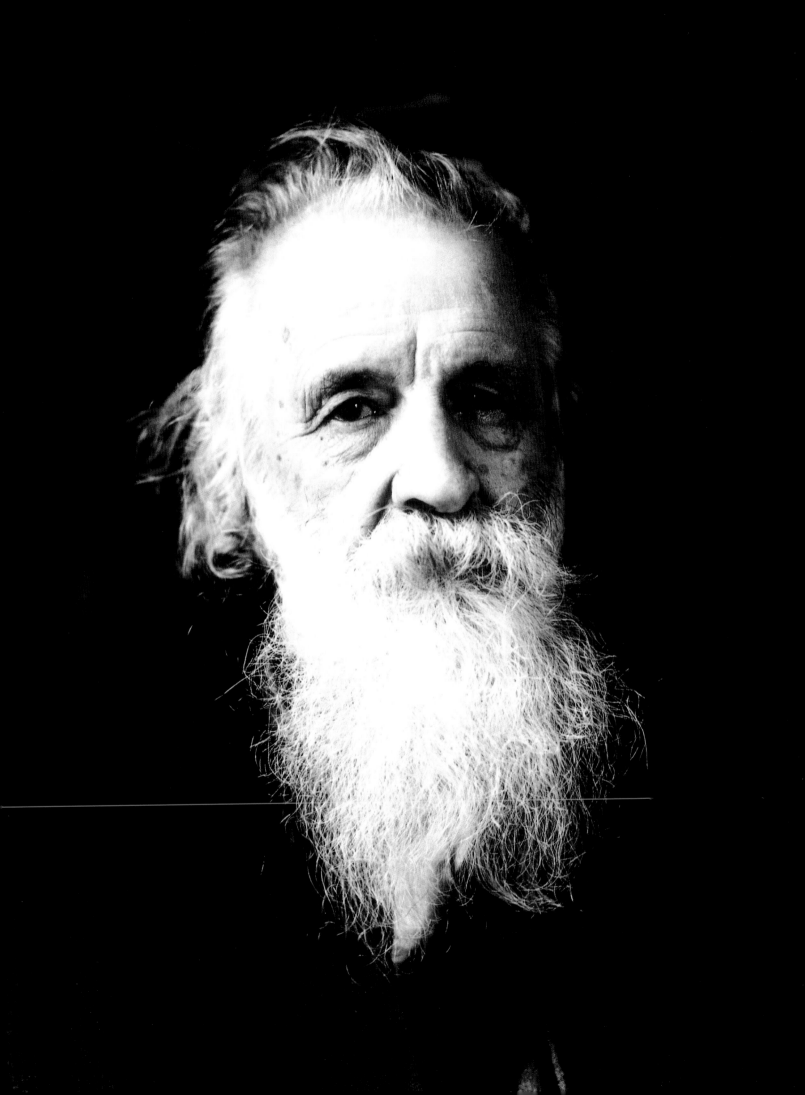

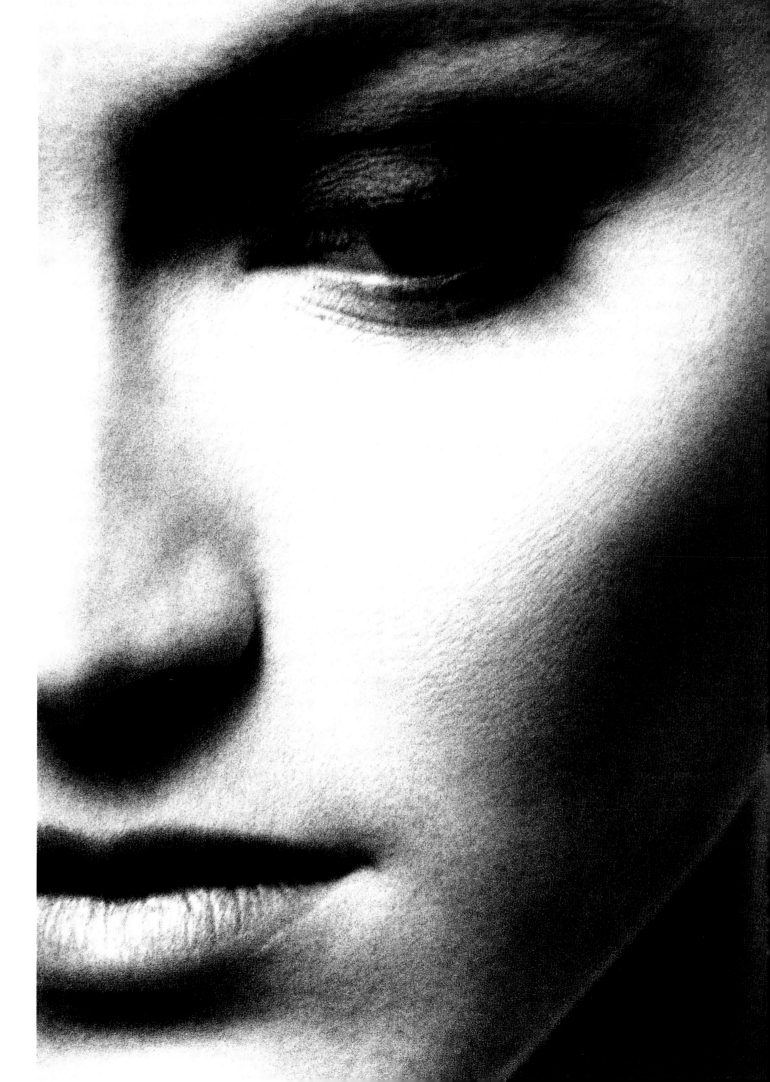

RAOUL UBAC
SOLARISED SELF-PORTRAIT, 1940.
FACING PAGE:
DOMINIQUE ISSERMAN
PORTRAIT OF ANNE ROHART, 1984.

182

CLAUDE CAHUN
SELF-PORTRAIT, C. 1927.
FACING PAGE: **LUCIA MOHOLY**
PORTRAIT OF FLORENCE HENRI, 1927.

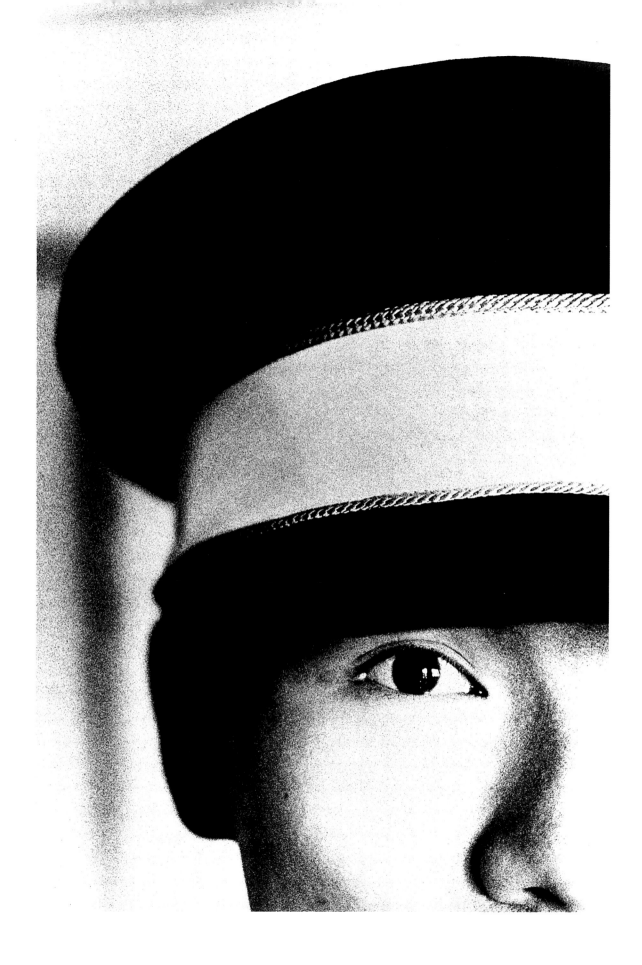

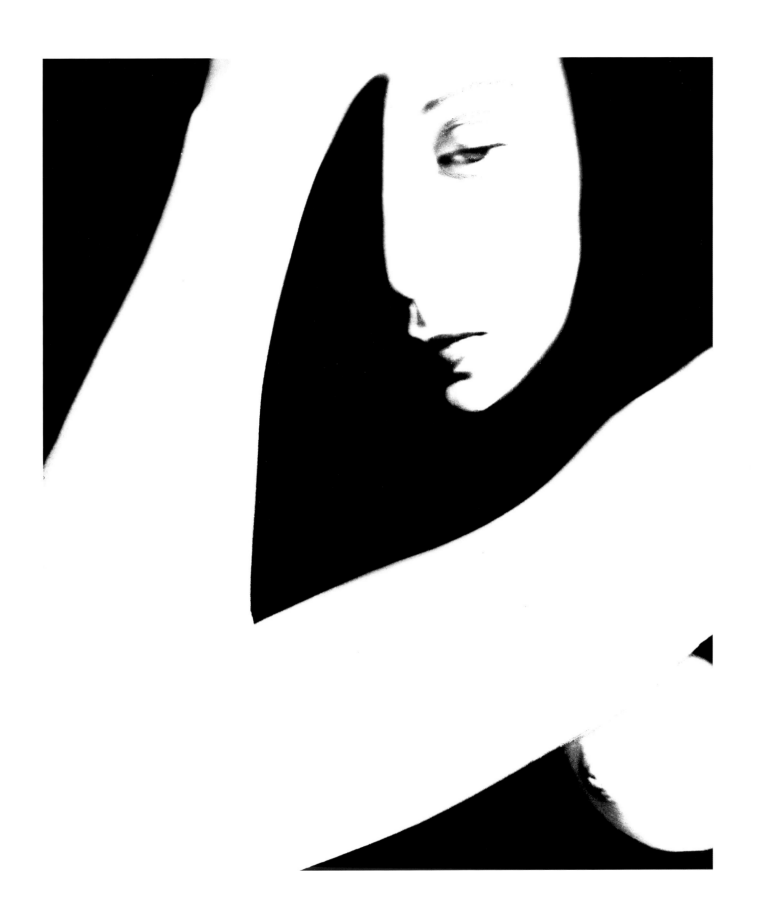

BILL BRANDT
LONDON, 1957.
FACING PAGE:
RALPH GIBSON
MAN WITH HAT, 1983.

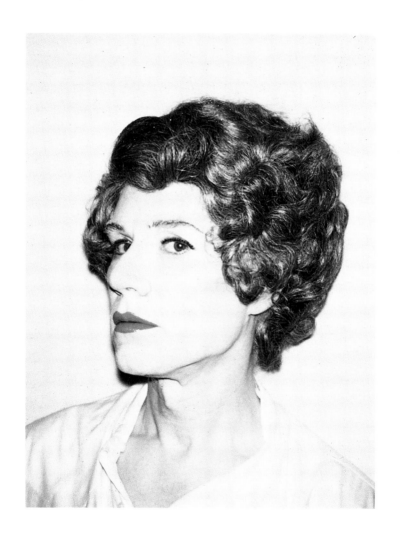

ANDY WARHOL
SELF-PORTRAIT IN DRAG, 1979.
FACING PAGE:
ROMAN OPALKA
DÉTAIL 469 1935, 1965 1.

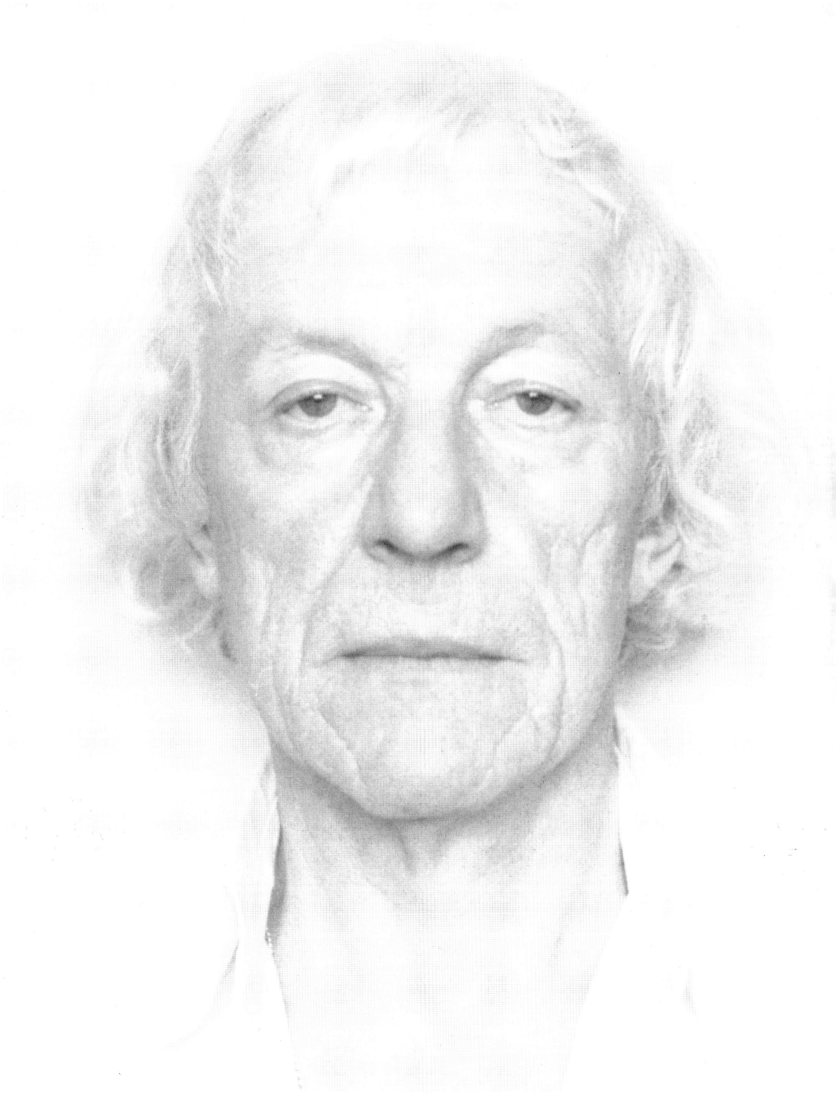

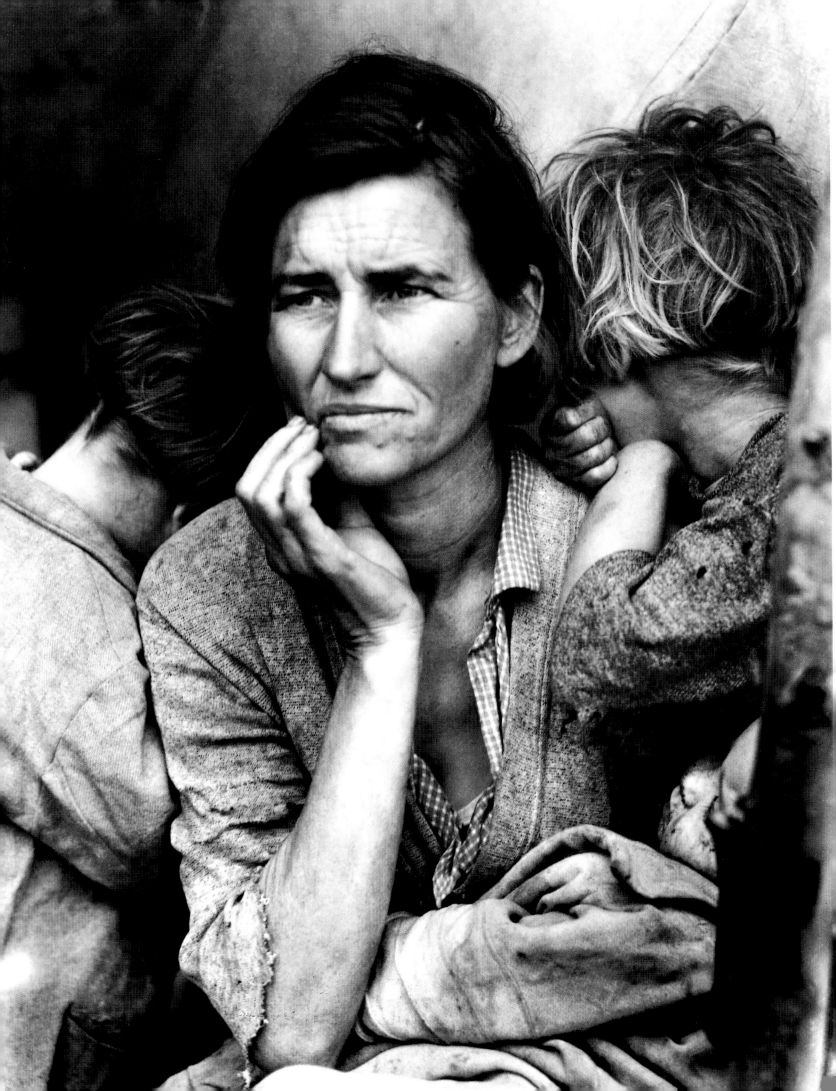

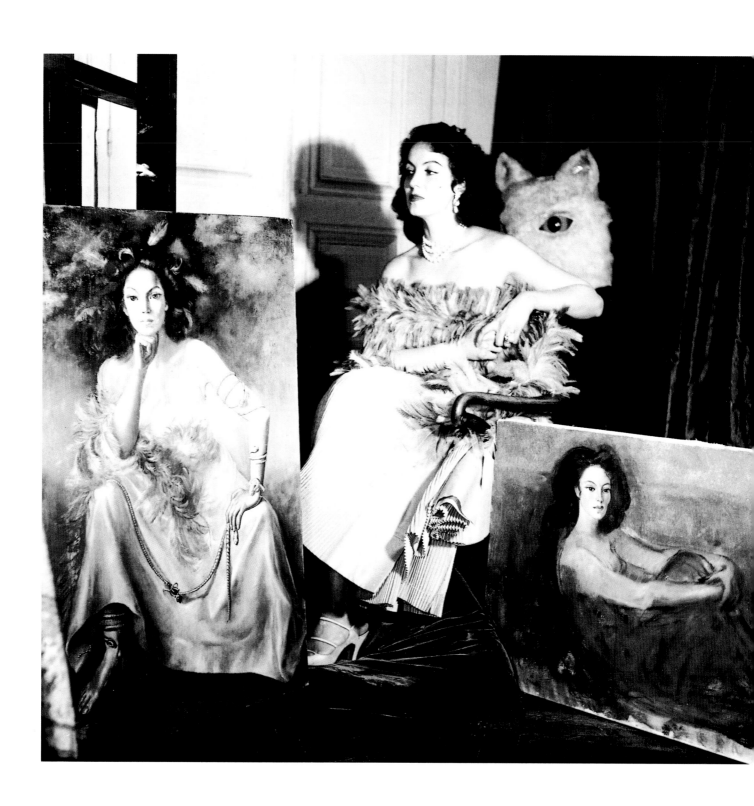

ANDRÉ OSTIER
MARIA FÉLIX IN LEONORE FINI'S ATELIER C. 1950.
FACING PAGE: **DOROTHEA LANGE**
MIGRANT MOTHER, NIPONO, CALIFORNIA, 1936.

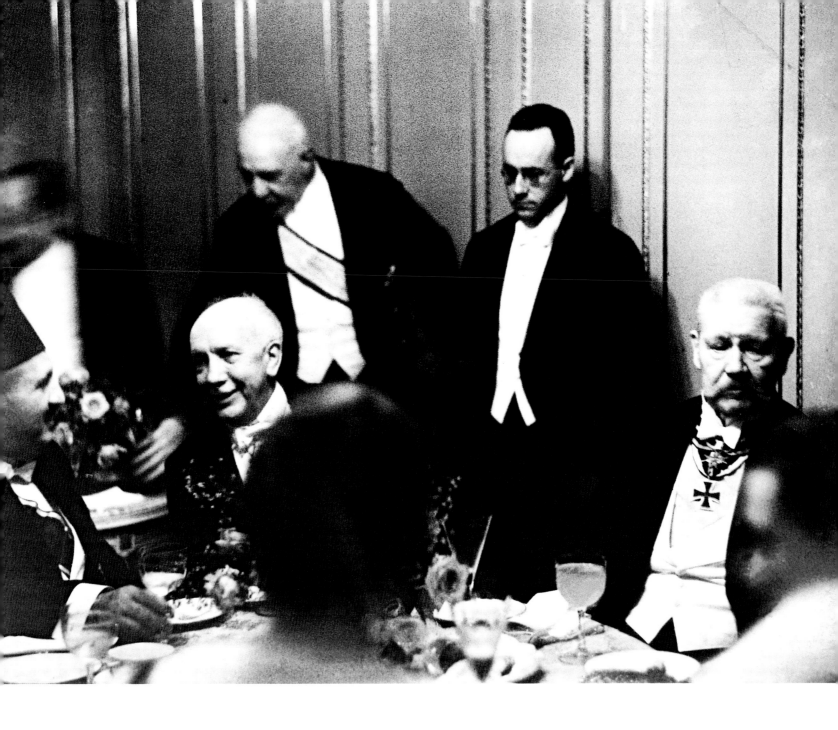

KENNETH ANGER *RENATA LOOME*
IN INAUGURATION
OF THE PLEASURE DOME.
FACING PAGE:
WERNER DAVID FEIST
THE MAN WITH THE PIPE, 1929.

ANTON CORBIJN
HENRY ROLLINS, 1994.
FACING PAGE:
ADRIEN TOURNACHON
SELF-PORTRAIT, 1855.

202

NADAR
FELIX, PAUL AND ERNESTINE, C. 1863–1865.
FACING PAGE: **DON MCCULLIN**
THE DEATH COLLECTOR, HOLLOWAY ROAD,
LONDON, MIDDLE OF THE SIXTIES.

EDWARD STEICHEN *AUGUSTE RODIN*, 1907.
FACING PAGE: **UMBO**
PHYSIOGNOMIE DES KRIEGES
(WARRIOR PHYSIOGNOMY), 1927.

208

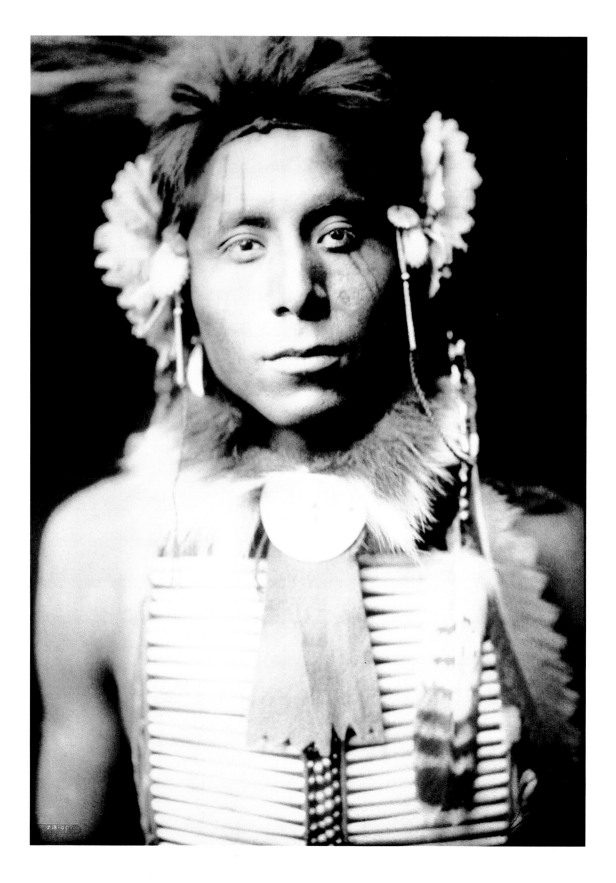

EL LISSITZKY *SELF-PORTRAIT*, 1924–1925.
FACING PAGE: **EDWARD CURTIS** *SITTING EAGLE*, 1905.
FOLLOWING PAGES:
LEFT: **ROGER CORBEAU** *HARRY BAUR IN* NITCHEVO, *BY JACQUES DE BARONCELLI*, 1936.
RIGHT: **CECIL BEATON** *MARLON BRANDO*, C. 1950.

WILLY MAYWALD
THE VISCOUNTESS OF NOAILLES, PARIS, 1948.
FACING PAGE: **LEE MILLER**
CHRISTIAN BÉRARD, PARIS 1944.
FOLLOWING PAGES:
LEFT: **FRANÇOIS KOLLAR**
PORTRAIT OF MARIE BELL IN PHOTOMONTAGE, 1930.
RIGHT: **CECIL BEATON**
GWILI ANDRÉ, 1935.

216

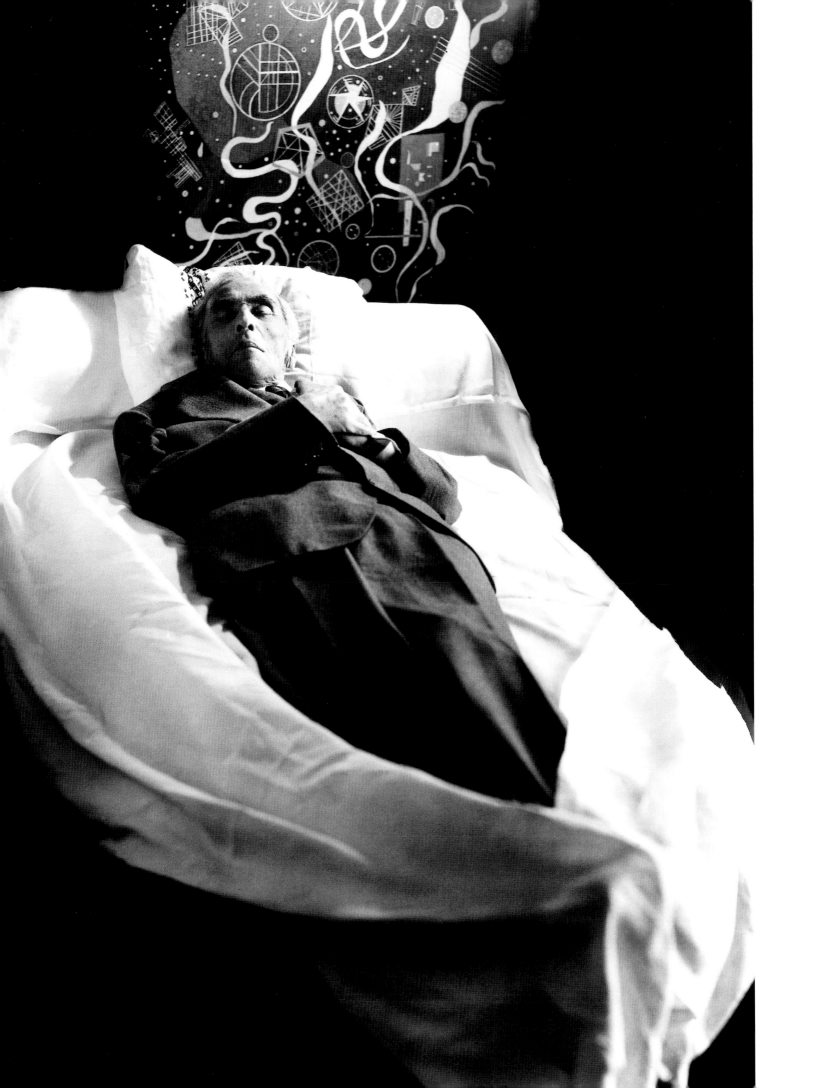

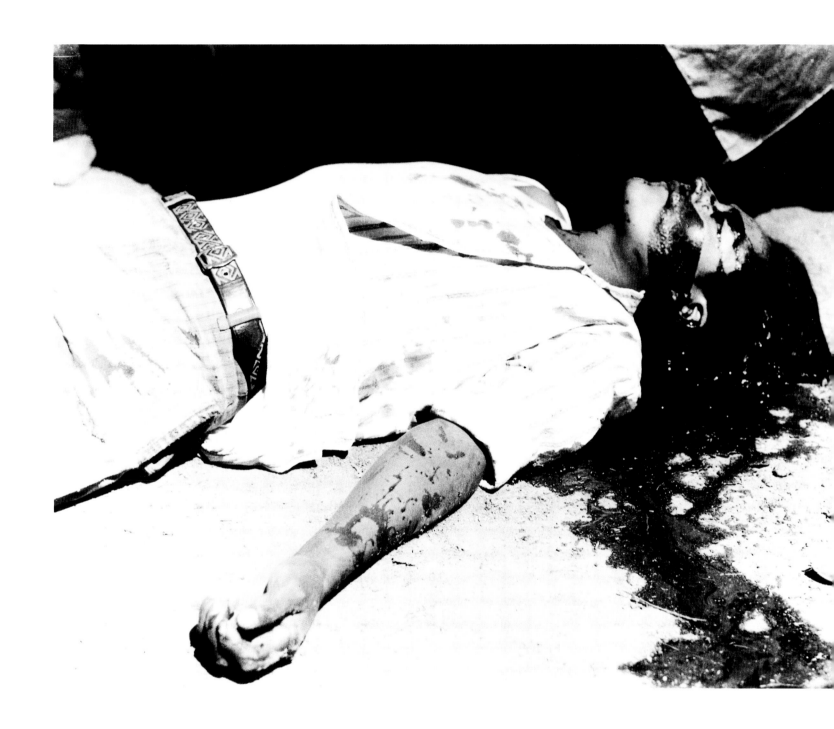

MANUEL ALVAREZ BRAVO
OBRERO EN HUELGA, ASESINADO (STRIKING WORKER, ASSASSINATED), 1934.
FACING PAGE: **ROGI ANDRÉ**
WASSILY KANDINSKY, 1944.
FOLLOWING PAGES:
LEFT: **DENNIS STOCK**
JAMES DEAN ON THE FARM OF HIS UNCLE MARCUS WINSLOW, FAIRMOUNT, INDIANA, 1955.
RIGHT: **RAYMOND DEPARDON**
GILBERT, 17 YEARS, TUTSI SURVIVOR,
AUGUST 1999, RWANDA.

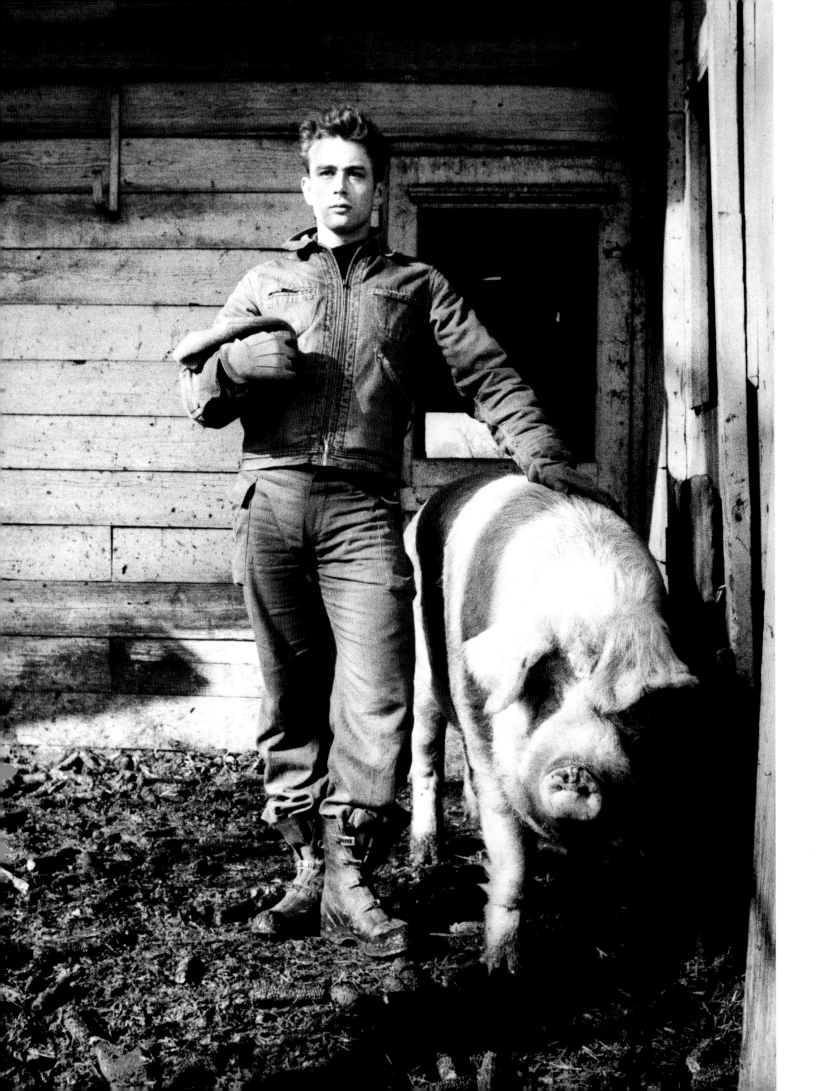

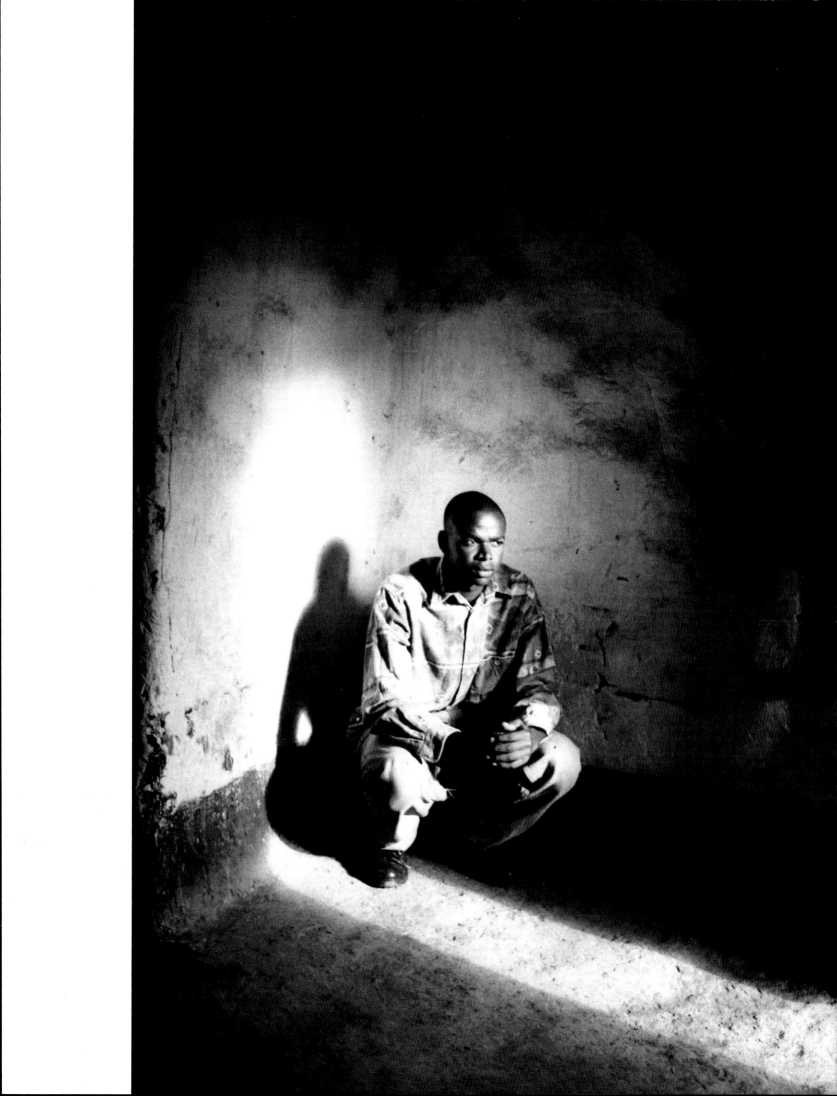

222

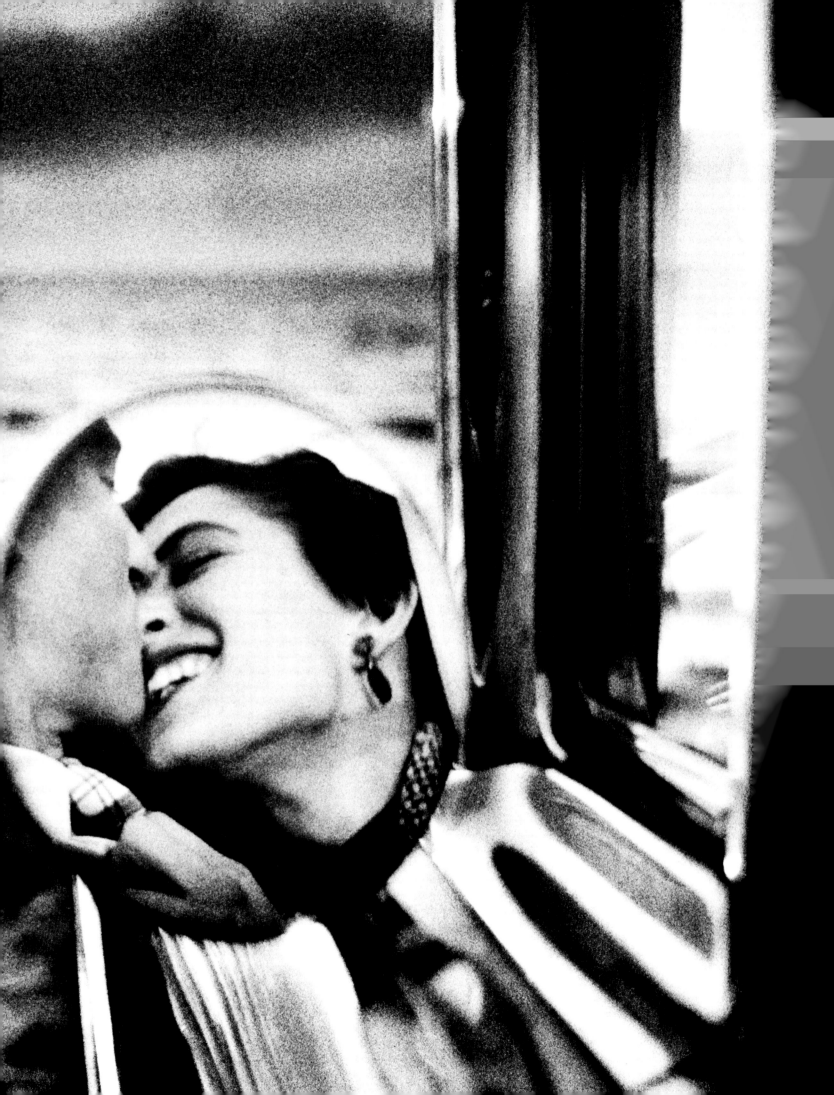

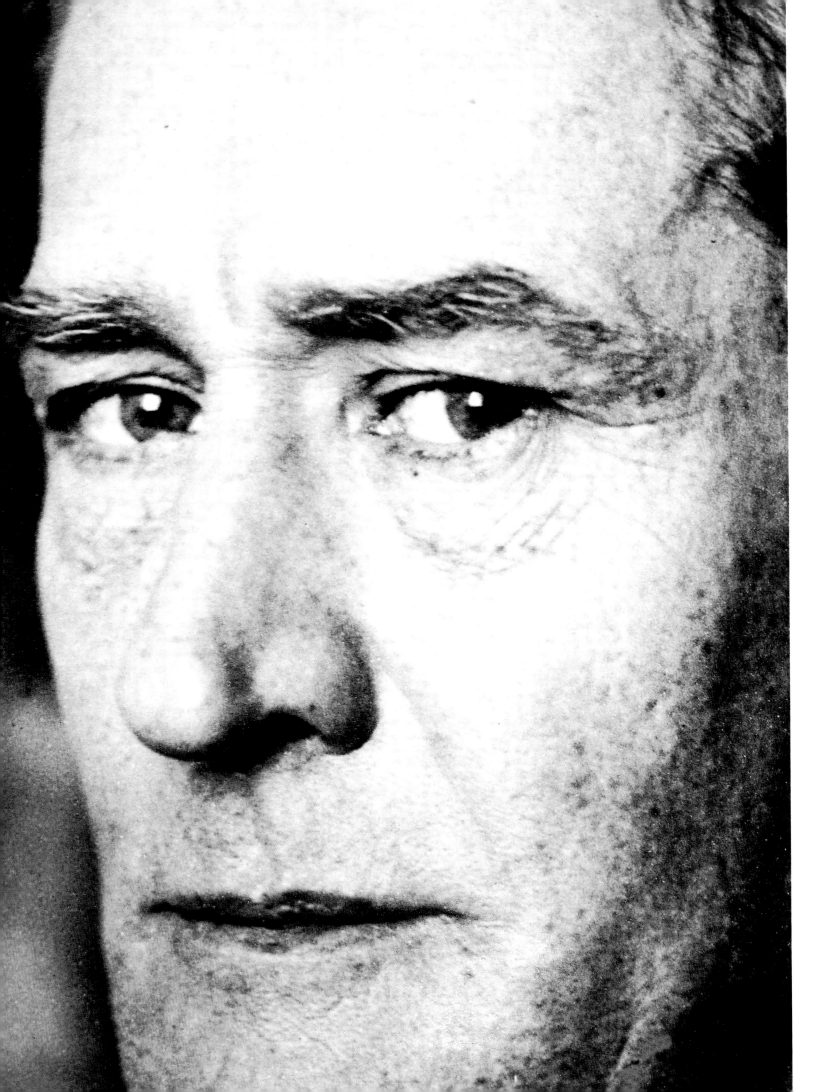

226

WEEGEE
SELF-PORTRAIT, C. 1955.
FACING PAGE: **GERMAINE KRULL**
SELF-PORTRAIT, 1925.
PRECEDING PAGES:
LEFT: **ANDREAS FEININGER**
PORTRAIT OF LIONEL FEININGER, 1929.
RIGHT: **INGE MORATH**
DONA MERCEDES FORMICA, MADRID, 1955.

CHRISTIAN COURRÈGES
UNTITLED, HAÏTI 1999-2001.
FACING PAGE: **ORLAN**
REFIGURATION: SELF-HYBRIDATION
PRÉCOLOMBIENNE N°16, 1998.

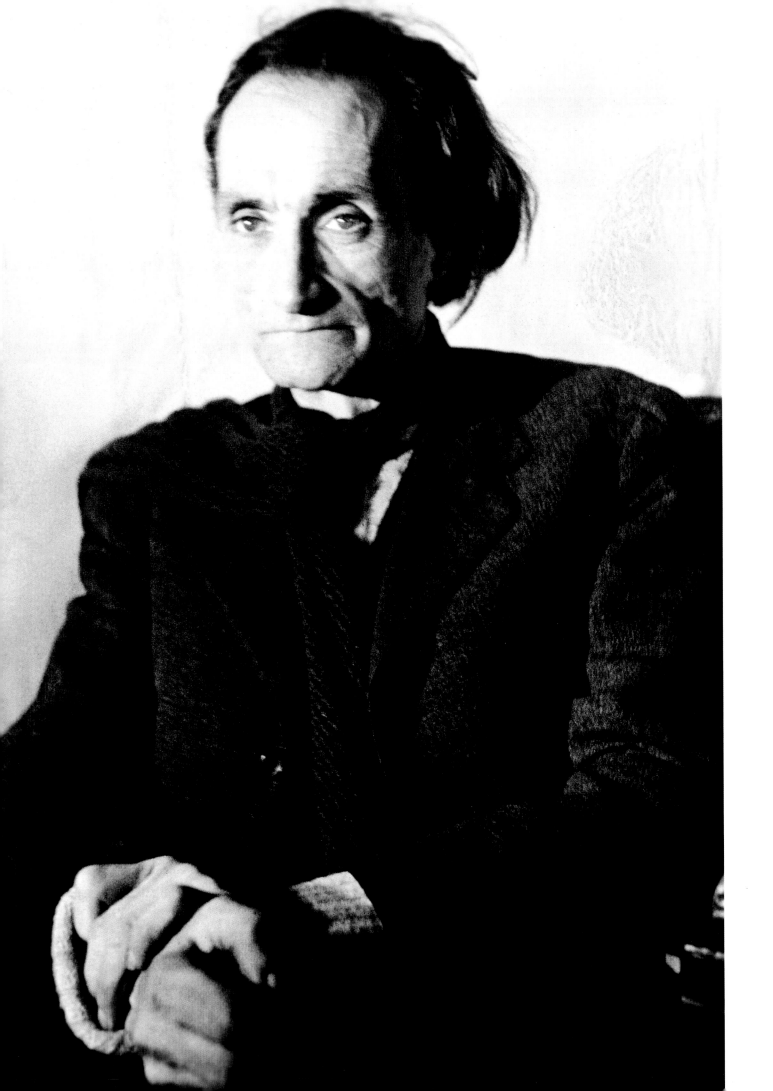

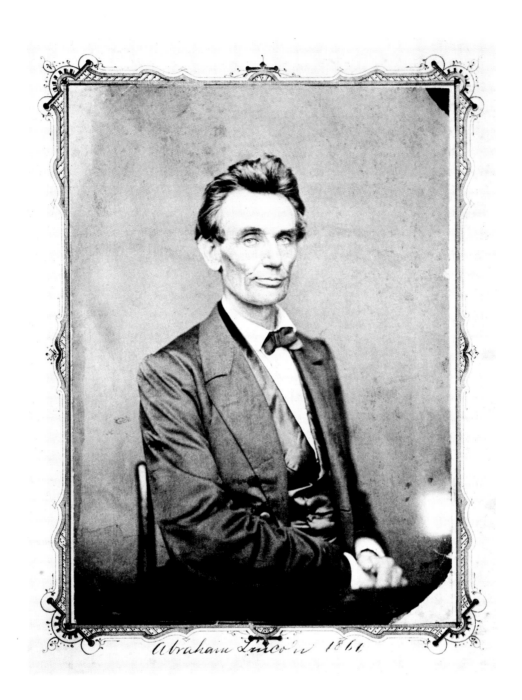

Abraham Lincoln 1861

WILLIAM MARSH
ABRAHAM LINCOLN, 1860.
FACING PAGE:
DENISE COLOMB
ANTONIN ARTAUD, 1947.

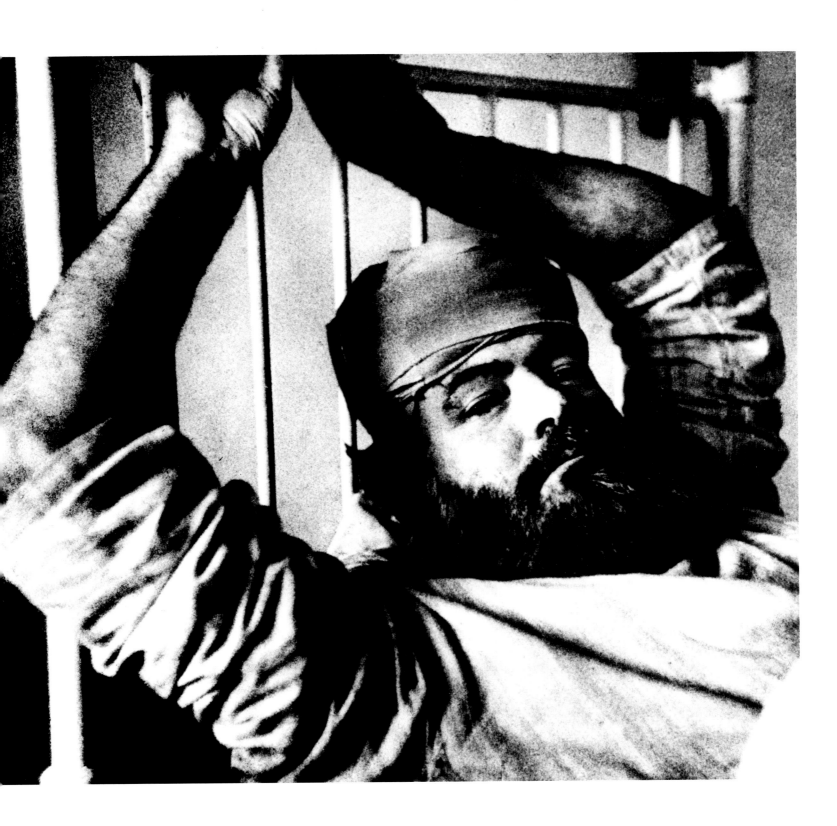

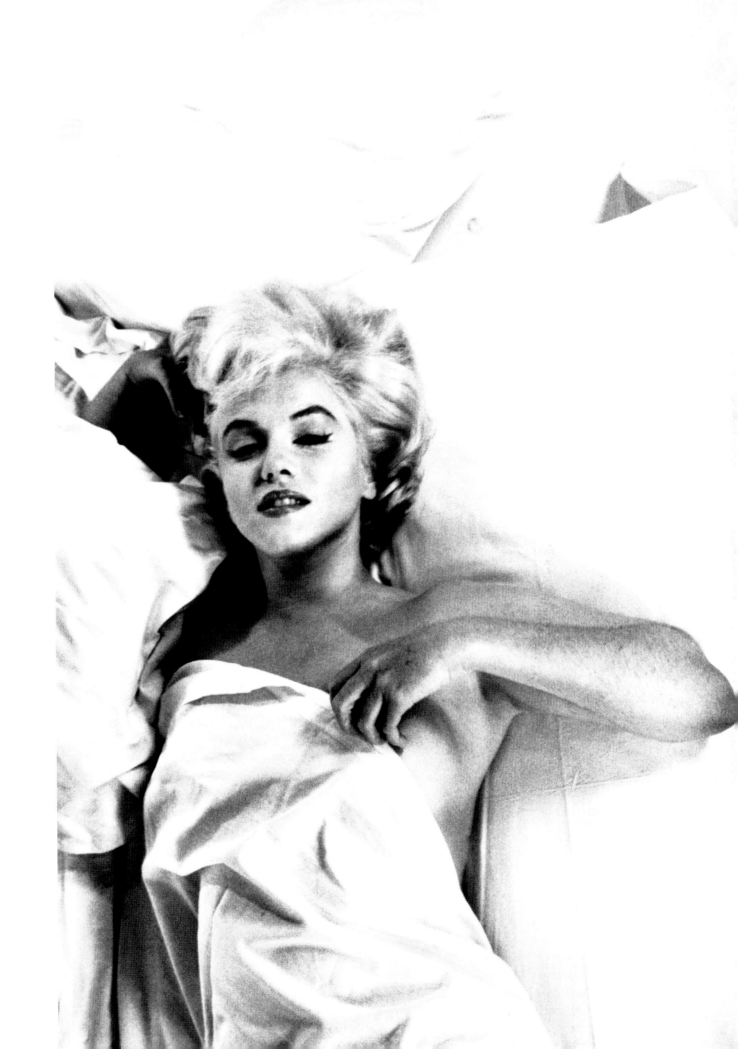

DIANE ARBUS
UNTITLED, 1969–1971.
FACING PAGE:
ROGER BALLEN
SKEW MASK, 2002.

ALISON JACKSON
DI, DODI AND BABY, 1999.
FACING PAGE:
PAUL STRAND
UNTITLED, 1955.

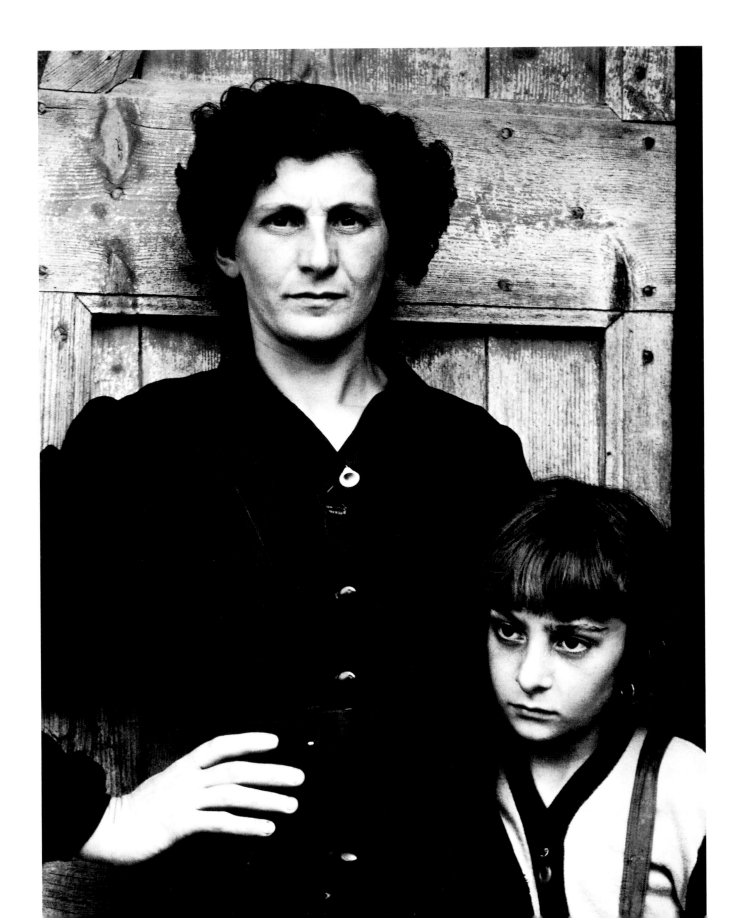

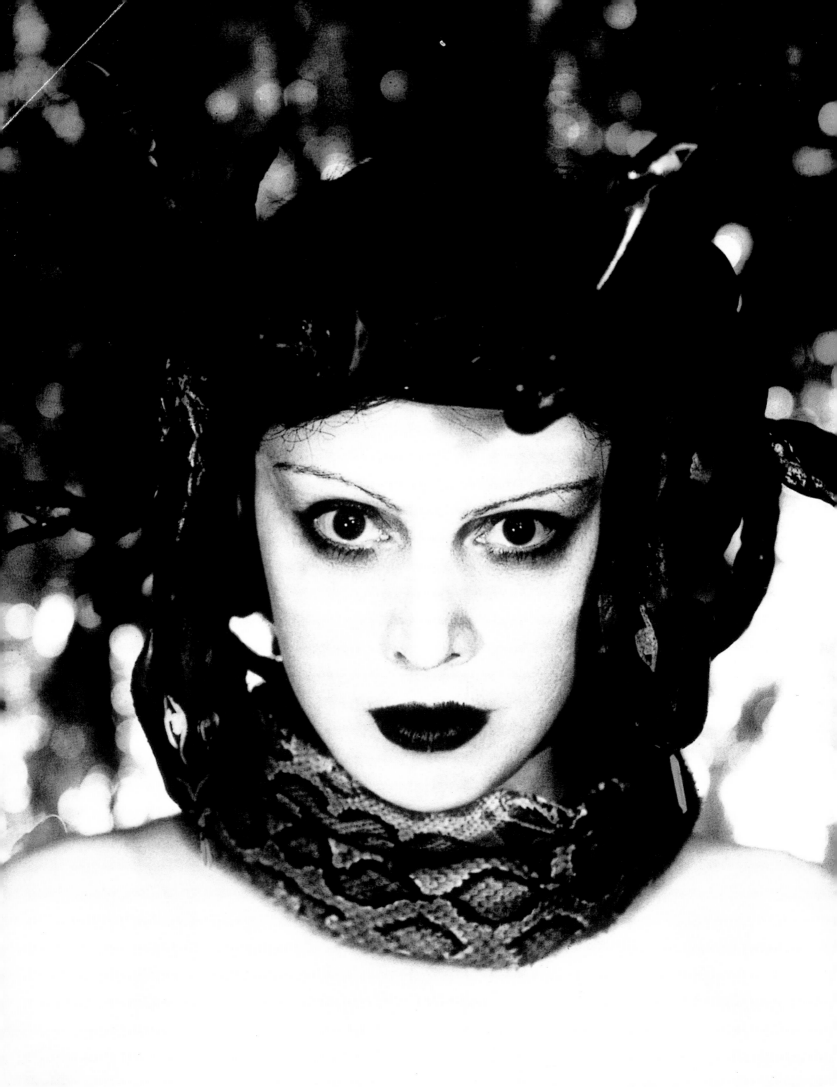

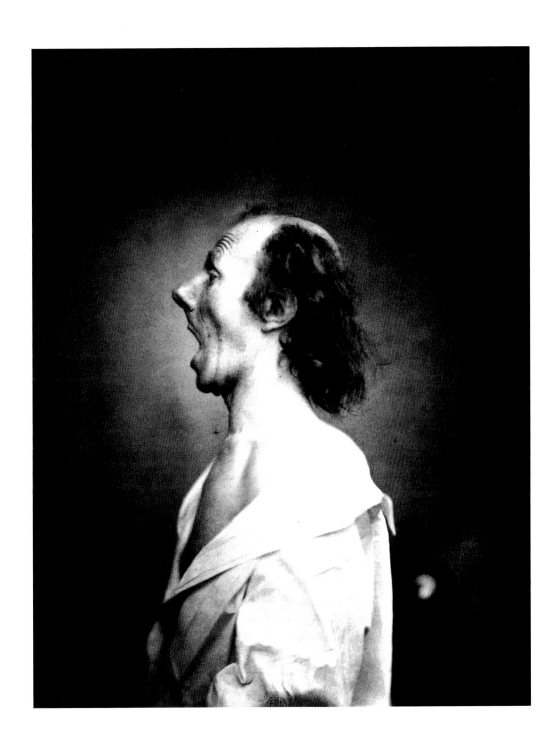

GUILLAUME DUCHENNE DE BOULOGNE
SÉRIE MUSCLES COMPLÉMENTAIRES DE LA SURPRISE
(COMPLEMENTARY MUSCLES OF SURPRISE SERIES), 1855-1856.
FACING PAGE: **MADAME YEVONDE**
MRS EDWARD MAYER AS MEDUSA, FROM THE SERIES *GODDESSES*, 1935.

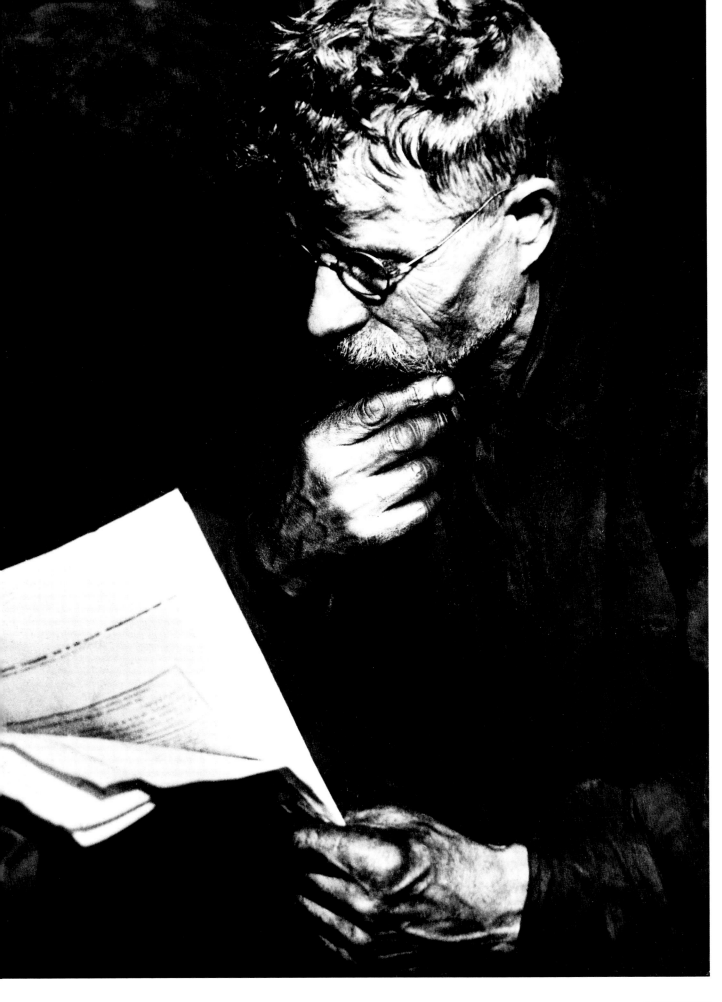

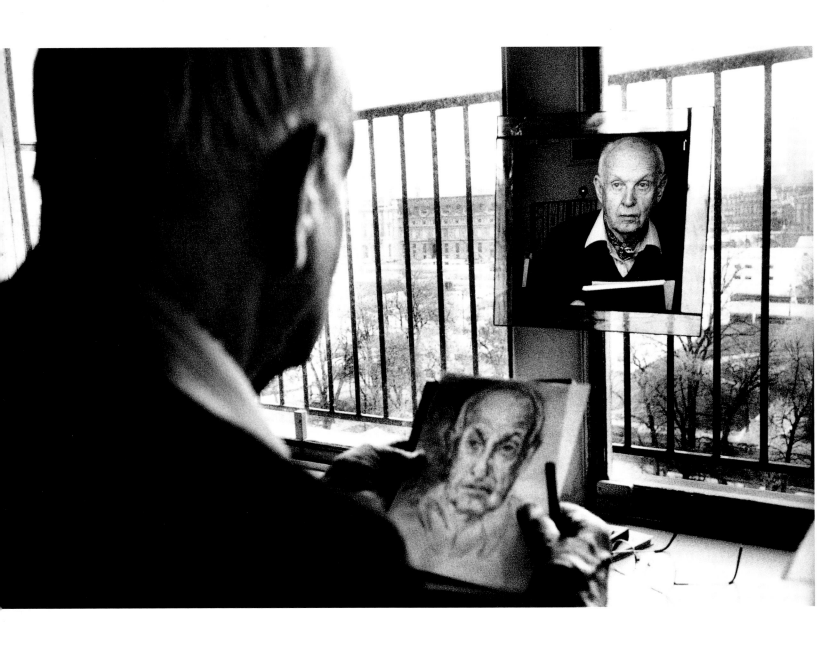

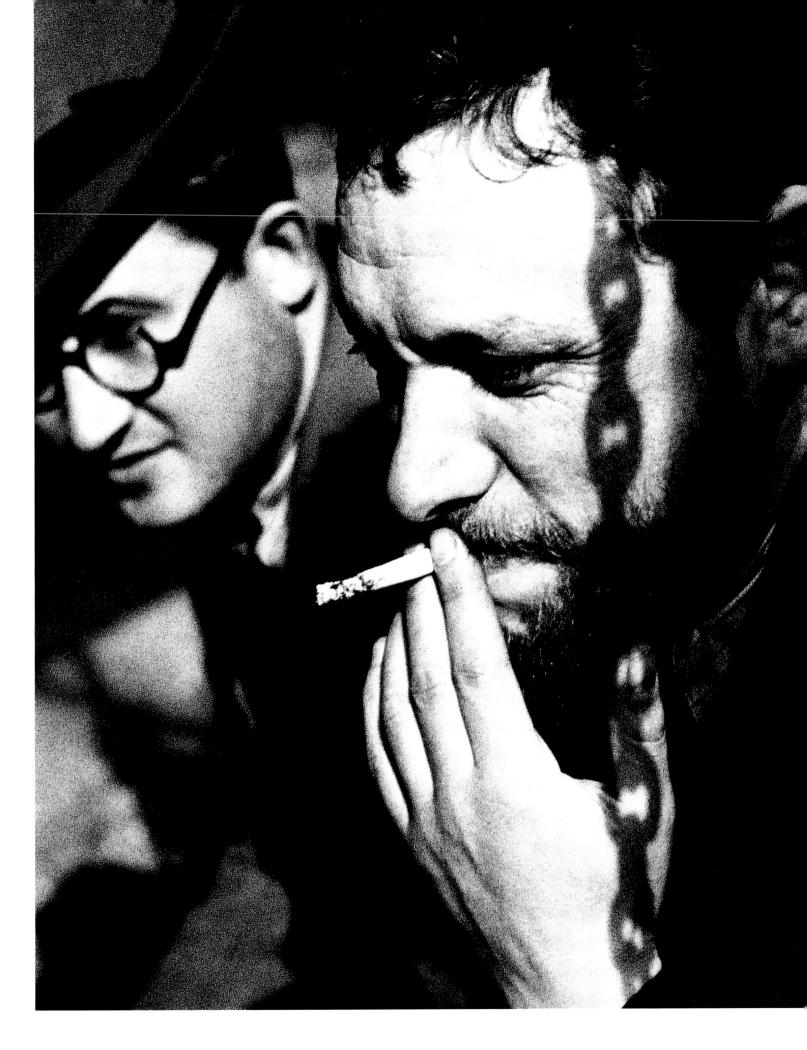

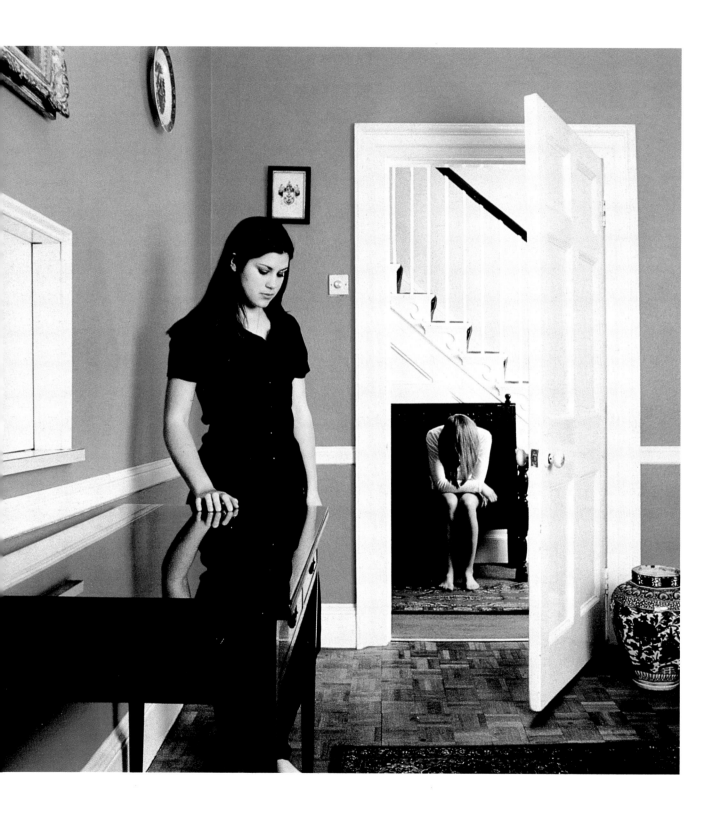

VIRXILIO VIEITEZ
GALICE (ESPAGNE), 1957–1970.
FACING PAGE: **SARAH JONES**
THE HOUSE (FRANCIS PLACE) II, 1997.

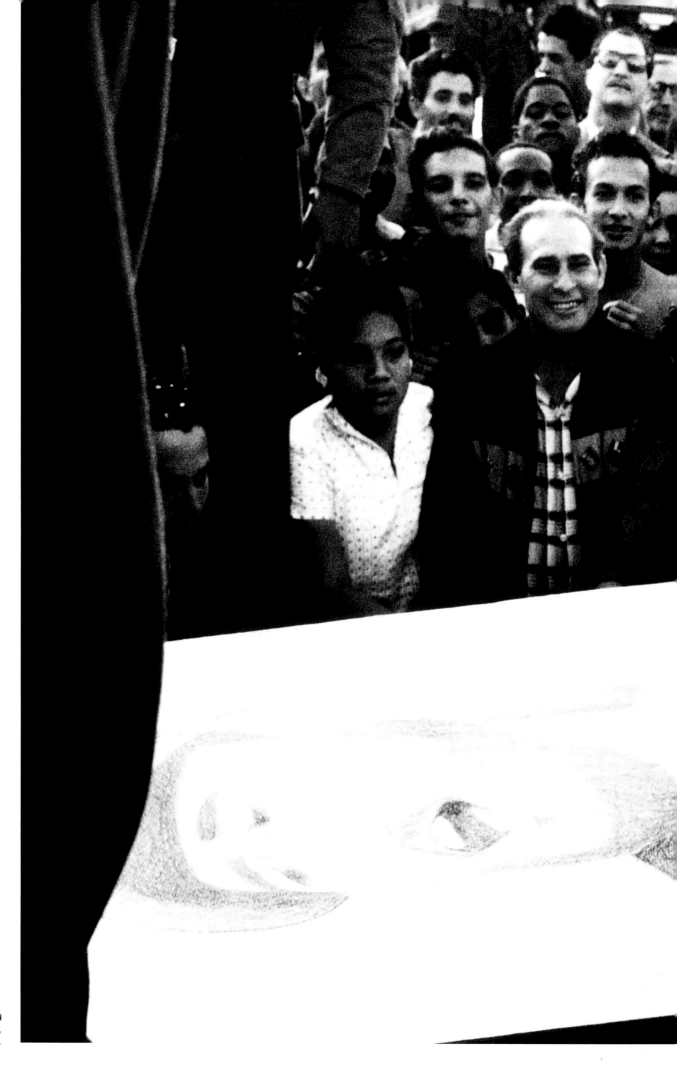

246

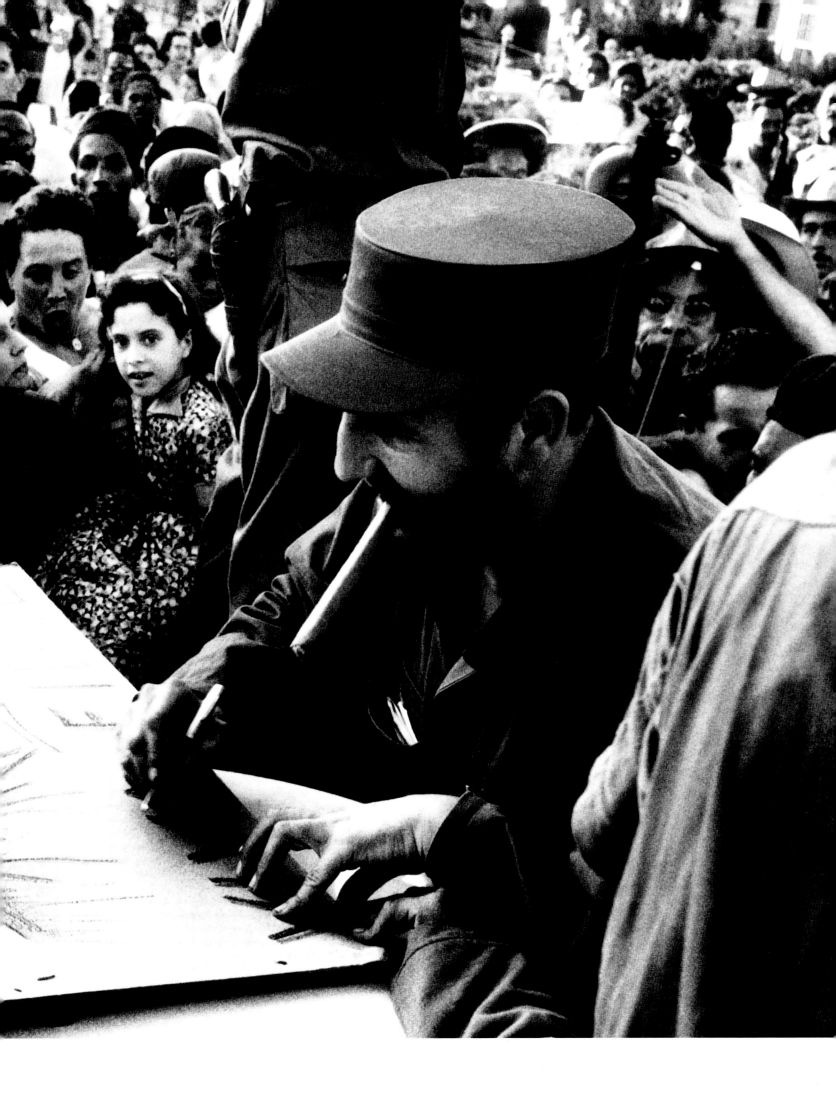

HARRY CALLAHAN
PROVIDENCE, CHICAGO, C. 1947.
FACING PAGE: **SERGIO LARRAIN**
CHILI, VALPARAISO, 1963.

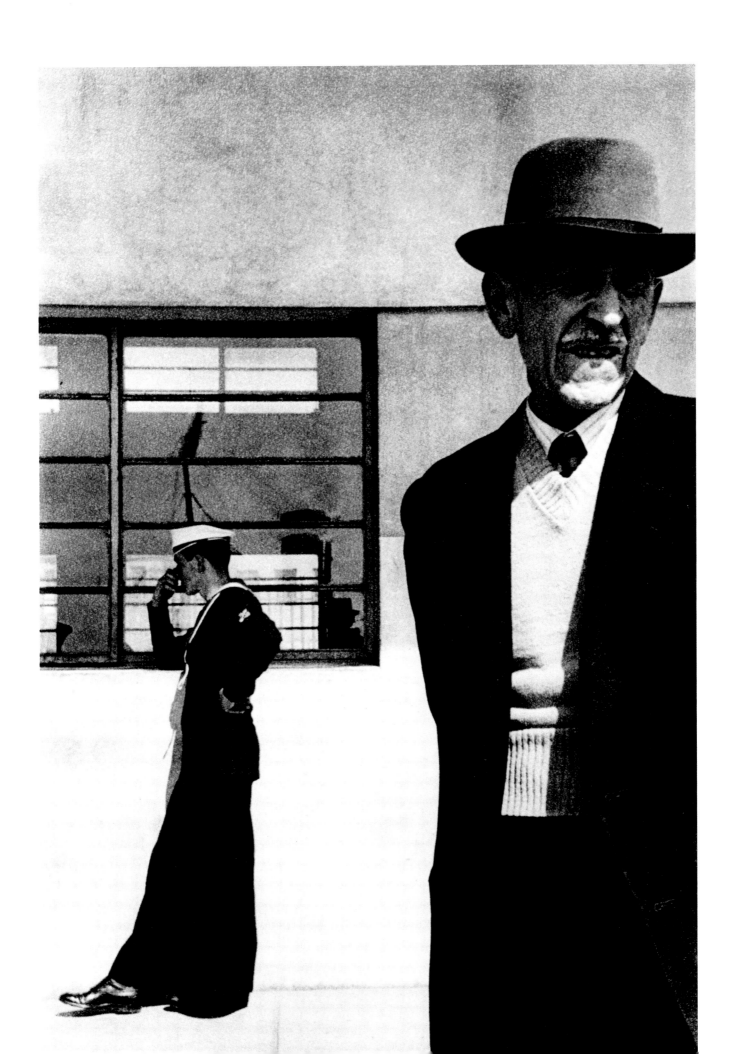

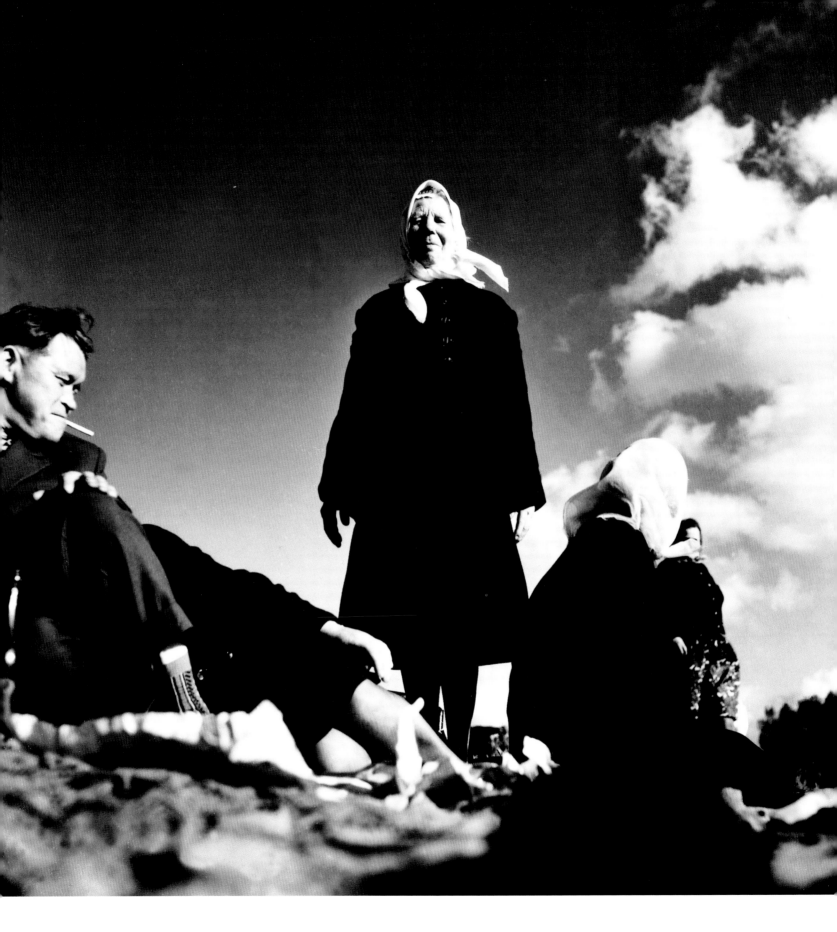

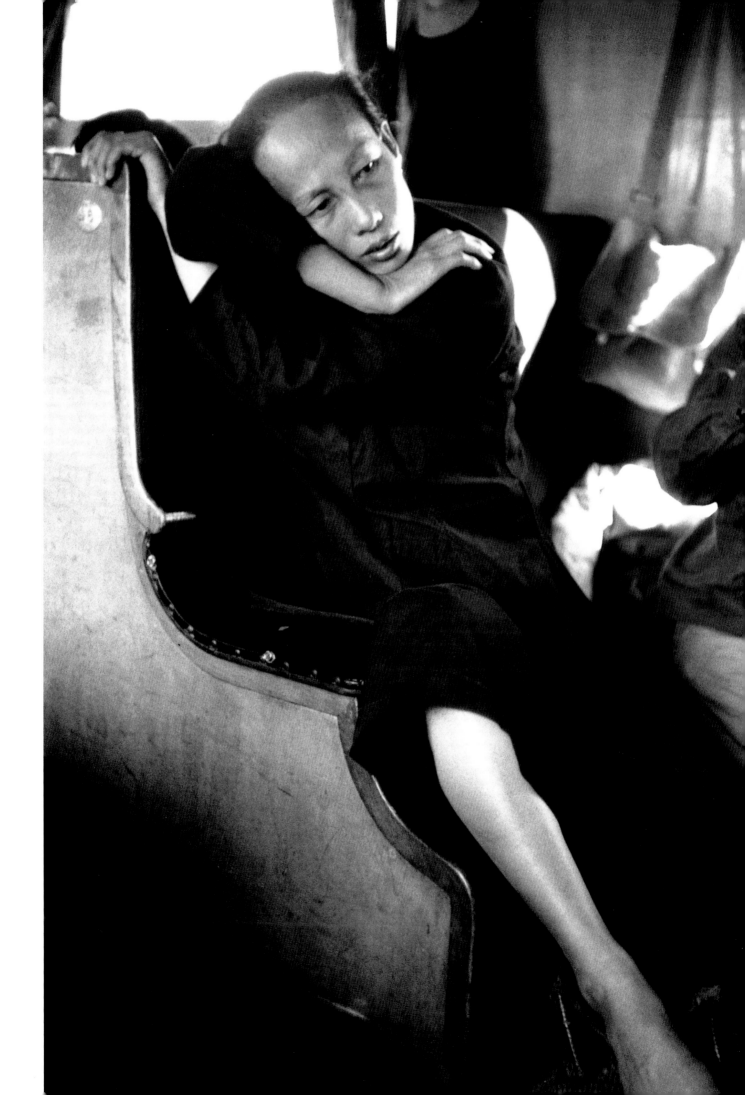

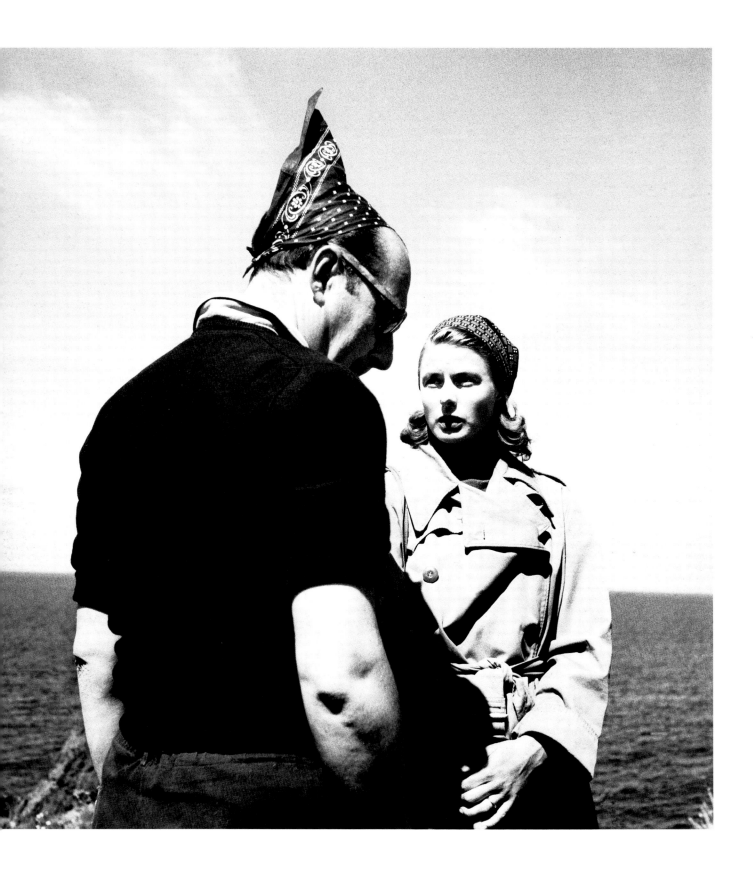

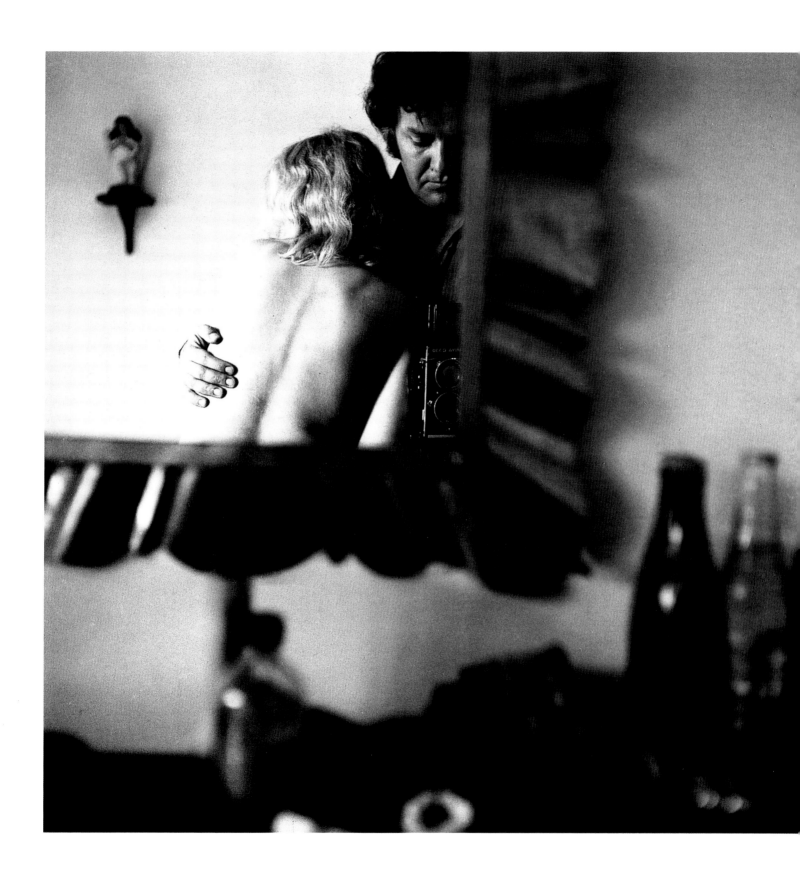

DENIS ROCHE
JULY 19, 1978, TAXCO, MEXICO. VICTORIA HOTEL, ROOM 80.
FACING PAGE:
FEDERICO PATELLANI
ROBERTO ROSSELLINI AND INGRID BERGMAN, STROMBOLI, 1949.

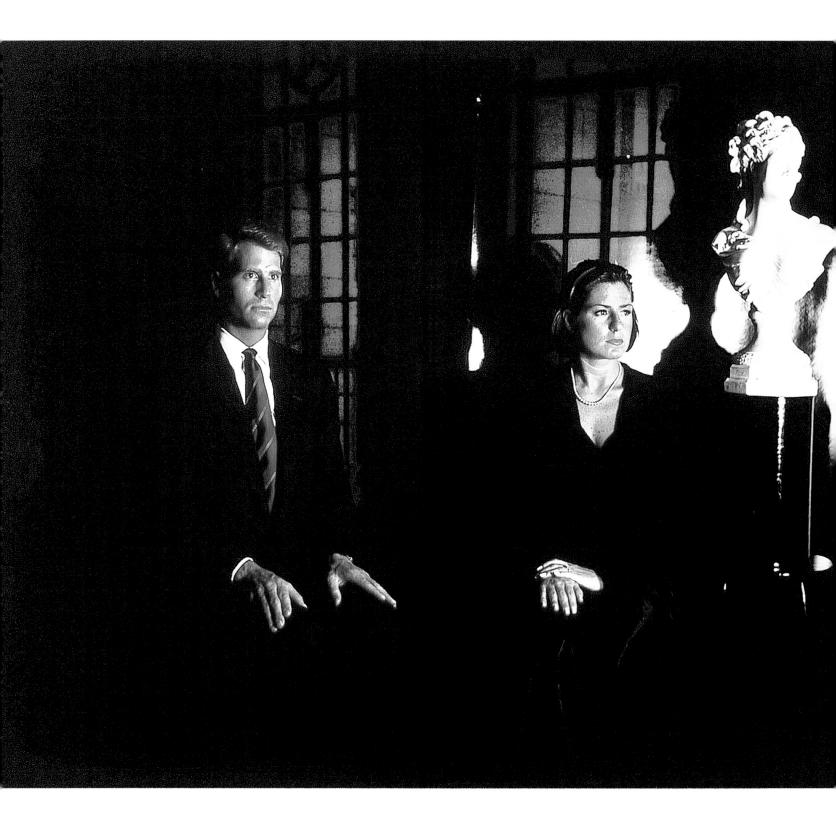

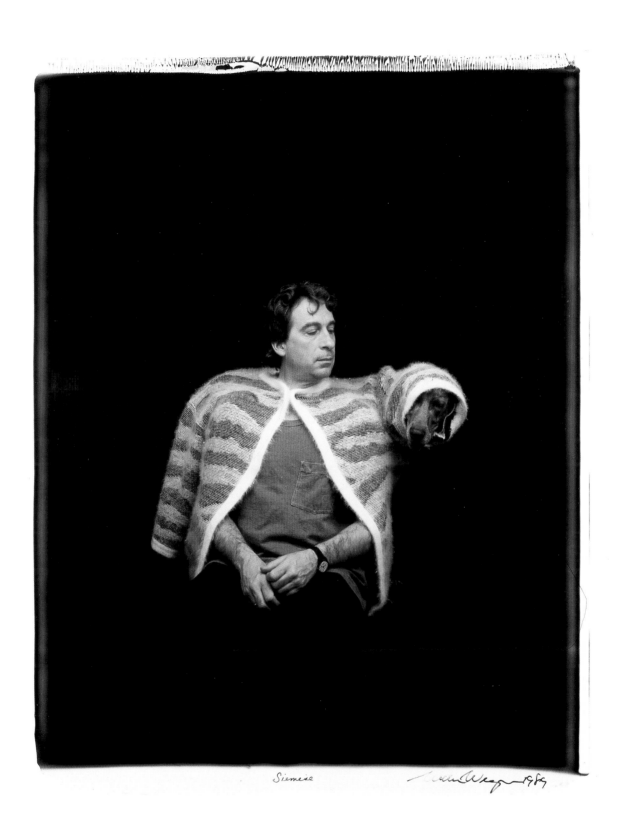

Siamese

WILLIAM WEGMAN
SIAMESE, 1989.
FACING PAGE:
CLEGG AND GUTTMANN
PORTRAIT OF TWO YOUTHS WITH A BUST OF MARIE-ANTOINETTE, 1987.

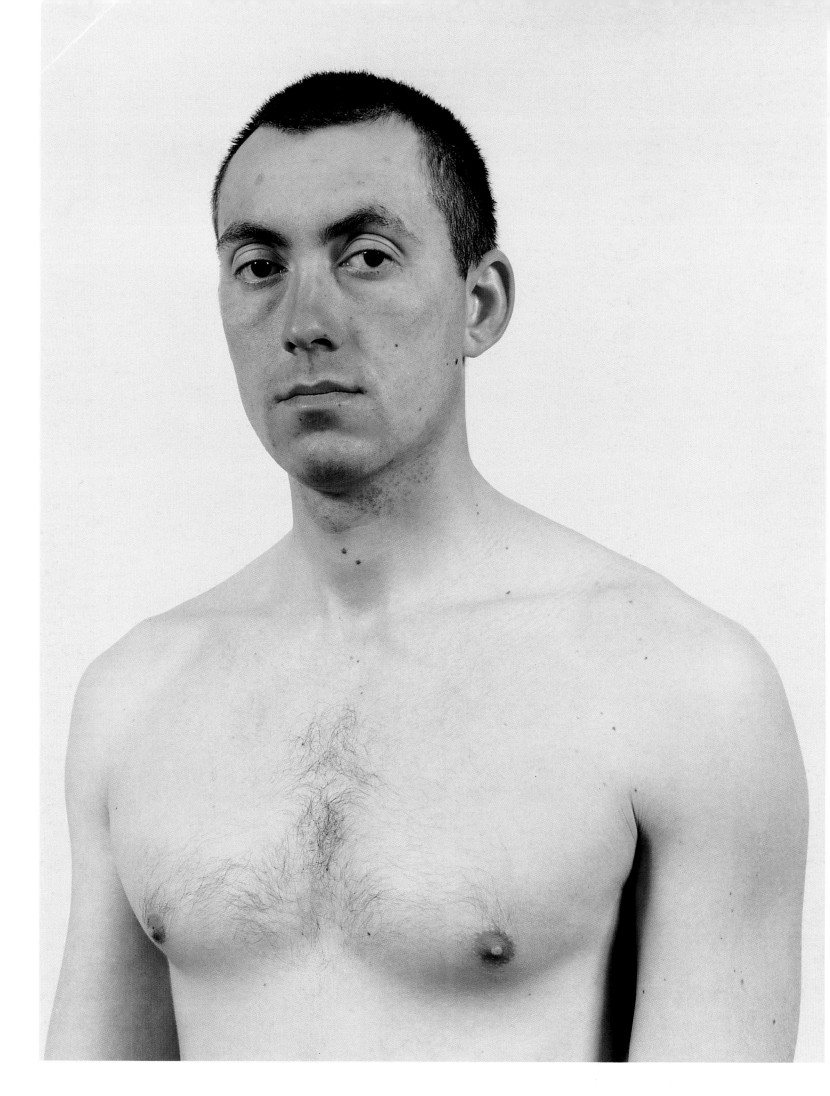

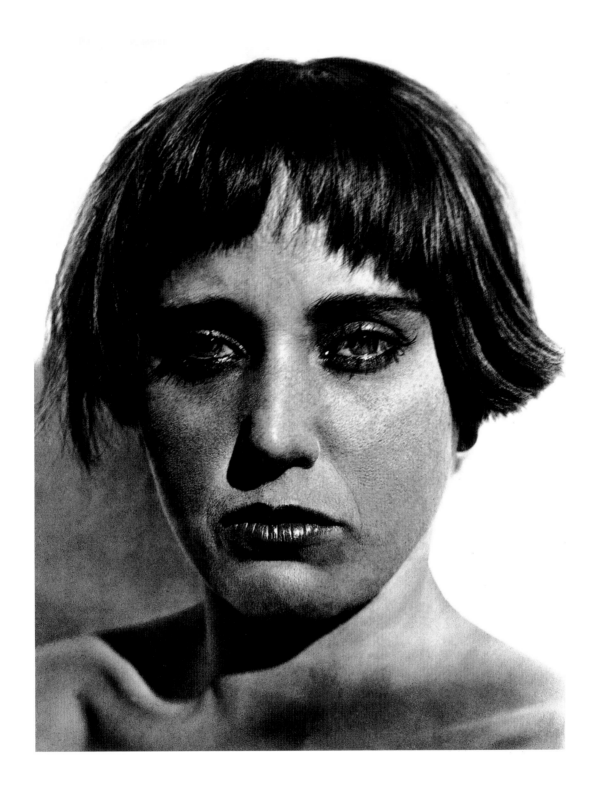

EDWARD WESTON
NAHUI OLIN, 1924.
FACING PAGE: **CHARLES FRÉGER**
ENGAGÉ VOLONTAIRE (VOLUNTARY CONSCRIPT),
FROM THE SERIES LÉGIONNAIRES, 2001.
FOLLOWING PAGES: **GARY LEE BOAS**
SNAPSHOTS FROM THE 1960S TO 1990S.

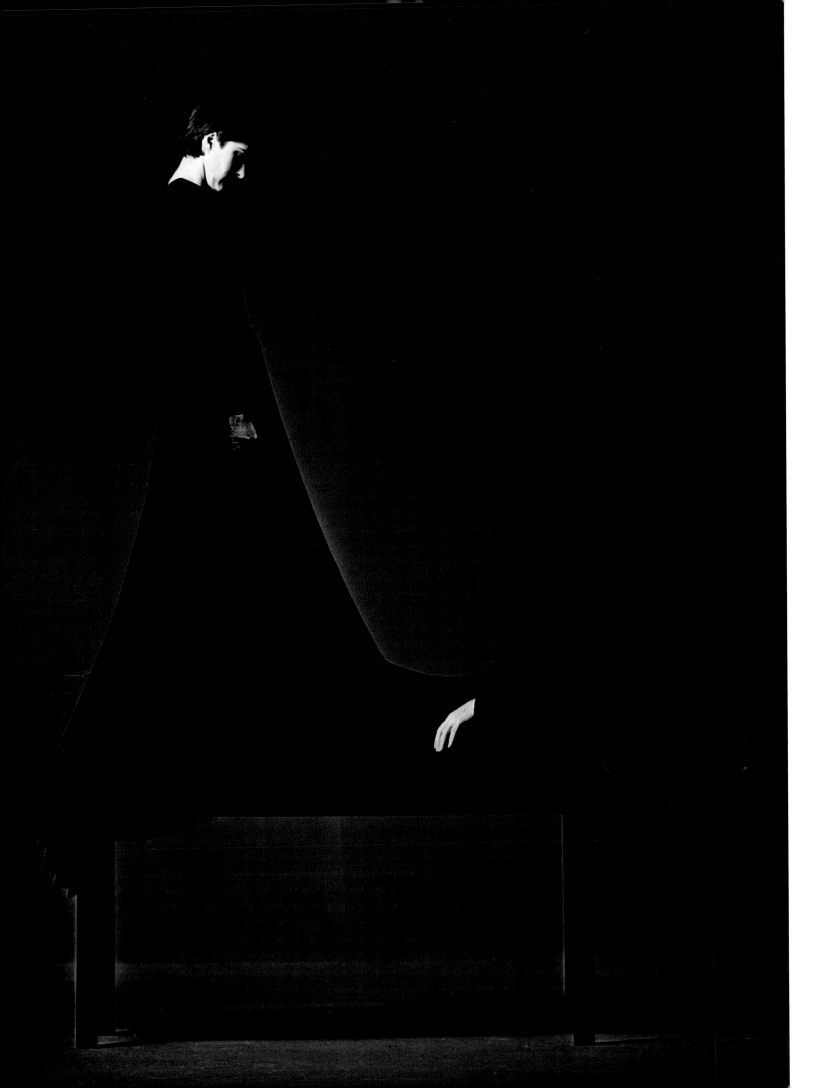

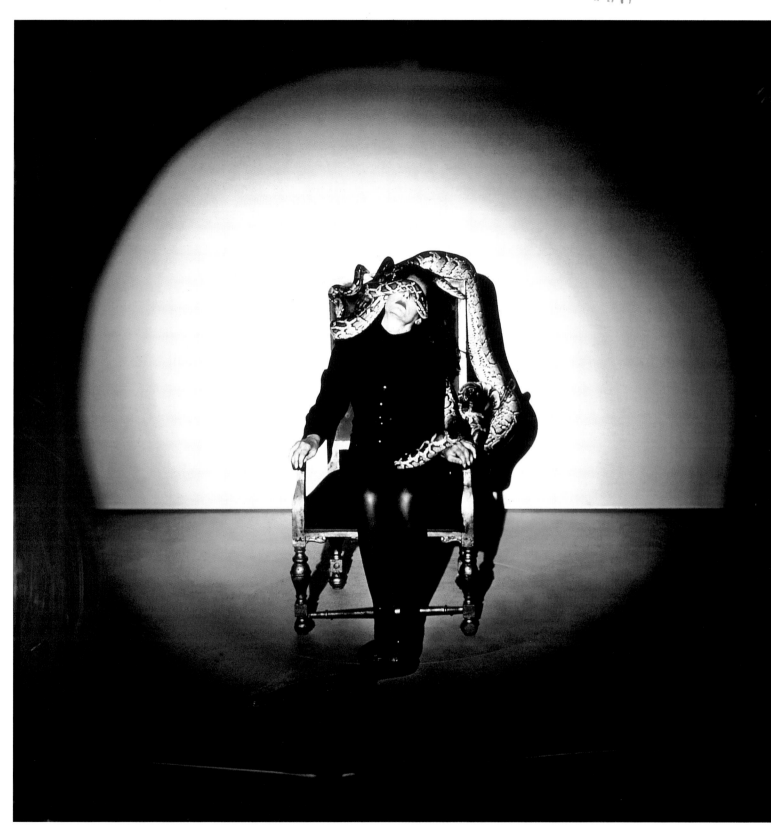

MARINA ABRAMOVIC´
DRAGON HEADS, 1990-1992.
FACING PAGE:
JÜRGEN KLAUKE
HEIMSPIEL, 1990-1992.

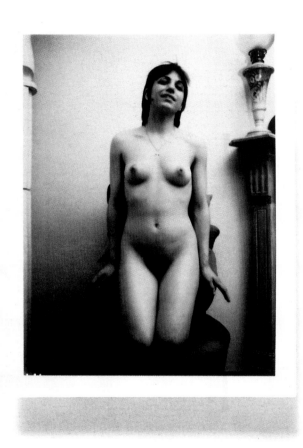

CARLO MOLLINO
UNTITLED.
FACING PAGE: **SOPHIE CALLE**
LE MARIAGE DE RÊVE (THE DREAM WEDDING), 2001.
FOLLOWING PAGES:
LEFT: **SIMON COSTIN**
SENSELESS, 1996.
RIGHT: **HANS NAMUTH**
JACKSON POLLOCK, 1950.

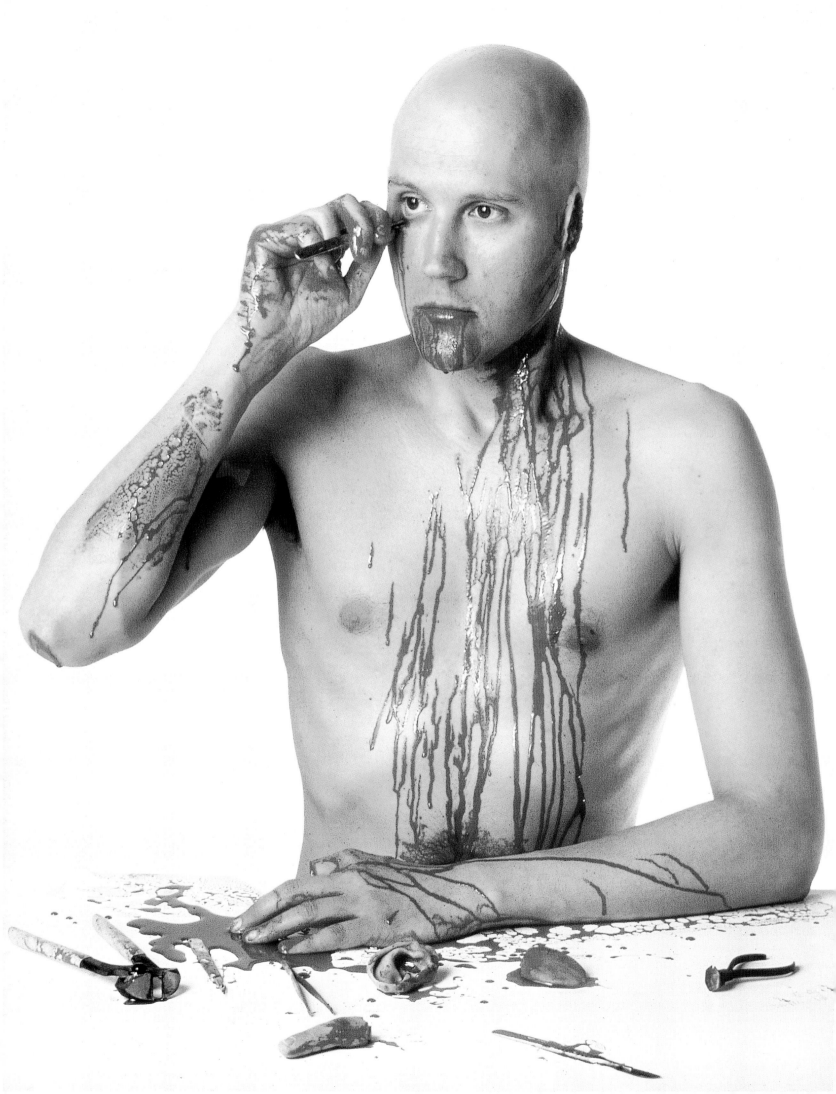

BRUCE NAUMAN
SELF-PORTRAIT AS A FOUNTAIN,
1966-1967/1970.
FACING PAGE:
DOLORÈS MARAT
UNTITLED.

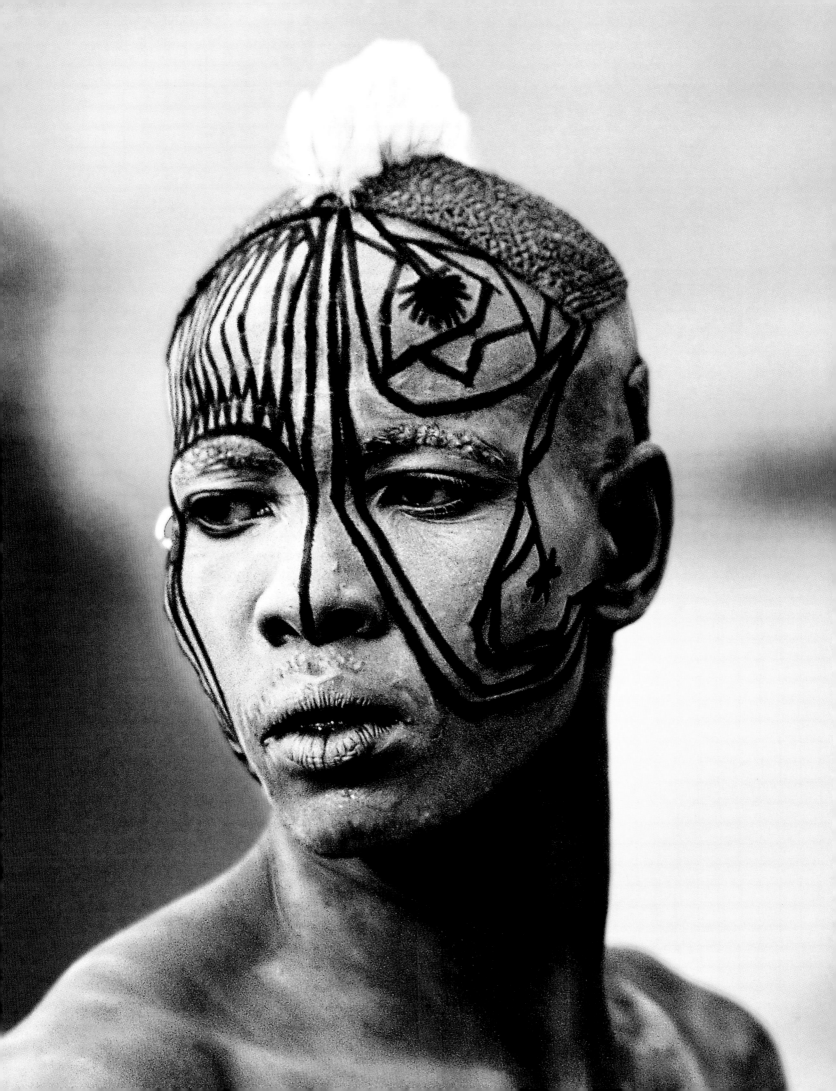

JEFF WALL
MILK, 1984.
FACING PAGE:
LENI RIEFENSTAHL
NUBA, C. 1965.

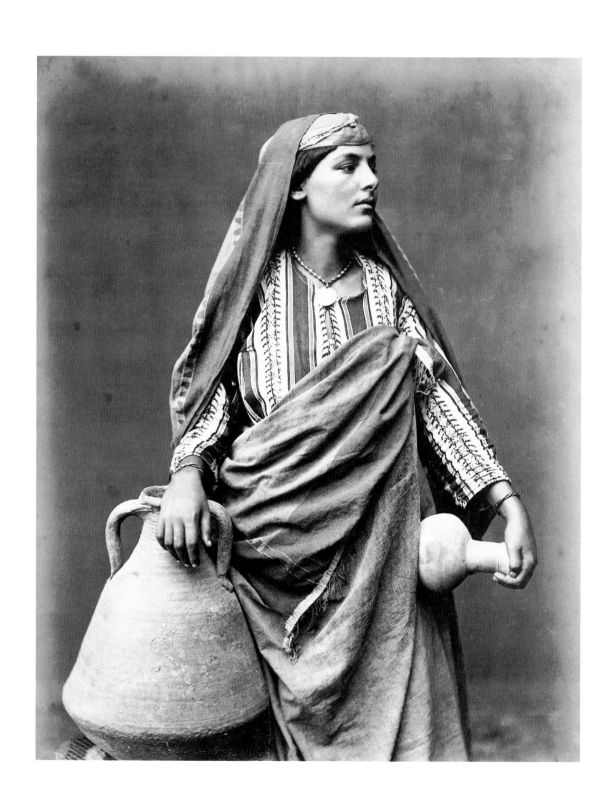

CARLO NAYA
WATER-CARRIER, EGYPT, 1876.
FACING PAGE:
NICOLE TRAN BA VANG
UNTITLED, FROM THE SERIES
SPRING/SUMMER COLLECTION, 2000.

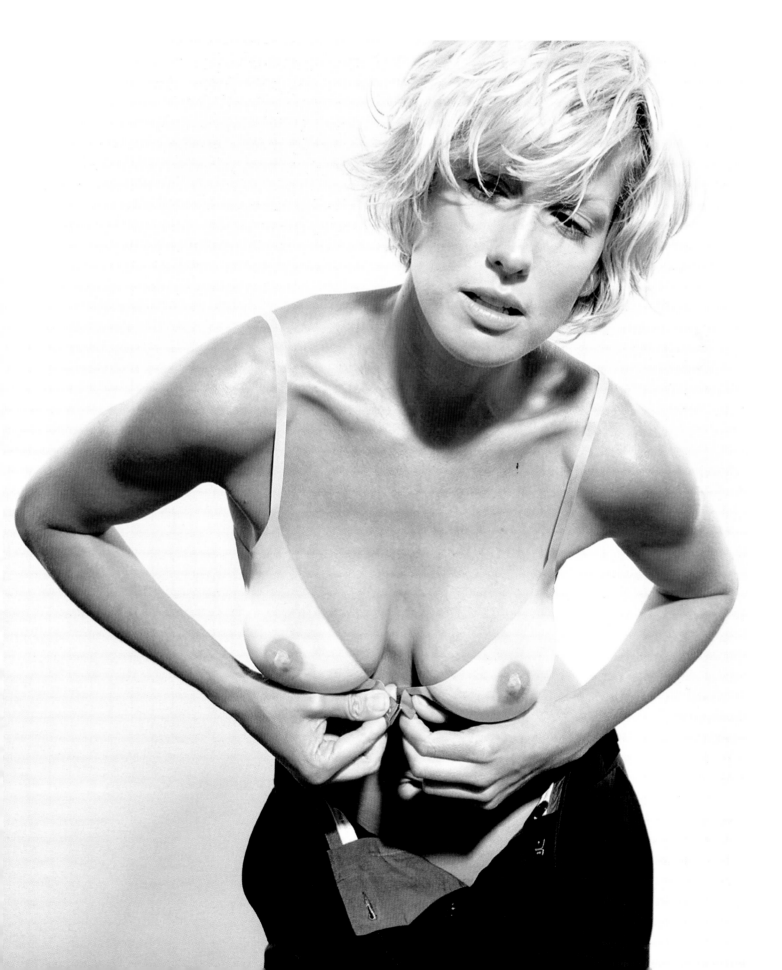

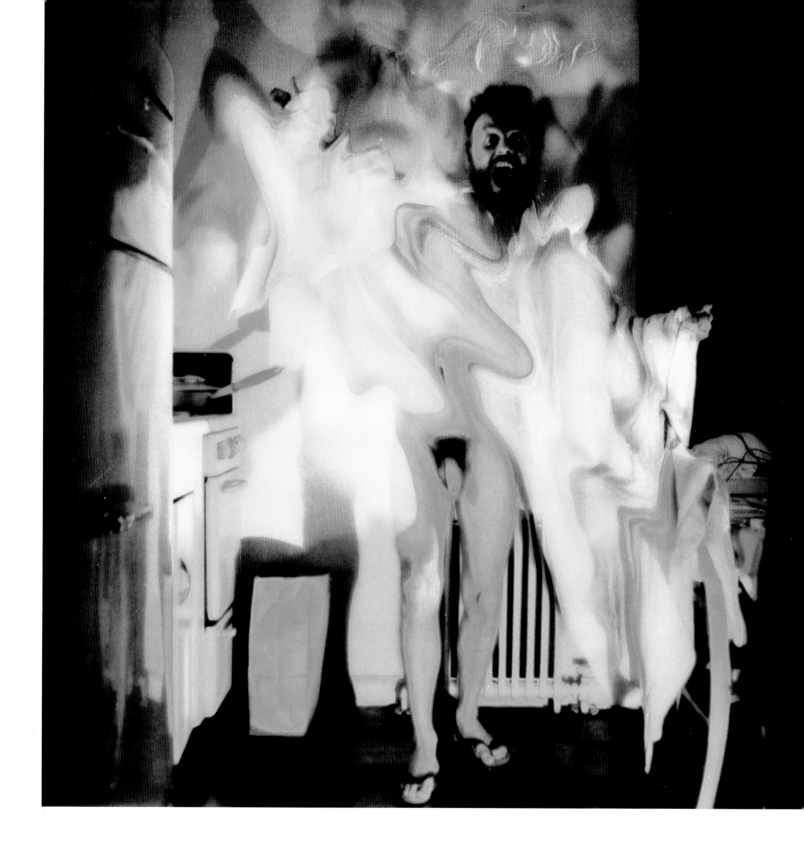

LUCAS SAMARAS
JUNE 13, 1974.
FACING PAGE:
PIERRE MOLINIER
SELF-PORTRAIT, 1967.

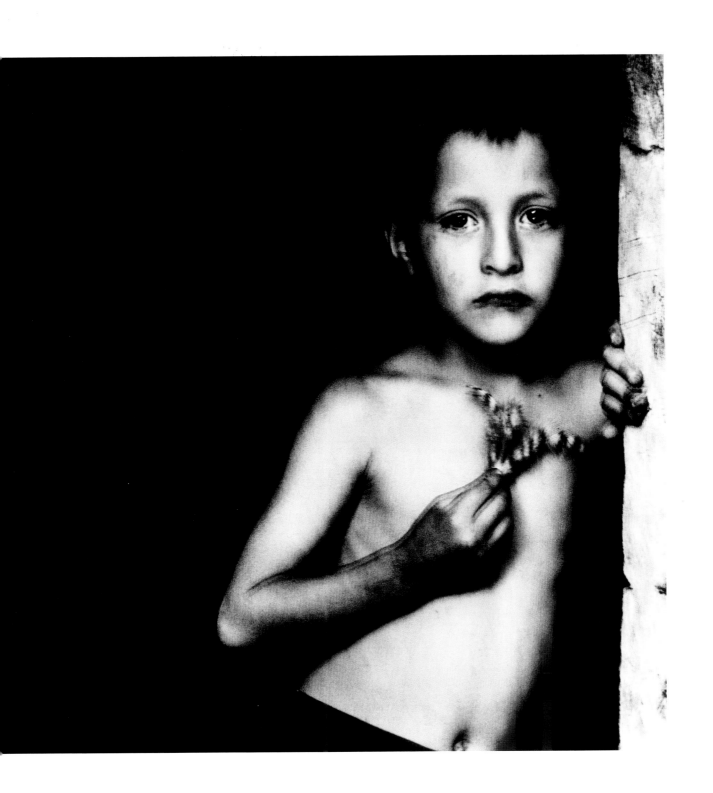

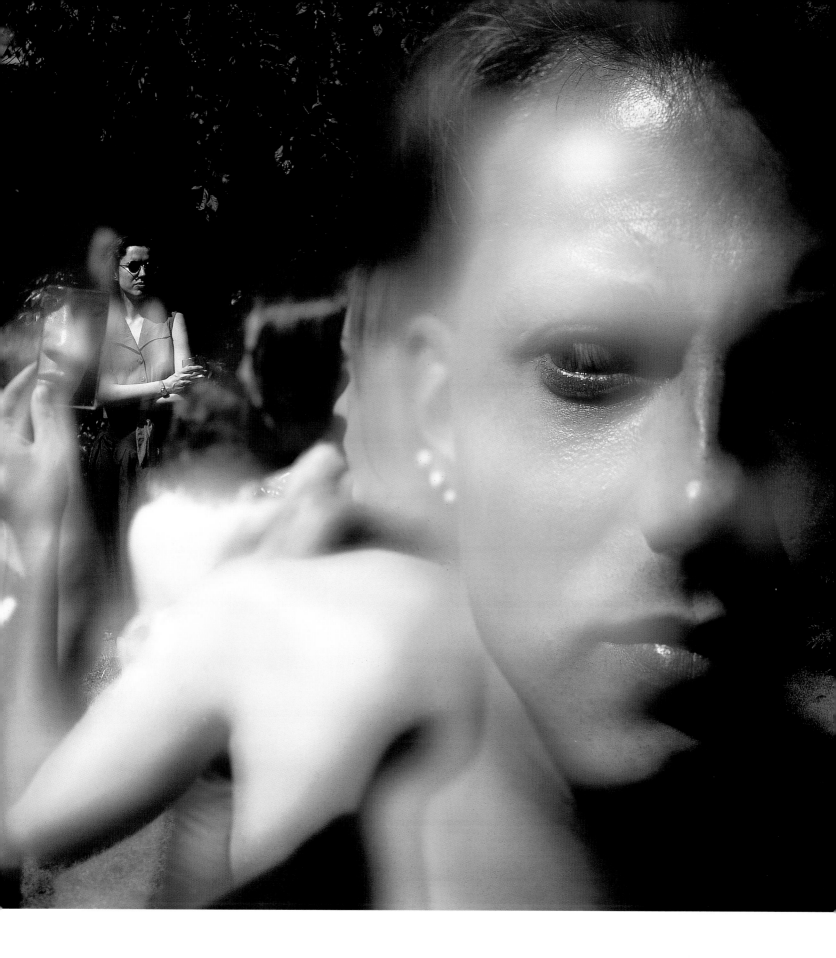

JOHN HILLIARD
STOLEN GLANCES, 1993.
FACING PAGE:
DEBBIE FLEMING CAFFERY
MEXICO, 1998.

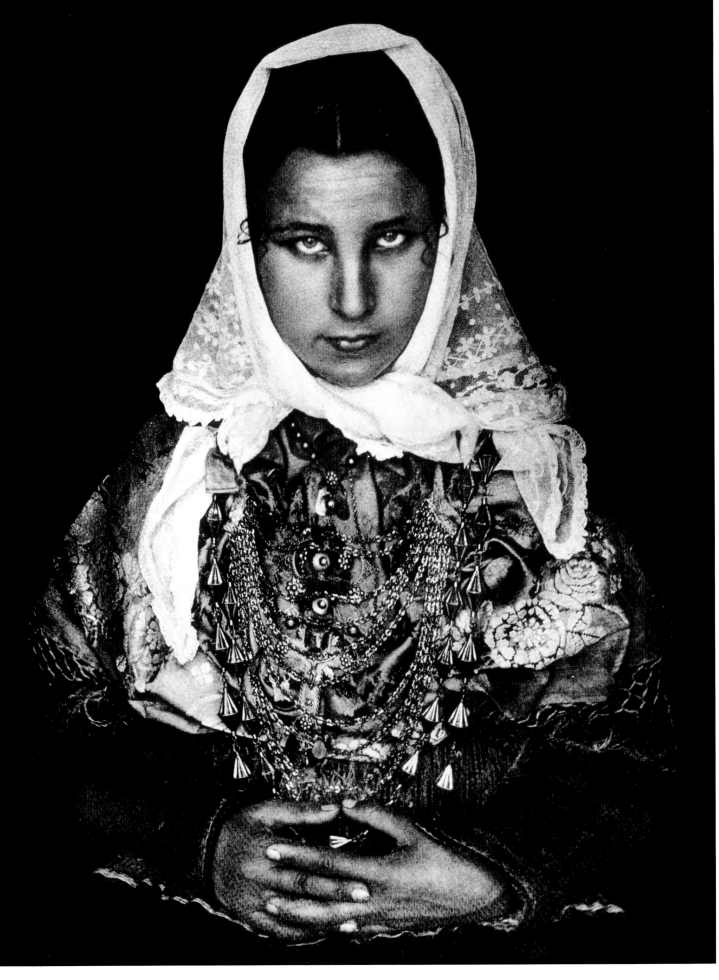

JOSÉ ORTIZ-ECHAGÜE *CHICA DE IBIZA (GIRL FROM IBIZA)*, C. 1930.
FACING PAGE: **MICHEL SÉMÉNIAKO**
"IDENTITÉ/ACTIVITÉ," PORTRAITS NÉGOCIÉS D'AGENTS EDF ("IDENTITY/ACTIVITY," NEGOTIATED PORTRAITS
OF ÉLECTRICITÉ DE FRANCE EMPLOYEES), 2000.

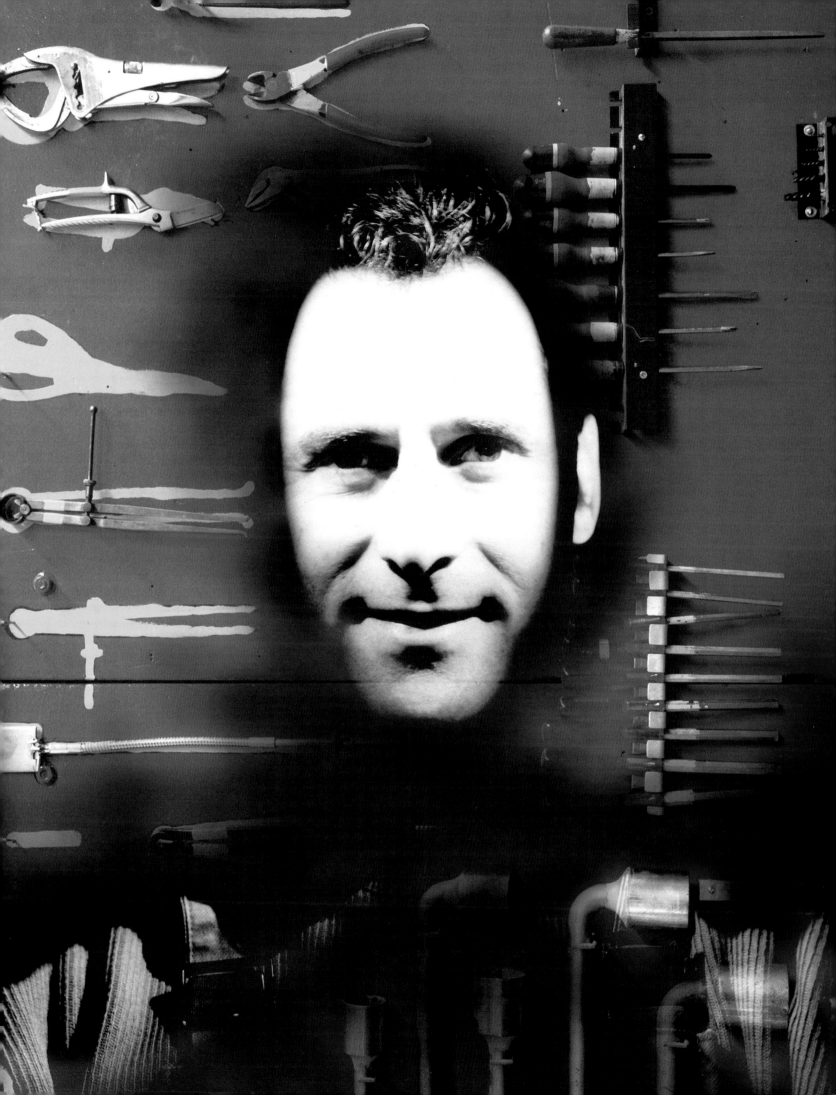

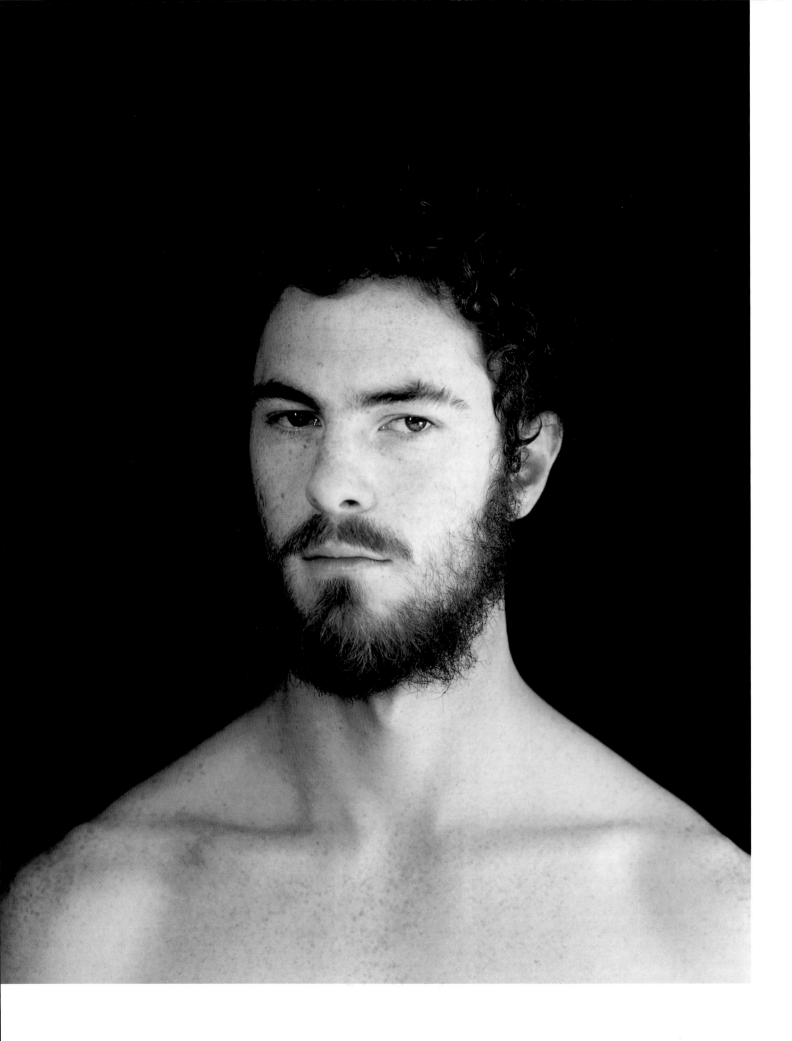

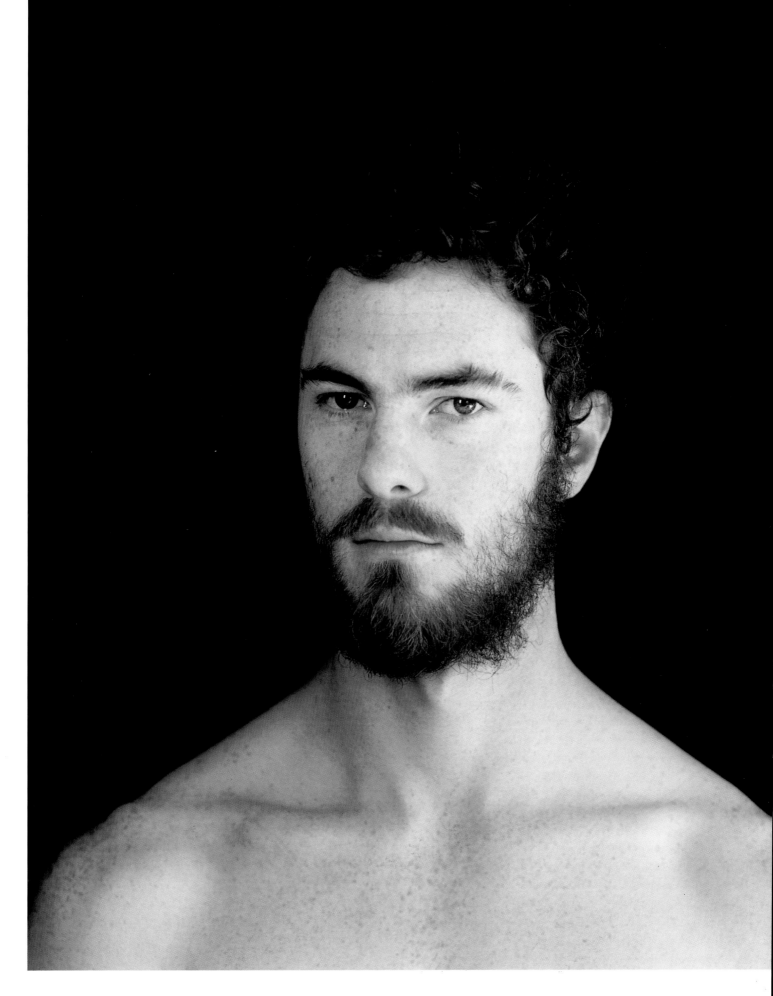

ISABELLE WATERNAUX
UNTITLED (COLOR PHOTOGRAPH OF BORIS CHARMATZ),
FROM THE SERIES ÉCARTS (DIFFERENCES), 2003.

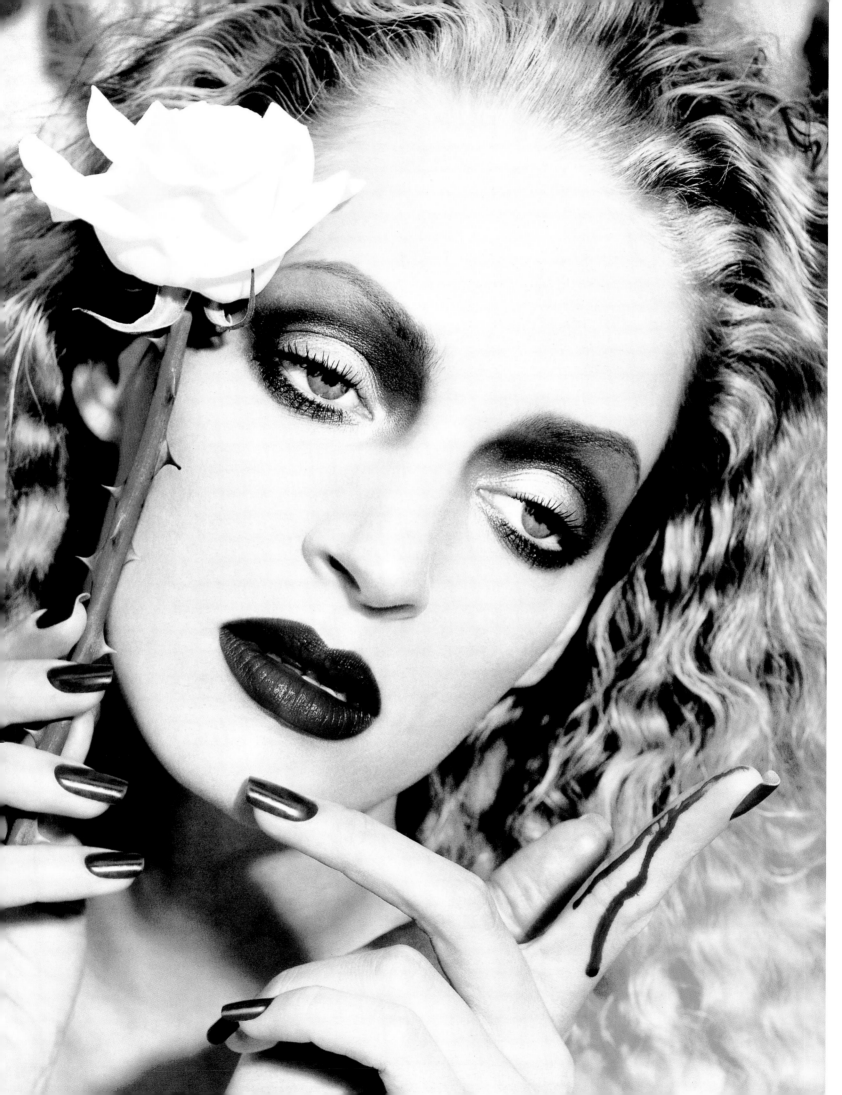

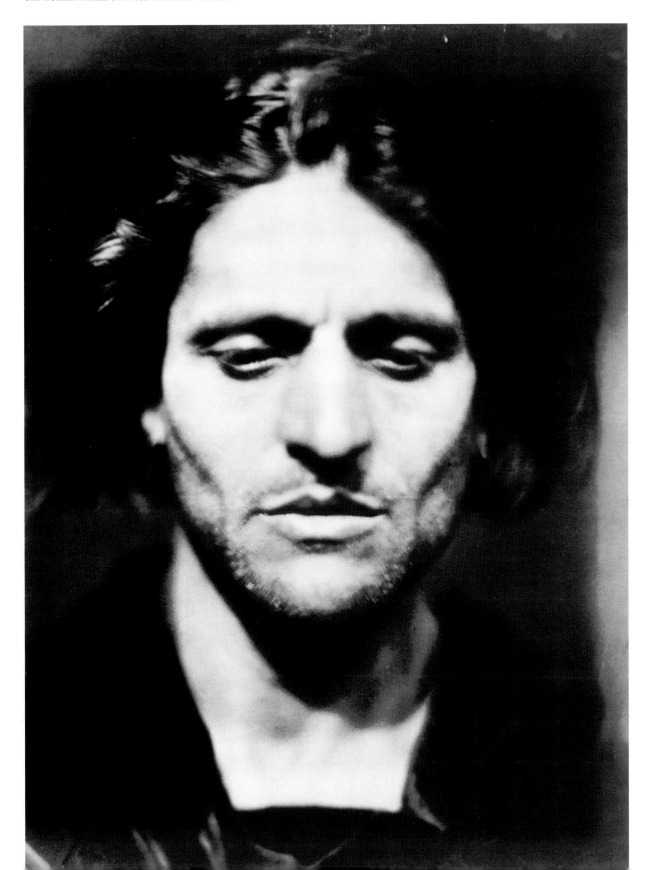

BETTINA RHEIMS *I.N.R.I,*
LE LAIT MIRACULEUX DE LA VIERGE, VILLE-EVRARD
(I.N.R.I, THE MIRACULOUS MILK OF THE VIRGIN, VILLE-EVRARD), MARCH 1997.
FACING PAGE:
JOSÉ ORTIZ-ECHAGÜE
MORO DEL RIF (MOOR OF THE RIF), 1909–1915.

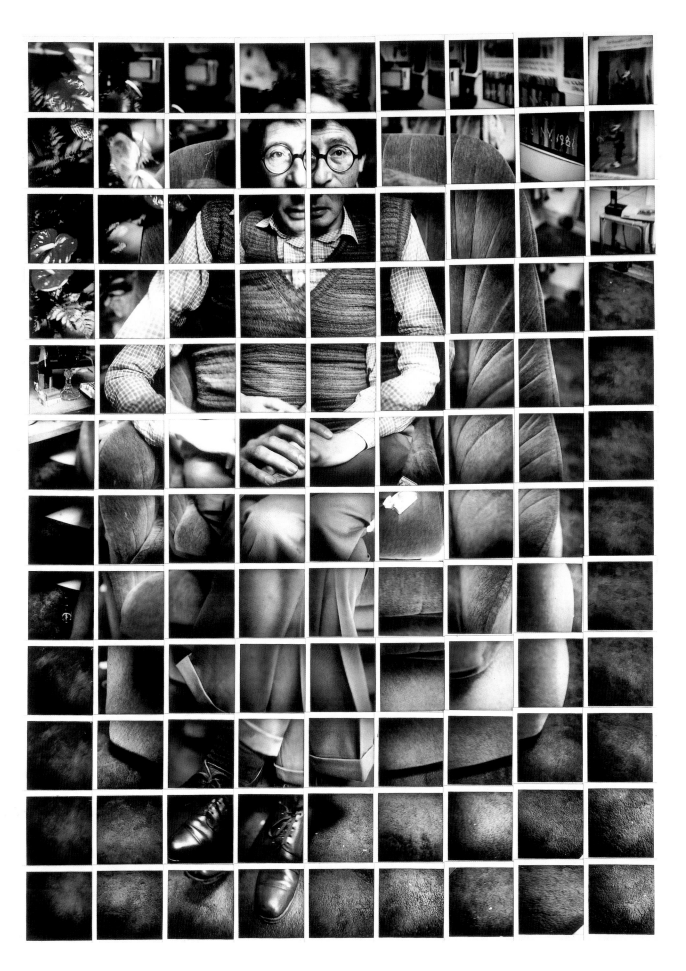

DAVID HOCKNEY
KASMIN, LOS ANGELES, 28 MARCH 1982.
FACING PAGE:
INEZ VAN LAMSWEERDE
BIANCA TALKING, 1999.

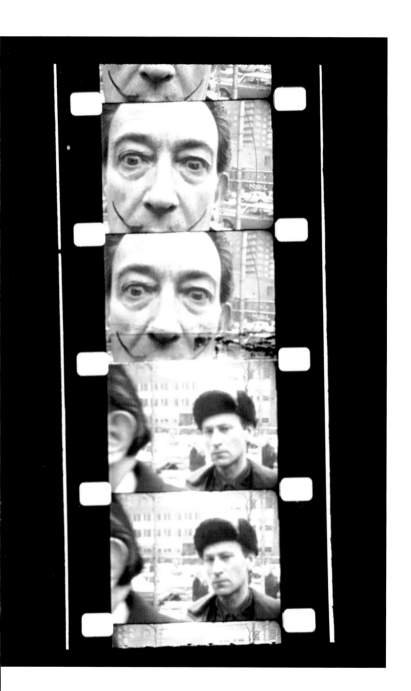

JONAS MEKAS
SALVADOR DALI, MYSELF,
FOOTING AROUND, NEW YORK, 1964
(PHOTOGRAMS OF THE FILM *IN BETWEEN*).
FACING PAGE:
SAM TAYLOR WOOD
SOLILOQUY VIII, 2000.

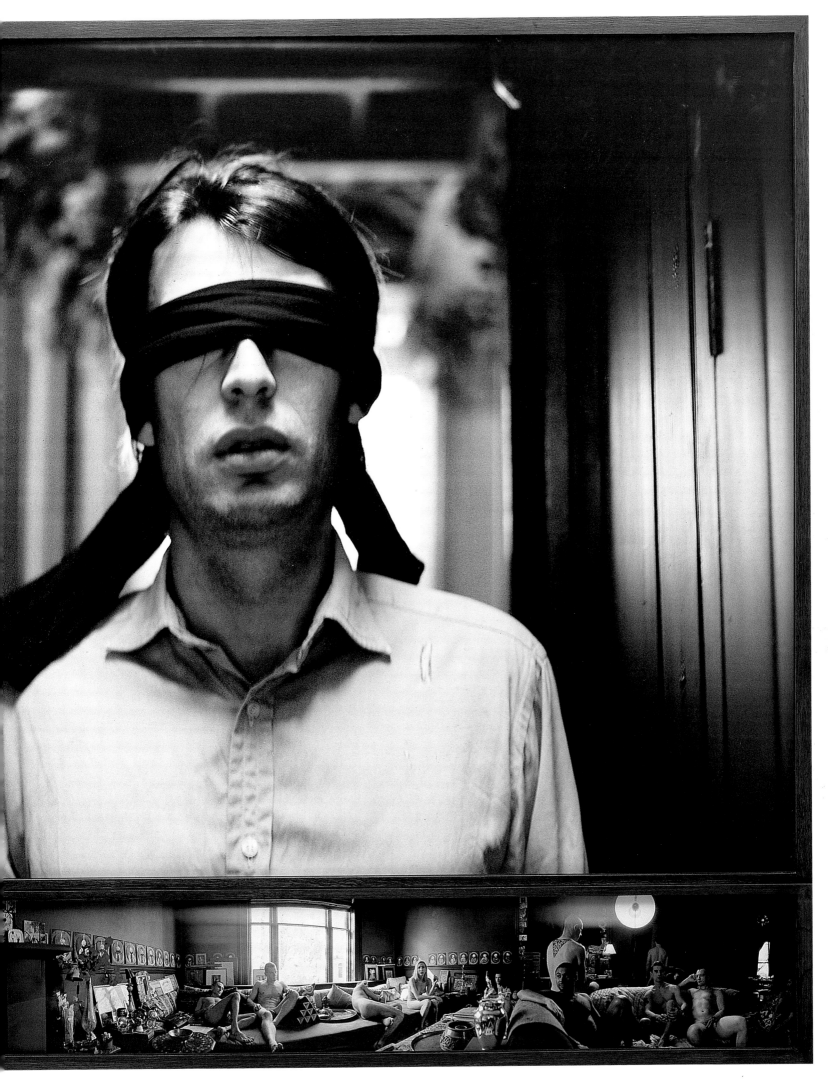

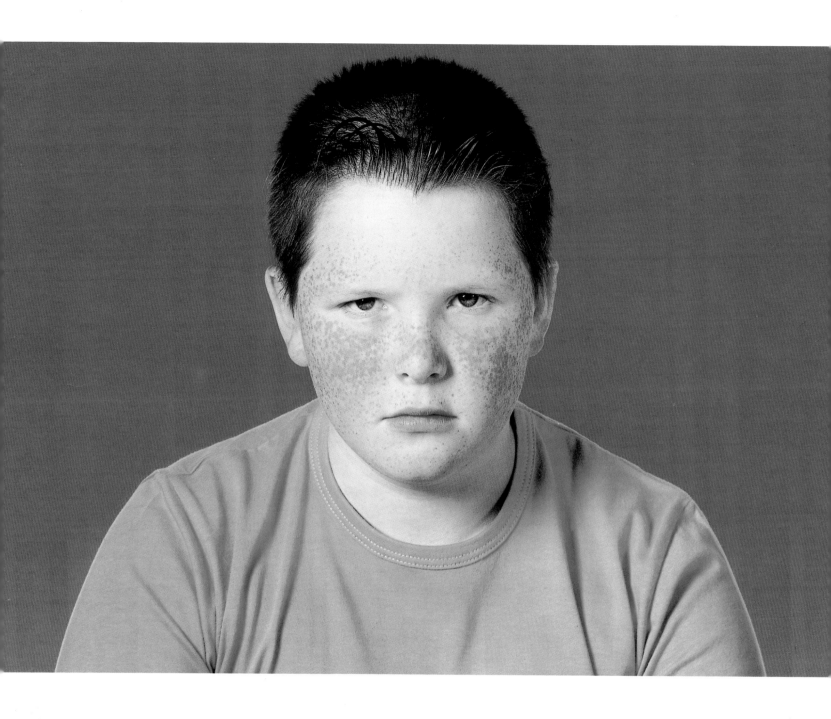

VALÉRIE JOUVE
UNTITLED NO. 54, 1988.
FACING PAGE: **STÉPHANE PASSET**
*TRANCHÉES DES LOGES, GUERRE
(LODGE TRENCHES, WAR)*, 1915.

CONSTANTIN BRANCUSI
*SELF-PORTRAIT
IN THE ATELIER AND TREE
TRUNK*, PARIS, C. 1933–1934.
FACING PAGE:
VIVAN SUNDARAM
AMRITA AND INDIRA.

JACQUES-HENRI LARTIGUE
*JACQUES-HENRI LARTIGUE
AND RICHARD AVEDON,
NEW YORK, 1966.*

INDEX
OF PHOTOGRAPHERS

KRULL, GERMAINE *SELF-PORTRAIT*, 1925. COURTESY ANNE AND JÜRGEN WILDE, ZÜLPICH-SPRENGEL MUSEUM, HANNOVER.
PAGE 227

KÜHN, HEINRICH *HANS UND LOTTE*, C. 1914. COURTESY DIDIER GRUMBACH
PAGE 138

LACHAPELLE, DAVID *UMA THURMAN PRICKED BY A ROSE THORN*, NEW YORK, 1997. © DAVID LACHAPELLE. COURTESY GALERIE KAMEL MENNOUR, PARIS.
PAGE 280

LAFONTAINE, MARIE-JO *BELLE JEUNESSE (BEAUTIFUL YOUTH)*, 1998. © MARIE-JO LAFONTAINE. COURTESY GALERIE THADDAEUS ROPAC, PARIS.
PAGE 288

LAMSWEERDE, INEZ VAN *BIANCA TALKING*, 1999. © VAN LAMSWEERDE MATADIN LTD. CARE OF MATTHEW MARKS GALLERY, NEW YORK.
PAGE 284

LANGE, DOROTHEA *MIGRANT MOTHER*, NIPONO, CALIFORNIA, 1936. COURTESY THE LIBRARY OF CONGRESS, WASHINGTON.
PAGE 190

LARRAIN, SERGIO *CHILI*, VALPARAISO, 1963. © SERGIO LARRAIN/MAGNUM PHOTOS, PARIS.
PAGE 249

LARTIGUE, JACQUES-HENRI *JACQUES-HENRI LARTIGUE AND RICHARD AVEDON*, NEW YORK, 1966. © MINISTÈRE DE LA CULTURE, FRANCE/A.A.J.H.L.
PAGE 294

LARTIGUE, JACQUES-HENRI *NICOLE GROULT'S GREYHOUNDS*, JANUARY 1926. © MINISTÈRE DE LA CULTURE, FRANCE / A.A.J.H.L.
PAGE 192

LAUGHLIN, CLARENCE JOHN *THE EYE THAT NEVER SLEEPS*, 1941. COURTESY GALERIE ROBERT MILLER, PARIS.
PAGE 166

LAWICKMÜLLER *PERFECTLYSUPERNATURAL: ATENA LEMNIA, VALERIA, AGNES, LENA, NADINE*, 1999. © LAWICKMÜLLER. COURTESY GALERIE PATRICIA DORFMANN, PARIS.
PAGE 115

LEBNIKOV, ALEXANDRE *PORTRAIT FOR A PERFUME*, 1928. COURTESY BAUHAUS-ARCHIV, BERLIN.
PAGE 111

LEHNERT AND LANDROCK *FATHMA, DE LA TRIBU DES OULED NAIL (FATHMA, OF THE OULED NAIL TRIBE)*, C. 1900.
PAGE 144

LEIBOVITZ, ANNIE *ANDRÉE PUTMAN*, 1989. © ANNIE LEIBOVITZ.
PAGE 99

LESUEUR, NATACHA *UNTITLED*, 2002. © NATACHA LESUEUR. COURTESY GALERIE PRAZ DELAVALLADE, PARIS.
PAGE 133

LEVIN, SAM *GINA LOLLOBRIGIDA*, 1952. © SAM LEVIN/MINISTÈRE DE LA CULTURE, FRANCE.
PAGE 130

LEVINSTEIN, LEON *TIME SQUARE/42ND STREET*, C. 1970. © LEON LEVINSTEIN. COURTESY BAUDOIN LEBON, PARIS.
PAGE 81

LEVITT, HELEN *NEW YORK, BOY IN DOORWAY*, 1938. © HELEN LEVITT. COURTESY COLECCIÓN ORDÓÑEZ-FALCÓN DE FOTOGRAFÍA.
PAGE 139

LINDBERGH, PETER *CHARLOTTE RAMPLING*, PARIS, 1987. © PETER LINDBERGH.
PAGE 57

LISSITZKY, EL *SELF-PORTRAIT*, 1924–1925. COURTESY BAUHAUS-ARCHIV, BERLIN.
PAGE 209

LIST, HERBERT *IRÁKLION DOCK WORKER*, CRETE, 1936–1938. © HERBERT LIST ESTATE, MAX SCHELER, HAMBURG.
PAGE 153

LOEW, HEINZ, AND EDMUND LOLLEIN *PORTRAIT AND SHADOW OF PROFILE*, 1927–1928. COURTESY BAUHAUS-ARCHIV, BERLIN.
PAGE 37

LOLLEIN, EDMUND, AND HEINZ LOEW *PORTRAIT AND SHADOW OF PROFILE*, 1927–1928. COURTESY BAUHAUS-ARCHIV, BERLIN.
PAGE 37

MAAR, DORA, AND PIERRE KEFER *PORTRAIT DE FEMME (PORTRAIT OF WOMAN)*, 1934. © ADAGP, PARIS, 2003. COURTESY GALERIE MICHÈLE CHOMETTE, PARIS.
PAGE 91

MAN RAY *LEE MILLER*, 1930. © MAN RAY TRUST/ADAGP, PARIS 2003.
PAGE 241

MAN RAY *RAYOGRAPH*, 1922. © MAN RAY TRUST/ADAGP, PARIS 2003.
PAGE 98

MÄNNIKKÖ, ESKO *KHUMO*, 1994. © ESKO MÄNNIKKÖ. COURTESY GALERIE CENT8-SERGE LE BORGNE, PARIS.
PAGE 129

MAPPELTHORPE, ROBERT *PORTRAIT OF ANDY WARHOL*, 1986. © ROBERT MAPPELTHORPE FOUNDATION. COURTESY GALERIE BAUDOIN LEBON, PARIS.
PAGE 178

MARAT, DOLORES *UNTITLED*. COURTESY GALERIE SERGE ABOUKRAT, PARIS.
PAGE 266

MARSH, WILLIAM *ABRAHAM LINCOLN*, 1860.
PAGE 231

MAYWALD, WILLY *THE VISCOUNTESS OF NOAILLES*, PARIS, 1948. © ADAGP, PARIS 2003.
PAGE 213

MCCULLIN, DON *THE DEATH COLLECTOR, HOLLOWAY ROAD, LONDON, MIDDLE OF THE SIXTIES*. © DON MCCULLIN.
PAGE 203

MEISELAS, SUSAN *PANDORA'S BOX, AWAITING MISTRESS NATASHA, THE VERSAILLES ROOM*, NEW YORK, 1995. © SUSAN MEISELAS/MAGNUM PHOTOS, PARIS.
PAGES 68–69

MEKAS, JONAS *SALVADOR DALI, MYSELF, FOOTING AROUND*, NEW YORK, 1964 (PHOTOGRAMS OF THE FILM *IN BETWEEN*). © JONAS MEKAS. COURTESY GALERIE DU JOUR AGNÈS B, PARIS.
PAGE 286

MEYER, BARON ADOLPHE DE *PORTRAIT OF A MAN*, C. 1920. © INTERNATIONAL MUSEUM OF PHOTOGRAPHY AT GEORGE EASTMAN HOUSE, ROCHESTER, NEW YORK.
PAGE 70

MICHALS, DUANE *PORTRAIT OF THE MAN WHO LOOKS LIKE EDOUARD MANET ON THE ANNIVERSARY OF HIS DEATH, 30 APRIL 1883*. © DUANE MICHALS. COURTESY DIDIER GRUMBACH.
PAGE 147

MILLER, LEE *CHRISTIAN BÉRARD*, PARIS, 1944. © LEE MILLER ARCHIVES.
PAGE 212

MODEL, LISETTE *BILLIE HOLIDAY*, 1959. © GALERIE BAUDOIN LEBON, PARIS.
PAGE 78

MODEL, LISETTE *WOMAN WITH A VEIL*, 1947. © GALERIE BAUDOIN LEBON, PARIS. COURTESY COLECCIÓN ORDÓÑEZ-FALCÓN DE FOTOGRAFÍA.
PAGE 149

MOHOLY, LUCIA *PORTRAIT OF FLORENCE HENRI*, 1927. © ADAGP, PARIS 2003. COURTESY BAUHAUS-ARCHIV/COLLECTION THOMAS WALTER, BERLIN.
PAGE 184

MOHOLY-NAGY, LÁSZLÓ *PORTRAIT OF ELLEN FRANK*, C. 1929. © ADAGP, PARIS 2003. COURTESY BAUHAUS-ARCHIV, BERLIN.
PAGE 36

MOLINIER, PIERRE *SELF-PORTRAIT*, 1967. © ADAGP, PARIS 2003. COURTESY GALERIE KAMEL MENNOUR, PARIS.
PAGE 272

MOLLINO,CARLO *UNTITLED*. © CARLO MOLLINO.
PAGE 263

MOON, SARAH *AIMÉ DEUDÉ*, 1997. © SARAH MOON. COURTESY GALERIE CAMERA OBSCURA, PARIS.
PAGE 289

MORATH, INGE *DONA MERCEDES FORMICA*, MADRID, 1955. © INGE MORATH/MAGNUM PHOTOS, PARIS.
PAGE 225

MORIMURA, YASUMASA *TO MY LITTLE SISTER: FOR CINDY SHERMAN*, 1998. © YASUMASA MORIMURA. COURTESY GALERIE THADDAEUS ROPAC, PARIS.
PAGE 135

MUNIZ, VIK *CHUCK*, 2001. © ADAGP, PARIS 2003. COURTESY COLECCIÓN ORDÓÑEZ-FALCÓN DE FOTOGRAFÍA.
PAGE 128

MUNKACSI, MARTIN *MARLENE DIETRICH*, C. 1936. © JOAN MUNKACSI. COURTESY HOWARD GREENBERG GALLERY, NEW YORK.
PAGE 95

NADAR *FELIX, PAUL AND ERNESTINE*, C. 1863–1865.
PAGE 202

NAMUTH, HANS *JACKSON POLLOCK*, 1950. © HANS NAMUTH.
PAGE 265

NAPPELBAUM, MIKHAIL *MEYERHOLD*, 1932.
PAGE 50

NAUMAN, BRUCE *SELF-PORTRAIT AS A FOUNTAIN*, 1966–1967/1970. THE HEITHOFF FAMILY COLLECTION AND GERALD S. ELLIOTT, CHICAGO.
PAGE 267

NAYA, CARLO *WATER-CARRIER*, EGYPT, 1876.
PAGE 270

NEWTON, HELMUT *AVA GARDNER*, LONDON, 1984. © HELMUT NEWTON.
PAGE 96

NEWTON, HELMUT *ISABELLE HUPPERT AT THE CARLTON HOTEL*, CANNES, 1976. © HELMUT NEWTON.
PAGE 38

NEWTON, HELMUT *RAINER WERNER FASSBINDER*, MUNICH, 1980. © HELMUT NEWTON.
PAGE 109

NEWTON, HELMUT *SELF-PORTRAIT*, MONTE-CARLO, OCTOBER 1993. © HELMUT NEWTON.
PAGE 4

NEWTON, HELMUT *SELF-PORTRAIT WITH HIS WIFE JUNE AND MODELS*, PARIS, 1981. © HELMUT NEWTON/STUDIO VOGUE, PARIS 1981.
PAGE 42

STOCK, DENNIS *JAMES DEAN ON THE FARM OF HIS UNCLE MARCUS WINSLOW*, FAIRMOUNT, INDIANA, 1955.
© DENNIS STOCK/MAGNUM PHOTOS, PARIS.
PAGE 220

STOLL, GEORGES TONY *LES TROIS FRÈRES (THE THREE BROTHERS)*, DECEMBER 1997. © GEORGES TONY STOLL.
COURTESY GALERIE DU JOUR AGNÈS B, PARIS.
PAGE 45

STRAND, PAUL *UNTITLED*, 1955.
© APERTURE FOUNDATION INC.
PAGE 237

STUDIO HARCOURT *BUSTER KEATON*, 1947.
© MINISTÈRE DE LA CULTURE, FRANCE.
PAGE 101

SUNDARAM,VIVAN *AMRITA AND INDIRA*. © VIVAN SUNDARAM.
COURTESY GALERIE DU JOUR AGNÈS B, PARIS.
PAGE 292

SZAGIN, IVAN *HENRI BARBUSSE*, 1936.
PAGE 112

TABUCHI, KANEYOSHI *MAN*, FROM THE SERIES *WONDERING JEW*, KOBE, 1941. COURTESY MRS RYUSHI KANEKO/TOKYO METROPOLITAN MUSEUM OF PHOTOGRAPHY.
PAGE 243

TAYLOR WOOD, SAM *SOLILOQUY VIII*, 2000.
© SAM TAYLOR WOOD.
COURTESY COLECCIÓN ORDÓÑEZ-FALCÓN DE FOTOGRAFÍA.
PAGES 286–287

TILLMANS, WOLFGANG *ARND*, REMSCHEID, 1991.
© WOLFGANG TILLMANS.
PAGE 58

TOSANI, PATRICK *PO 37*, 1985. © ADAGP, PARIS 2003.
COURTESY COLLECTION NSM VIE/ABN AMRO.
PAGE 40

TOURNACHON, ADRIEN *SELF-PORTRAIT*, 1855.
PAGE 200

TRAN BA VANG, NICOLE *UNTITLED*, FROM THE SERIES *SPRING/ SUMMER COLLECTION*, 2000. © NICOLE TRAN BA VANG.
COURTESY COLLECTION NSM VIE/ABN AMRO.
PAGE 271

TRIVIER, MARC *THOMAS BERNHARD*, AUSTRIA 1983.
© MARC TRIVIER. COURTESY COLLECTION NSM VIE/ABN AMRO.
PAGE 51

UBAC, RAOUL *SOLARISED SELF-PORTRAIT*, 1940.
© ADAGP, PARIS 2003.
PAGE 181

UMBO *PHYSIOGNOMIE DES KRIEGES (WARRIOR PHYSIOGNOMY)*, 1927.
COURTESY BAUHAUS-ARCHIV, BERLIN.
PAGE 204

VAN DORSSEN, SACHA *PIERRE MENDÈS FRANCE*, 1967.
© SACHA VAN DORSSEN.
PAGE 151

VIEITEZ, VIRXILIO *GALICE (ESPAGNE)*, 1957–1970.
© VIRXILIO VIEITEZ/AGENCE VU, PARIS.
PAGE 245

VOINQUEL, RAYMOND *LE REPOS POUR MICHEL-ANGE (REST FOR MICHAELANGELO)*, 1943.
© RAYMOND VOINQUEL/MINISTÈRE DE LA CULTURE, FRANCE.
PAGES 86–87

WAGNER, STEFAN *DIE ESSAYISTIN SUSAN SONTAG (THE WRITER SUSAN SONTAG)*, MUNICH 1978.
© FOTOMUSEUM IM MÜNCHNER STADTMUSEUM.
PAGE 110

WALL, JEFF *MILK*, 1984. © JEFF WALL. COLLECTION FRAC CHAMPAGNE ARDENNES, REIMS.
PAGE 269

WARHOL, ANDY *SELF-PORTRAIT IN DRAG*, 1979.
© ADAGP, PARIS 2003. COURTESY COLECCIÓN ORDÓÑEZ-FALCÓN DE FOTOGRAFÍA.
PAGE 188

WATERNAUX, ISABELLE *UNTITLED (COLOR PHOTOGRAPH OF BORIS CHARMATZ)*, FROM THE SERIES *ECARTS (DIFFERENCES)*, 2003. © ISABELLE WATERNAUX.
PAGES 278–179

WEEGEE *SELF PORTRAIT*, C. 1955.
COLLECTION DEBORAH BELL. COURTESY GALERIE FRANÇOISE PAVIOT, PARIS.
PAGE 226

WEGMAN, WILLIAM *SIAMESE*, 1989.
© WILLIAM WEGMAN.
COURTESY GALERIE DURAND DESSERT, PARIS.
PAGE 255

WESTON, EDWARD *NAHUI OLIN*, 1924.
© CENTER FOR CREATIVE PHOTOGRAPHY, ARIZONA BOARD OF REGENTS.
PAGE 257

WITKIN, JOEL-PETER *SELF-PORTRAIT. REMINISCENT OF PORTRAIT AS A VANITÉ*, 1995.
© JOEL-PETER WITKIN.
COURTESY GALERIE BAUDOIN LEBON, PARIS.
PAGE 83

YEVONDE, MADAME *MRS EDWARD MAYER AS MEDUSA*, FROM THE SERIES *GODDESSES*, 1935.
© YEVONDE PORTRAIT ARCHIVE.
PAGE 238

BIBLIOGRAPHY

AUTOPORTRAITS PHOTOGRAPHIQUES, EXHIBITION CATALOG, CENTRE GEORGES POMPIDOU, JULY–SEPTEMBER 1981. CURATED BY ALAIN SAYAG. PARIS: ÉDITIONS HERSCHER, 1981.

BAQUÉ, DOMINIQUE. *LA PHOTOGRAPHIE PLASTICIENNE : UN ART PARADOXAL.*
PARIS: ÉDITIONS DU REGARD, 1998.

BARTHES, ROLAND. *CAMERA LUCIDA: REFLECTIONS ON PHOTOGRAPHY.*
TRANSLATED BY RICHARD HOWARD. NEW YORK: HILL & WANG, 1982.

BARTHES, ROLAND. "SUR LA PHOTOGRAPHIE." INTERVIEW BY ANGELO SCHWARZ.
LE PHOTOGRAPHE, FEBRUARY 1980.

BRUNE, FRANÇOIS. *LA NAISSANCE DE L'IDÉE DE PHOTOGRAPHIE.*
PARIS: PRESSES UNIVERSITAIRES DE FRANCE, 2000.

FRIZOT, MICHEL. "PORTRAIT D'IDENTITÉ, IDENTITÉ DU PORTRAIT."
ART PRESS, NO. 120, DECEMBER 1987.

LACAN, JACQUES. "LE STADE DU MIROIR COMME FORMATEUR DE LA FONCTION DU JE."
PAPER PRESENTED AT THE 16TH INTERNATIONAL PSYCHOANALYTICAL CONGRESS, ZURICH, 1949.

LAVOIE, VINCENT. *L'INSTANT-MONUMENT : DU FAIT DIVERS À L'HUMANITAIRE.*
LES ÉTUDES SERIES. MONTRÉAL: ÉDITIONS DAZIBAO, 2001.

NANCY, JEAN-LUC. *LE REGARD DU PORTRAIT.* PARIS: ÉDITIONS GALILÉE, 2000.

OLLIER, BRIGITTE, AND ÉLISABETH NORA. *BEST REGARDS.* COLLECTION NSM VIE/ABN AMRO.
PARIS: ÉDITIONS DU REGARD, 2002.

ORTEL, PHILIPPE. *LA LITTÉRATURE À L'ÈRE DE LA PHOTOGRAPHIE : ENQUÊTE SUR UNE RÉVOLUTION INVISIBLE.* NÎMES: ÉDITIONS JACQUELINE CHAMBON, 2002.

PULZ, JOHN, AND ANNE DE MONDENARD. *LE CORPS PHOTOGRAPHIÉ.*
PARIS: ÉDITIONS FLAMMARION, 1995.

ROUILLÉ, ANDRÉ. "LES ATELIERS DE PORTRAIT" IN *HISTOIRE DE LA PHOTOGRAPHIE.*
EDITED BY JEAN-CLAUDE LEMAGNY AND ANDRÉ ROUILLÉ. PARIS: ÉDITIONS BORDAS, 1986.

SCHAEFFER, JEAN-MARIE. *PORTRAITS, SINGULIER PLURIEL,*
EXHIBITION CATALOG. ÉDITIONS MAZAN/BIBLIOTHÈQUE NATIONALE DE FRANCE, 1997.

STRAND, PAUL. *SIXTY YEARS OF PHOTOGRAPHY.*
NEW YORK: APERTURE FOUNDATION, 1976.

THE PORTRAIT IN PHOTOGRAPHY SERIES. EDITED BY GRAHAM CLARKE. LONDON: REAKTION BOOKS, 1992.

VERNANT, JEAN-PIERRE. *LA MORT DANS LES YEUX : FIGURES DE L'AUTRE EN GRÈCE ANCIENNE.* PLURIEL SERIES. PARIS: HACHETTE LITTÉRATURES, 1998.

ACKNOWLEDGMENTS:

THE PUBLISHER WOULD LIKE TO THANK PAUL ARDENNE AND ELISABETH NORA, RESPECTIVELY THE AUTHOR AND PHOTO RESEARCHER OF THIS BOOK. THANKS ARE ALSO EXTENDED TO LAURE BOLLINGER, ADELINE BOYER AND DOROTHÉE THIRION-FREICHE WHO ASSISTED ELISABETH NORA IN HER PHOTOGRAPHIC RESEARCH. FINALLY WE WOULD LIKE TO THANK THE ARTISTS AND ALL WHO CONTRIBUTED TO THE CREATION OF THIS WORK:

MARINA ABRAMOVIC, GALERIE AEROPLASTICS (BRUSSELS), COLLECTION ALBERT KAHN, COLETTE ALVAREZ URBAJTEL, GALERIE ANNE BARRAULT (PARIS), GALERIE ANNE DE VILLEPOIX (PARIS), ANNE AND JÜRGEN WILDE, KENNETH ANGER, COLLECTION ANTON CORBIJN, APERTURE FOUNDATION, PIERRE APRAXINE, NOBUYOSHI ARAKI, DIANE ARBUS, ARCHIV DES STUDIENGANGS FOTODESIGN AN DER FACHHOCHSCHULE (MUNICH), EVE ARNOLD, ASSOCIATION DES AMIS DE JACQUES-HENRI LARTIGUE (PARIS), AZIZ AND CUCHER, BARBARA GLADSTONE GALLERY (NEW YORK), MATTHEW BARNEY, DAVID BAILEY, ROGER BALLEN, GALERIE BAUDOIN LEBON (PARIS), BAUHAUS-ARCHIV (BERLIN), CLAUDE BERRI, ANNA AND BERNHARD BLUME, HOU BO, GARY LEE BOAS, KATHARINA BOSSE, PIERRE BOULAT, BILDARCHIV PREUSSICHER KULTURBESITZ (BERLIN), BILL BRANDT, KOOS BREUKEL, DAVID BUCKLAND, GENEVIÈVE CADIEUX, HARRY CALLAHAN, SOPHIE CALLE, GIOVANNA CALVENZI, GALERIE CAMERA OBSCURA (PARIS), DENIS CANGUILHEM, ROBERT CAPA, GALERIE CENT8-SERGE LE BORGNE (PARIS), COLLECTION CHRISTIAN BOUQUERET (PARIS), LARRY CLARK, AGENCE COSMOS (PARIS), SIMON COSTIN, CHRISTIAN COURRÈGES, DONIGAN CUMMING, LUC DELAHAYE, RAYMOND DEPARDON, PHILIP-LORCA DICORCIA, RINEKE DIJKSTRA, MIREILLE DOHMEN, GEORGES DUBY, GALERIE DURAND DESSERT (PARIS), ELLIOTT ERWITT, GALERIE EMMANUEL PERROTIN (PARIS), PATRICK FAIGENBAUM, DEBBIE FLEMING CAFFERY, FOTOMUSEUM IM MÜNCHNER STADTMUSEUM, FRAC CHAMPAGNE ARDENNES (REIMS), GALERIE DE FRANCE (PARIS), MARTINE FRANCK, GALERIE FRANÇOISE PAVIOT (PARIS), ALBERTO GARCIA ALIX, ANNE GARDE, RALPH GIBSON, GILBERT AND GEORGE, ROBERT GLIGOROV, NAN GOLDIN, DIDIER GRUMBACH, PHILIPPE HALSMAN, THE HEITHOFF FAMILY COLLECTION & GERARD S. ELLIOTT (CHICAGO), HERBERT LIST ESTATE, JOHN HILLIARD, ROBERT VAN DER HILST, DAVID HOCKNEY, FRANCK HORVART, HOWARD GREENBERG GALLERY (NEW YORK), PETER HUJAR, JEAN-BAPTISTE HUYNH, INTERNATIONAL MUSEUM OF PHOTOGRAPHY AT GEORGE EASTMAN HOUSE (NEW YORK), DOMINIQUE ISSERMAN, ALISON JACKSON, GALERIE JÉRÔME DE NOIRMONT (PARIS), GALERIE J. RABOUAN MOUSSION (PARIS), GALERIE DU JOUR AGNÈS B (PARIS), SARAH JONES, VALÉRIE JOUVE, GALERIE KAMEL MENNOUR (PARIS), RYUSHI KANEKO, KINSEY INSTITUTE, JÜRGEN KLAUKE, NICK KNIGHT, DAVID LACHAPELLE, MARIE-JO LAFONTAINE, INEZ VAN LAMSWEERDE MATADIN LTD, SERGIO LARRAIN, LAWICKMÜLLER, LEHNERT AND LANDROCK, ANNIE LEIBOVITZ, LENI RIEFENSTAHL PRODUKTION, NATACHA LESUEUR, LEON LEVINSTEIN, HELEN LEVITT, THE LIBRARY OF CONGRESS (WASHINGTON), PETER LINDBERG, LOTTE JACOBI ARCHIVES, LUHRING AUGUSTINE GALLERY (NEW YORK), MAGNUM PHOTOS (PARIS), ESKO MÄNNIKKÖ, DOLORÈS MARAT, MATTHEW MARKS GALLERY (NEW YORK), FONDS MAYER&PIERSON, DON MCCULLIN, PETER MCGILL, JONAS MEKAS, SUSAN MEISELAS, THE METROPOLITAN MUSEUM OF ART (NEW YORK), DUANE MICHALS, GALERIE MICHÈLE CHOMETTE (PARIS), GALERIE MICHEL REIN (PARIS), SARAH MOON, YASUMASA MORIMURA, INGE MORATH, VIK MUNIZ, MUSEUM FÜR KUNST UND GEWERBE (HAMBURG), HANS NAMUTH, NATIONAL MUSEUM OF PHOTOGRAPHY, FILM & TELEVISION (BRADFORD), BRUCE NAUMAN, HELMUT NEWTON, GABRIELE AND HELMUTH NOTHHELFER, COLLECTION NSM VIE/ABN AMRO, COLECCIÓN ORDÓNEZ-FALCÓN DE FOTOGRAFÍA, ORLAN, ANDRÉ OSTIER, PACE/MACGILL GALLERY (NEW YORK), PHILIPPE PACHE, MARTIN PARR, FREDERICO PATELLANI, GALERIE PATRICIA DORFMANN (PARIS), PATRIMOINE PHOTOGRAPHIQUE (PARIS), J. PAUL GETTY MUSEUM, PEABODY ESSEX MUSEUM (SALEM), IRVING PENN, ANDERS PETERSEN, PIERRE ET GILLES, JACK PIERSON, IVAN PINKAVA, BERNARD PLOSSU, GALERIE PRAZ DELAVALLADE (PARIS), RICHARD PRINCE, BERNHARD PRINZ, ARNULF RAINER, OLIVIER RENAUD-CLÉMENT, BETTINA RHEIMS, ROBERT MAPPELTHORPE FOUNDATION, GALERIE ROBERT MILLER, GEORGE RODGER, ERIC RONDEPIERRE, PAOLO ROVERSI, THOMAS RUFF, LUCAS SAMARAS, MAX SCHELER (HAMBURG), DAVID SEIDNER, MICHEL SÉMÉNIAKO, GALERIE SERGE ABOUKRAT (PARIS), CINDY SHERMAN, BARBARA SIEFF, SOTHEBY'S (LONDON), ANTANAS SUTKUS, ALICE SPRINGS, JEAN STEIN, DENNIS STOCK, GEORGES TONY STOLL, SAM STOURDZÉ, VIVAN SUNDARAM, GALERIE THADDAEUS ROPAC (PARIS), COLLECTION THOMAS WALTER (BERLIN), WOLFGANG TILLMANS, TOKYO METROPOLITAN MUSEUM OF PHOTOGRAPHY (TOKYO), PATRICK TOSANI, NICOLE TRAN BA VANG, MARC TRIVIER, RONNY VAN DE VELDE, SACHA VAN DORSSEN, VIRXILIO VIEITEZ, VOGUE, AGENCE VU (PARIS), JEFF WALL, WASHBURN GALLERY (NEW YORK), ISABELLE WATERNAUX, WILLIAM WEGMAN, JOEL-PETER WITKIN, SAM TAYLOR WOOD, GALERIE XIPPAS (PARIS), YEVONDE PORTRAIT ARCHIVE, GALERIE YVON LAMBERT (PARIS), GALERIE YVONAMOR PALIX (PARIS), YOHJI YAMAMOTO, ZÜLPICH-SPRENGEL MUSEUM (HANNOVER).